THE
ARTIST AS
PHOTO-
GRAPHER

THE ARTIST AS PHOTO- GRAPHER

MARINA VAIZEY

SIDGWICK & JACKSON
LONDON

First published in Great Britain in 1982
by Sidgwick and Jackson Limited

Copyright © 1982 Marina Vaizey

Designed by James Campus

ISBN 0-283-98739-1

Printed and bound in Great Britain by
Hazell Watson & Viney Limited
Aylesbury, Bucks
for Sidgwick and Jackson Limited
1 Tavistock Chambers,
Bloomsbury Way
London WC1A 2SG

For J

With very special thanks to William Abrahams,
Annie Horton, Marigold Johnson, Libby Joy, and
Nicola Thomson; and to all the colleagues and
friends with whom I have discussed various aspects
of this book

ALSO BY THE AUTHOR
100 Masterpieces of Art

CONTENTS

INTRODUCTION

In the second and third decades of the nineteenth century technical processes and methods which were to make possible the mechanics of photography were both discovered and explored. By 1839 some of these processes were public knowledge. Their dissemination led to the practice of photography on a very large scale, even though at first the equipment was cumbersome and elaborate.

A significant number of photographers, both amateur and professional, had been trained as artists or were in any event more than competent in the conventions of the visual arts. The Frenchman Louis Jacques Mandé Daguerre (1789-1851) was a painter and stage designer who made his living as the creator and entrepreneur of the diorama, a panorama displayed in public auditoriums; Daguerre was anxious to find some way of fixing the image made by the camera obscura, a mechanical aid used by artists for centuries. His sometime collaborator, Joseph Nicéphore Niepce (1765-1833), credited with taking the first (1826) photograph directly from nature which has survived, was a gifted amateur, not a professional artist.

The Englishman William Henry Fox Talbot (1800-77), who came from a social class similar to Niepce, was the ideal nineteenth-century polymath of the arts and sciences, the monied gentleman amateur, as adept with the use of the sketchbook as with the ideas of speculative mathematics, a man of enthusiastic curiosity, as passionate about botanical collecting as scientific enquiry and experiment. His invention of the positive-negative process is the true progenitor of modern photography, and his intellectual involvement was as important as his practical genius. Daguerre and Fox Talbot are the best-known pioneers of the mechanics of early photography. Visual sophistication and visual skill were integral to the impulses that led to the practical foundations of modern photography.

From photography's beginning people who were artists and

were to continue calling themselves such availed themselves of the new medium. Some saw it as an aid and a short cut, and some as a threat to their profession. But by the 1880s and 1890s the era of the new portable cameras made photography unavoidable, and further technical advances have made it ubiquitous: the omnipresence of photographs in publications of all kinds, its use as a sophisticated vehicle for information accepted as authentic, the nearly universal practice of photography as a hobby and in casual haphazard manner by the general public, ordinary people with no particular training.

Photography has naturally been used by artists both for their art – as source material, as an image bank, and as a kind of drawing – and parallel to their art, from the time of its invention. Since the 1960s, the ways in which artists have used photography from its beginning have been explored in a number of substantial publications and exhibitions. This new interest in the intermingling of art and photography, and in the complex relationships between paintings, sculptures and photographs, has taken a very broad view. And recently, to turn full circle, a significant number of avant-garde artists has turned from sculpture and painting to use the camera as a primary tool and the photograph as a primary medium.

The wealth of photography available to the artist has come from photographers and easily accessible publications: artists have happened upon photographs as we all do. But there is an interesting specialist aspect of the relationship between the artist and photography: how, why and to what purpose artists themselves have been photographers, or have directly collaborated in the direction and commissioning of photographs. Artists who used photography immediately and at first hand in this way, taking their own photographs, or directing them, naturally imposed, consciously or unconsciously, their own styles on the photographic image. Although the purposes behind their own photographs were and are various – photographs used as working drawings, as documentation, and simply enjoyed in themselves without a direct relationship to work in other media – there is a shared sensibility. The photographs taken by artists are one more aspect of their visual vocabulary. And enough artists have been substantial photographers in their own right to suggest that a selective exploration of their own photographs in conjunction with their other work might remind us yet again of the intricate cross-references between art and photography, but in a very particular way: the artist as his own photographer.

1

FROM TODAY PAINTING IS DEAD

The most famous opening remark, apocryphal or not, in the history of modern photography and its relationship to painting and sculpture, is that of the distinguished French painter of historical subjects, Paul Delaroche (1797-1856). Delaroche, chairman of a committee set up by the French Academy in 1839 to investigate and evaluate the claims of Louis Daguerre (1789-1851) to have succeeded in the elusive business of permanently, through chemical means, fixing a momentary image of the real world, simply exclaimed, 'From today painting is dead!'

Few remarks have turned out to be less prophetic. Ironically, Delaroche himself, perhaps the most influential and successful history painter of his times, trained many an artist whose reputation eventually was made through the new medium of photography, including the Englishman Roger Fenton, the photographer of the Crimean War.

Far from the birth of modern photography heralding the death of the traditional fine arts, the complex and complicated relationships that ensued between painting and photography in many respects enabled a hardly imaginable expansion in techniques and subject matter for the former. However, at the

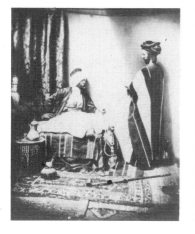

1 Roger Fenton
Two Gentlemen in Eastern Costume,
c.1857

Fenton is the English photographer now best known for his photographs of the Crimean War. He was not the only photographer there – a significant number of French photographers were at work – but his name is permanently associated with the military campaigns that were the first in the world to be extensively covered by photography. When he understood the difficulties in the way of making a living as a painter –

Fenton had studied in Paris with Paul Delaroche – he turned to photography; for a period he was the official photographer to the British Museum. Fenton amused himself in many portraits that he took by either dressing up himself, or dressing up his subjects. There was of course a very strong vogue for the exotic in art as well as photography, and wide travel throughout the nineteenth century encouraged the dissemination of 'Orientalism' in painting and photography.

time, the technical innovations – the daguerreotypes of Daguerre, himself a painter, and several years later (1841) the patenting by William Henry Fox Talbot, of his positive-negative process calotype, which turned out to be the basis of the method from which photography as we know it today has grown – were extremely frightening for many artists who were naturally quick to see that their function and their livelihood might be substantially under threat.

Our own times may praise the great landscape painter Joseph Mallord William Turner (1775-1851) for what appear to be the most adventurous experiments in the uses of colour and the dissolutions of forms to produce atmospheric interpretations of landscape. But Turner began his career as a delineator of most exact topographical views, and he greeted the invention of photography, it is reported, with the remark, 'I am glad I have had my day.' Indeed, several artist friends, when inspecting some daguerreotypes recently brought from Paris, had informed Turner that the profession of being an artist was vanquished by photography. This incident was noted down in an anecdote by John Ruskin, the English critic and champion of Turner's art and himself an enthusiast for photography. Ruskin's vacillating enthusiasm for the medium was vastly influential. For a time, Ruskin collected photographs, particularly as sources for architectural details. He also took photographs, with the help of servants who carried the cumbersome equipment.

Charles Landseer, RA (1799-1879), an older brother, highly successful in his own time, of Sir Edwin Landseer, RA (1802-73) – he whose animal paintings in particular were adored by Queen Victoria – simply quipped that photography was the 'foe-to-graphic' art.

Certain functional crafts have almost totally disappeared it is true: that of the miniaturist and the maker of silhouette portraits to name but two, for the steady necessary supplying of 'likenesses' has in large part been taken over by photography. But even here, there are curiosities. President Carter, as an economy measure, suggested that official portraits during his administration could – indeed should – be in the acceptable medium of photography; not too revolutionary we may think for the end of the 1970s. Come the Republicans, and President Reagan, and the official portrait for officials is once again the painting in oils. Obviously, the idea of the painting implies luxury and status still, perhaps because of the widespread availability of photography.

Yet, from the very beginning of the history of modern

photography, artists whose allegiance remained with the older visual arts embraced the new medium with enthusiasm. The history of mutual influence is intricate. But artists have used the photographic medium in three major ways.

First, photographs could be used as potentially the richest visual sources imaginable for painting. And from the beginning we find artists themselves not only passive recipients of whatever photographic source came to hand and eye, but actively collaborating with the photographers, and becoming photographers themselves. Some thus became deeply involved with photography as a medium in its own right, pursuing artistic concerns parallel with their activities in other media. And some, in common with the rest of us, simply enjoyed taking photographs. And the interest in looking at these photographs taken by artists is to see the reflection of their specific sensibility in the photographs they took.

So artists from the beginning of modern photography have themselves both used photography and been conditioned by photographic imagery, a photographic vision. Simultaneously, photographers have often imitated artists, and in many poses, many points of view, shared by photographers and artists it is difficult if not impossible to say what conditioned what. For on the one hand, Realism in all its complexity was a mode of thought that conditioned all art forms, from literature to painting, which grew in strength at the same time as the growth of photography. And on the other it is arguable that the existence of photography may well have liberated art from certain mimetic or imitative functions, so that painting, for instance, moved towards those modes described as Impressionist, Symbolist, Expressionist, Constructivist and Abstract. Pablo Picasso, the twentieth century's most famous artist, a polymath who certainly used anything he fancied, including photographs, as source material, declared that with photography we were now at last able to know 'everything that painting isn't'.

Indeed Picasso told his great friend, the photographer Brassai (himself first trained as a painter) that photography was 'capable of liberating painting from all literature, from the anecdote, and even from the subject', and felt that this newly acquired liberty should be exploited by painters so they could do many other things.

One of the earliest and most important artists of the nineteenth

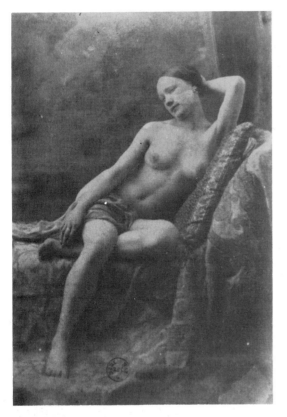

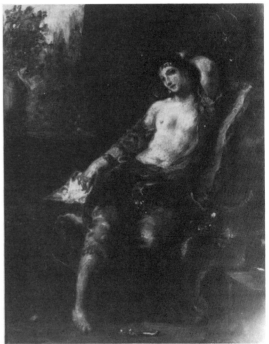

2 *Photograph of a naked woman, c.* 1853

The reclining woman, given an exotic flavour by the draperies, is of course a centuries-old motif in Western painting. Here is one of some photographs of a young woman in a pose echoed several years later in a small painting by the artist.

3 **Eugène Delacroix**
The Odalisque, 1857

The pose – subtly altered – is evidently connected with the photographs taken earlier, and which were in the artist's possession.

century to be interested in photography was Eugène Delacroix (1798-1863), often described as the greatest master of colour among all French artists. He had a taste for the exotic, and was as much at home with the intimate as he was with the sweeping, irresistible grandeur of the romantic historical subject. He called himself a rebel rather than a revolutionary. He had an omnivorous appetite for absorbing the lessons of the history of art and a passionate interest in great literature. He cultivated a supple, brilliantly vivid, spontaneous yet disciplined prose style very much his own, both immediate and measured, as evidenced in his journals, reviews and letters.

Delacroix was a founder member (1851) of the first national photographic society in France (Société Héliographique) but was never himself, as far as is known, a photographer. He wrote about being 'daguerreotyped' as his own portrait was taken; and he embraced the use of photography with high intelligence as a sometime collaborator, an aid, an intriguing element in his work. He thought photography had 'unquestionable advantages, side by side with its drawbacks', and he publicly regretted that the invention of modern photography should have come too late for him, that he had not had the benefit of learning through photography as a student, for photography demonstrated 'nature's true pattern'.

4 **Eugène Durieu**
Photograph of a male nude, c.1853

The collaboration between Eugène Durieu, who retired early from a bureaucratic job to pursue his interest in photography, and the painter Eugène Delacroix, has never been fully explored. However, Delacroix had access to Durieu's photographs, and there are drawings by Delacroix of naked men in poses of marked similarity to Durieu's photographs. Delacroix may have drawn as Durieu photographed, or suggested appropriate poses for the models to take.

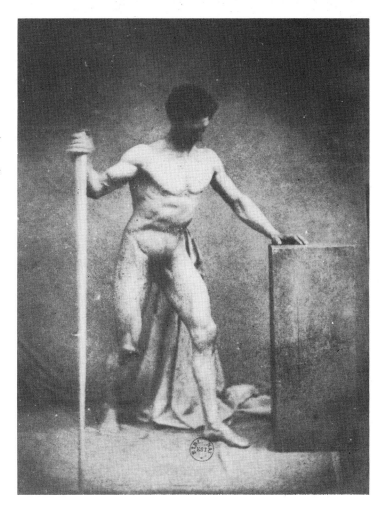

Through his friendship with Eugène Durieu (1800-74) – a talented, serious man, who had taken up photography as an abiding passion upon early retirement from his civil service job – Delacroix enjoyed the practice of arranging models in poses. Thus he was interested in acting as a kind of artistic director with Durieu's technical collaboration and back-up. Arranging the poses, which Durieu photographed, Delacroix drew either then in the photographic studio or perhaps later from photographs, echoing these arranged poses.

Photograph albums of nude men and women in various poses – distinguished by strikingly clear bodily outlines – were owned by Delacroix. At least one direct correspondence seems to exist: that of the photograph, about 1853, of a languorously posed young woman curled in sensuous style against a richly draped *chaise longue*, and her gentle transformation into the small oil of an odalisque (1857).

Photography therefore for Delacroix, one of the most intelligent and most feeling artists of the nineteenth century, was primarily a tool, a tool he regretted not mastering, but which he did not feel to be a threat. His involvement only stretches for a few years in the 1850s, when he was middle-aged, his reputation secure, his body of work substantial, secure on foundations both intellectual and imaginative.

Delacroix recorded his view that photography was a reflection of the real, a copy, and 'in some ways false just because it is so exact'. For one of Delacroix' maxims was that realism was the antithesis of art. Photography properly used was invaluable ('let a man of genius make use [of photography] as it should be used, and he will raise himself to a height that we do not know', was one of his speculations). But Delacroix never felt that photography would replace painting. That he considered it something valuable in itself is evidenced by his support for photographers who wished to show their work at the Salon, the method by which artists brought their products to the attention of the public. But certain kinds of selectivity, choice and exaggeration – in a sense lying to tell the truth – Delacroix implicitly reserved for painting.

The painter collaborating with the photographer was a pattern that was to be followed a good deal in the nineteenth century. Dante Gabriel Rossetti (1828-82), the Pre-Raphaelite artist, was a member of a splendid family whose exceptionally splendid mother's most fervent desire was that they be distinguished by intellect. 'Alas', she then declared, 'I have had my wish, and now I wish there were a little less intellect in the

5 Photograph of *Jane Morris*, 1865

Rossetti was for a period obsessed by
Jane Morris. The full extent of their
mutual involvement has been the
subject of unresolved speculation for
over a century. He did not take this
photograph of Jane Morris himself, but
posed her for the photographer in the
garden of his house in Chelsea in 1865;
the photographer is probably Emery
Walker. The pose was used later for
Reverie.

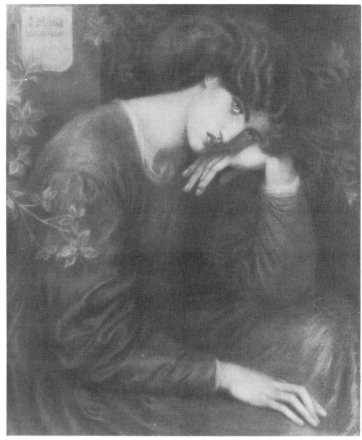

6 Dante Gabriel Rossetti
Reverie, 1868

family, so as to allow for a little more common sense.' Rossetti
had a stormy life, marked by emotional onslaughts and tem-
pestuous relationships. He and his glittering circle of talented
colleagues appear in a scintillating series of photographs taken
by that most intriguing and talented amateur of the camera,
Lewis Carroll. Rossetti certainly used photographs as an aid to
his work, had his own work photographed (an early instance of
the artist using photography as documentation), and in the
summer of 1865 actively collaborated with a photographer,
whose identity is still uncertain, by posing Mrs William Morris,
model, and adored friend, in a series of characteristically brood-
ing appearances in the garden of his house in Cheyne Walk,

15

Chelsea. These photographs, directed by Rossetti, are related at least to one portrait, *Reverie* (1868).

Rossetti retained ambivalent feeling towards photography, too. On one occasion he drew and painted over a photograph, and carefully noted the incident in a letter to a friend in case misunderstandings might occur.

There are several fascinating examples in nineteenth-century art of painters who turned to photography to help them in their

7 David Octavius Hill and Robert Adamson
The Adamson Family, c. 1845

This calotype was used on the title page of Hill and Adamson's *Calotype Sketches* (Edinburgh, 1848) which included 100 calotypes. Dr John Adamson, professor of chemistry at St Andrew's University, is on the left and Robert Adamson is on

the right. It is possible that several of the family are looking at a mirror to reflect the light on to their faces.

8 David Octavius Hill and Robert Adamson
The Reverend Dr Abraham Capdoze, c. 1845

Dr Abraham Capdoze, of The Hague,

appears here almost as we see him in Hill's minutely detailed picture, *The First General Assembly of the Free Church of Scotland, signing the Act of Separation and Deed of Demission*. Hill worked on the painting for twenty-three years. Calotypes of the individuals portrayed were taken to gather the visual information necessary for the painting.

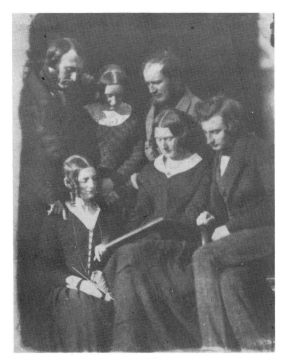

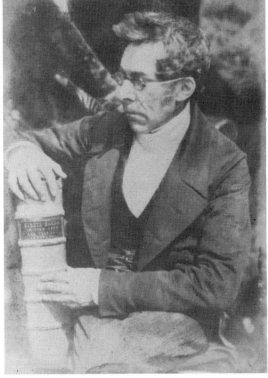

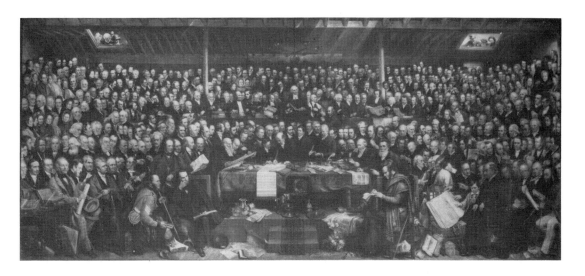

9 David Octavius Hill
The First General Assembly of the Free Church of Scotland, signing the Act of Separation and Deed of Demission, 1866

The painting for which Hill and Adamson took hundreds of calotypes was not actually finished until two decades after the event it commemorated. Over 180 calotype studies for the portraits in the painting can be traced, and the completed painting contains over 450 portraits. It is not, however, a totally accurate recording of the event because some people connected with it, but not actually present at the First General Assembly at the moment when the signing took place, are included.

painting, and who are now known to posterity not as artists but as photographers. Perhaps the most rewarding is that of the highly productive, aesthetically fertile partnership between two Scots: the painter David Octavius Hill (1802-70), and the engineer turned chemist Robert Adamson (1821-48). The charming, outgoing Hill was an artist who studied at Edinburgh, and was also obviously an able administrator and organizer, as he was secretary from his late twenties, for most of his life, to the Society of Artists which became the Royal Scottish Academy, as well as assisting in the foundation of the National Gallery of Scotland. In 1843, Hill undertook an enormous and ambitious commission to commemorate in a huge group portrait (which was to contain no less than 474 portraits of the participants) of the historic occasion, the signing of the Deed of Demission, in which leading members of the Scots clergy withdrew from the Church of Scotland, the established Presbyterian Church, from which the 'wee Frees' broke away. The painting itself took over twenty years to complete, and now hangs in the Free Church Assembly Hall, Edinburgh, its complete title being *The First*

17

General Assembly of the Free Church of Scotland, signing the Act of Separation and Deed of Demission. In the painting, Hill portrayed himself drawing, and his partner, the young engineer and chemist, and photographer, Robert Adamson, looking into a box camera. It was suggested to Hill when he undertook this commission, with the apparent impossibility of getting hundreds of people to pose for detailed sketches and drawings for the painting, that he work with Robert Adamson to take photographic portraits (calotypes) of the subjects. The collaboration between Hill, artistic director, and Adamson, the technician, lasted until Adamson's illness and tragically early death, and expanded far beyond the original project. The Hill-Adamson oeuvre reached something like 2,500 images, and included portraits not only of important and well-known people but of ordinary people too, of cityscapes of Edinburgh, of Newhaven fishing-village life, of local architecture, of daily life. Hill indeed even exhibited on at least three occasions the calotypes alongside his paintings of various subjects at the Scottish Academy's art exhibitions, with the explanation 'Calotype portraits executed under the artistic direction of D. O. Hill'.

Yet decades later, when Hill attempted to return to photography with another technical collaborator, the results were lack-lustre; the Hill–Adamson collaboration alone produced masterpieces. They were famous in their day, and when shown at the Great Exhibition of 1851 at the Crystal Palace, they received an official Honourable Mention; at the time, the Hill–Adamson portraits were favourably compared to the work of outstanding portrait painters like Sir Joshua Reynolds; and one well-known artist of the period, Clarkson Stanfield, announced that they were even better than Rembrandt. The subjects had to hold still, very still, for the early equipment used for photography was cumbersome and difficult to manage; Hill and Adamson, though, were able to take the equipment to the subject as well as to devise methods for posing people outside buildings in Edinburgh using just a few simple props. Thus a painter of mediocre ability, who never thought of himself as a photographer, and who painted throughout his career, is remembered today for portrait photographs that have never been surpassed, while his landscape and portrait paintings are quite forgotten. Hill's highly academic training and sympathies as a painter were indispensable to the alchemy of that mysterious and wonderful partnership: their simple, striking compositions owe much to Hill's knowledge of art, without ever being 'arty'. Adamson's contribution, which common sense

tells us must have extended significantly beyond the supply of technical skill, will probably never be properly assessed.

The Frenchman Charles Nègre (1820-80) had an oddly parallel career. He was a painter, a pupil of Ingres and Delaroche, who turned to photography as an aid for painting: today he is remembered – and exhibited – as the creator of exquisitely

10 Charles Nègre
The Vampire, c.1853

Charles Nègre was a pupil of the history painter Paul Delaroche, and about 1844 he began to experiment with daguerreotypes, in which the image was fixed on metal, a pursuit which Delaroche had recommended for painters, as aids to observation. Nègre, however, turned to paper photography, one of the first Frenchmen to do so. By the 1850s writers were responding to, and discussing, Nègre's photographs in terms appropriate to discussions of works of art. Thus he was one of the first artists whose photographs stand in their own right. Indeed, he worked over his paper negatives to heighten the effect. In this photograph the top-hatted man is Henri Le Secq, another artist who turned to photography. Nègre never hung up his brushes, however, and had a full career which embraced printing, teaching, the fine arts and photography.

memorable architectural scenes of Paris, and as the photographic reporter of life in Grasse. As a memorialist of great occasions and the everyday, Nègre may stand with a whole group of French photographers who trained as painters (or began as painters), first used photography as an aid to their painting, and then became professional, full-time photographers. Henri Le Secq (1818-82) is another, also a pupil of Delaroche's, as was Gustave Le Gray (1820-62), who turned from painting to full-time photography in 1848. The examples of artists becoming photographers in the nineteenth century could be multiplied almost infinitely it seems; they include two of the most famous 'art' photographers in Britain, Henry Peach Robinson (1830-1901) and Oscar Gustave Rejlander (1813-75), a Swede who settled in England after a career as a copyist and painter in Rome, and first began to make a living supplying photographs to other artists as an aid to their painting. What began as an aid to painting eventually supplanted painting in these careers: the servant became master. Whether the impulse was financial or aesthetic, economic or intellectual, is unclear.

Meanwhile, a significant number of the most successful artists of the day not only used photography but acknowledged that they did so. Photography was especially useful for the topographical painter, whose work was often wildly successful with the public. Jean-Léon Gérôme (1824-1906) resurrected the past with scenes from ancient Greece and Rome. Widely travelled in North Africa and the Middle East, he was not only interested in photographs to help achieve the meticulous glossy accuracy of his paintings, but took photographs of his own. Well over 150 bound volumes of photographs owned by Sir Lawrence Alma-Tadema (1836-1912), which he used as aids for his small yet panoramic vistas, his paintings of incidents in the life of ancient Greece and Rome, still survive. A Dutchman who studied in Antwerp, Alma-Tadema found riches and fame in Britain. He thought that photography was of 'the greatest use to painters', and his collection included photographs of sites, archaeological details, and objects such as jewellery.

While the immensely successful Victorian Sir John Everett Millais (1829-96), once a precocious member of the Pre-Raphaelite Brotherhood, did not take photographs himself, he believed in the beneficence of the camera, encouraged to do so by no less a personage than Queen Victoria, who adored photography. And Millais collaborated with an amateur photographer –Rupert Potter, father of Beatrix, the lady-farmer who created the tales of Peter Rabbit. Beatrix Potter recorded Millais in her

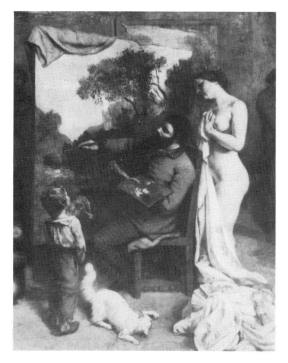
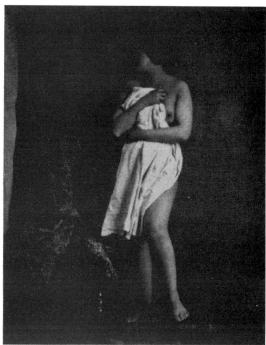

11 Gustave Courbet
The Painter's Studio, 1855 (detail)
12 Julien Vallou de Villeneuve
Nude Study, 1854

Courbet's huge painting devoted to the chief works of nineteenth-century French painting, aroused great controversy with its enormous cast of characters, both real people and prototypes, friends of the artist and those he had observed in passing. It was a gigantic pattern of life as he saw it: analogy, metaphor and reality all brought together on one canvas. Although there is no evidence that Courbet himself took photographs, he painted from photographs and was actively interested in finding photographs to work from. The photographer here, Villeneuve, was a printmaker and painter who took up photography in the 1840s. It is thought that Alfred Bruyas, a patron of Courbet's, and the subject of several of Courbet's paintings, introduced Courbet to Villeneuve's photographs of women.

diary as saying that 'all artists use photographs now'. She herself used photographs, sometimes her own, as aids for her delightful watercolours and drawings.

Both Millais and Alma-Tadema were subscribers to the pioneering scientific photographer Eadweard Muybridge's *Animal Locomotion.* Indeed, Alma-Tadema was instrumental in promoting (1882) the work of Muybridge in England. Jean Horace Vernet (1789-1863) was another wildly successful artist, a protégé of Louis-Philippe of France, criticized by his contemporaries for his photographic eye which noted all without

selectivity, unable to subordinate the detail to the whole. Indeed, on his travels he recorded extensively by means of his own daguerreotypes many of the details he might need for his paintings, so his enthusiasm for photography was well known.

Although the work of such establishment and established painters is only now cyclically coming back into fashion, with renewed interest in 'salon' or 'academic' painting, artists who have been thought of not as rearguard but vanguard were also openly reliant on photographs as aids for pictorial images. The most famous and controversial artist to use photographs openly in the nineteenth century was probably Gustave Courbet (1819-77). In his most complicated painting, *The Painter's Studio: A Real Allegory*, at least several of its figures are based on photographic images, and letters survive which indicate his broad-ranging requests to friends and photographers for images he wished to use in a variety of paintings and drawings.

However, though Courbet is known to have requested photographs for his work, at times taken in poses that he had suggested, he does not seem to have participated actively in the photographic process. Courbet was scandalously famous in his lifetime for his 'realism', a realism evident both in his subject matter, and in the immediate impact of his large paintings. Realism in nineteenth-century art – a determination in part to represent the immediacy of real life – is a complex movement that grew up in parallel to the spread of photography. But whether photography was the catalyst for Realism in painting, or vice versa, has yet to be fully investigated. Realism both in painting and photography was in the air.

Several of the nineteenth-century artists actually used early on a proto-photographic process, a kind of photoengraving known as *cliché-verre*. The practice was to draw with a stylus on a glass plate which had been coated with collodion or white lead. Instead of developing the drawing thus executed with acid, as in an etching, the plate was processed like a photographic plate, printed on photographic paper. Even Delacroix tried this process in 1854. For nearly twenty years Jean Baptiste Camille Corot (1796-1875), the gifted exponent of naturalistic landscape painting, made such prints – over seventy, both landscapes and portraits; and curiously the atmosphere to be found in Corot's landscape paintings from the 1850s is thought to be distinctly influenced by peculiarities, especially in the rendering of trees, that are characteristic of photographs of the period. Many another painter connected with the Barbizon school of landscape painting in France, including Théodore

Rousseau (1812-67), Charles François Daubigny (1817-78), and Jean François Millet (1814-75), also made *cliché-verre* prints.

Millet had several close photographer friends. An American pupil and admirer of Millet recorded that he thought 'photography a good thing', and would like to have a 'machine' himself, and was not averse to the idea of using photographs as notes of a kind, though antagonistic to painting from photographs. Letters of Millet's show that he both acquired photographs and probably used them in this way.

Perhaps the most interesting and attractive example of a highly gifted painter who used his photographs for his other artistic work, and was also an active and adventurous photographer, is the American Thomas Eakins (1844-1916). Eakins was one of the most visually adventurous realist painters of the nineteenth century, sophisticated, energetic, and highly trained. Born in Philadelphia, where indeed he spent most of his life, Eakins first studied at the Pennsylvania Academy of Fine Arts. There he followed the conventional course of drawing from plaster casts, but he also studied anatomy at Jefferson Medical College, his anatomical studies extending to the actual dissection of corpses. He was nothing if not thorough.

In his early twenties Eakins went to Europe and immersed himself for three intensive years in the strictly academic fine art training at the Ecole des Beaux Arts – where his chief teacher was that painter of glossy, blandly glamorous exotic scenes, Jean-Léon Gérôme, who himself used photography as an aid. He also pursued his anatomical studies and travelled extensively, being most impressed in Spain by the art of the great seventeenth-century painters, notably Velazquez. By the time he was twenty-six he had returned to Philadelphia, where he was to spend the rest of his life. His training had been conventional except for an unusual emphasis, self-directed it seems, on the scientific understanding of anatomy. He does not seem to have been in touch while in Paris with any of the potential leaders of the artistic innovations which were to become prominent in the 1870s.

Eakins consciously sought a truth to reality as he saw it, or as one art historian phrases it, a 'combination of the known, seen and remembered'. As he himself put it, he wanted to show 'what o'clock it is, afternoon or morning, winter or summer, and what kind of people are there, and what they are doing, and why they are doing it'.

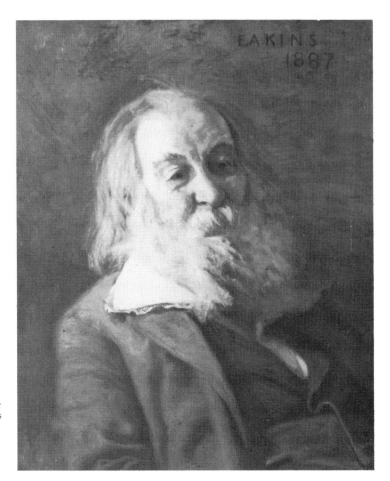

13 Thomas Eakins
Portrait of Walt Whitman, 1887

Eakins is one of the few artists whose
extensive use of photography, only
recently intensively explored, has been
the subject of exhibitions and scholarly
examination. Yet he, his artist friends,
colleagues, students, and collaborators,
would no doubt have been surprised to
see their photographs examined in their
own right. No less than ten photographs
of the great American poet, Walt
Whitman, are attributed to Eakins,
dating from 1887 to 1891, yet his
portrait of Whitman was painted from
the life.

His scientific curiosity was deployed towards this end. The
most scandalous episode of his career is typical: his pupils were
devoted to him, but at the Pennsylvania Academy of Fine Arts,
the oldest art school in America and Eakins' own training
ground, of which he became director, he taught anatomy and
drawing from the unclothed, live male nude, to both sexes.
Some of the Academy's women students protested at this
breach of genteel etiquette. When Eakins was dismissed, many
of his students followed him to an Art Students' League, which
flourished for a time.

Eakins' involvement with photography included experiment
and innovation. He worked directly with Eadweard Muybridge
(1830-1904), the tempestuous Englishman who in 1880 was

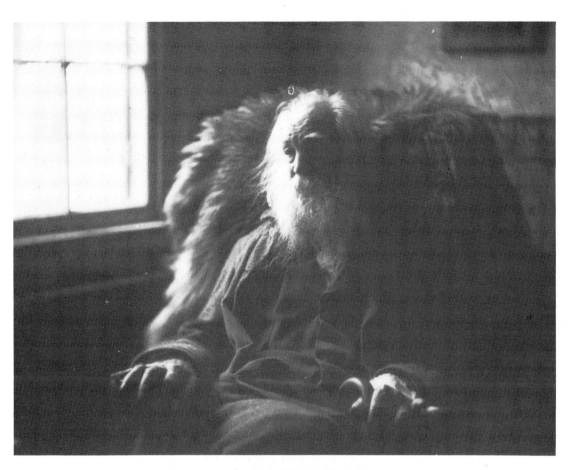

14 Photographs of *Walt Whitman*,
attributed to Thomas Eakins, *c.*
1891

These photographs were taken several
years after the portrait had been painted,
and show something of the same
sensibility and sensitivity to Whitman's
appearance; there is a use of light,
accidental or deliberate, that underlines
an approach which is circumspect
and full of respect, even reverence: an
approach that emphasizes Whitman's
dignity.

the first photographer successfully to photograph movement, during the course of a remarkable career which included his appointment as Director of Photographic Surveys for the United States Government. In the 1870s Muybridge worked for the railway millionaire, founder of Stanford University, sometime Governor of California, and a very distinguished horse-breeder, Leland Stanford. Muybridge's widely discussed and published studies of animal and human locomotion influenced painters immediately. By 1879, Eakins was already using Muybridge's accessible studies of the horse in motion for his painting *The Fairman Rogers' Four-in-Hand*.

In the early 1880s, Muybridge lectured extensively in Europe. In Paris, the academic painter Meissonier (1815-91) was particularly interested in the horse-in-motion, although at one point he noted rather loftily that he used photographs 'as Molière consulted his servants'. Meissonier gave a well-reported reception in honour of Muybridge (November 1881), summoning the most eminent artists, including Gérôme and Millet, scientists and the literary establishment of the day. Meissonier's painting of Leland Stanford (1881) shows Muybridge's photographs among the papers strewn on the table behind the imposing figure of the millionaire; this may be one of the first instances of a painting *of* a photograph.

And a few months later, in the winter of 1882, royalty, poets, politicians, and scientists excitedly attended the first public exhibition in London of Muybridge's work presented by the photographer himself at the Royal Institution. He lectured and gave a demonstration at the Royal Academy to an audience which included Sir Frederick Leighton and most of his fellow-painter Academicians, and was received with 'hearty applause' as one contemporary account put it.

By 1883, Muybridge was pursuing his photographic researches at the University of Pennsylvania in Philadelphia. He took hundreds of thousands of photographs; the outcome was his publication *Animal Locomotion: an electro-photographic investigation of consecutive phases of animal movement* (1887) which incorporated thirteen years of research in California and Pennsylvania. Muybridge had also worked in Paris with the French innovator Professor E. J. Marey.

Eakins may have already owned a camera by 1880, and certainly did so by 1883. He was a member of the commission that oversaw Muybridge's work at the university, and his practical nature has been credited with a refinement of Professor Marey's single disc camera. Eakins devised a method which involved two

perforated discs revolving behind the camera lens, one moving eight times as fast as the other. This meant eight to ten exposures per plate. It is thought that Eakins did not continue his own experiments in recording animal and human locomotion after 1885.

But there is bountiful evidence that Eakins, or his pupils, especially the sculptor Samuel Murray, and Eakins' wife Susan, herself a painter and photographer, made a significant number of photographs especially for use as *aide-mémoires* or for other practical reasons. For instance, several photographs were taken about 1895 of Frank Hamilton Cushing, the ethnographer who worked for years with the Zuni Indians. When Eakins came to paint him, Cushing, not yet forty, was already ill, too ill to stand for long periods in Indian regalia and costume. A series of portrait photographs was the answer for Eakins.

For several paintings of 1883 – *The Swimming Hole* and *Arcadia* – Eakins not only made a number of oil sketches, but many figure photographs were taken. Both were but methods: for the diving figure in *The Swimming Hole*, a figure was even modelled in wax. There is no evidence that Eakins himself regarded photographs *in their own right* as anything other than investigative tools which aided and perhaps even corrected visual memory and understanding. Yet now Eakins' photographs are looked at as independent works of art: in the new American Wing at the Metropolitan Museum of Art, New York, Eakins' photograph of *Standing Piper*, a study for *Arcadia*, is set among a selection of outstanding American photography by *photographers*.

There were modelling sessions by the athletes involved who were eventually portrayed by Eakins in several versions of *The Wrestlers*; they modelled for photographs as well as sketches. Typically, Eakins' search for visual truth led to such stratagems as actually strapping his model, his friend and pupil J. Laurie Wallace (also photographed as the piper for *Arcadia*), to a cross when he painted his life-size *Crucifixion*.

It is in this light that we must view Eakins' career-long involvement with photography. Now, with our changing aesthetic, and different evaluations of the art of photography, Eakins' photographs may be valued in and of themselves; but Eakins must have seen them as a kind of background, visual research and documentation. Although his photographs were certainly exhibited in his lifetime, it was most probably from this point of view. For it is not always certain who among his immediate circle took what: he and his pupil Samuel Murray both took superb photographic portraits of the great poet Walt Whitman ('life shown as it is' said

Whitman). Although Eakins photographed widely – his family, friends, his house, the countryside – it probably never occurred to him that posterity would be interested in Eakins the photographer as much more than just an adjunct to Eakins the painter. The Eakins eye – and that of his circle – is evident though in his superb photographs, which look as though they were taken as much for pleasure as for interest.

Although a significant number of American nineteenth-century painters, including the greatest landscape painters of the day, from Albert Bierstadt, Frederic Edwin Church, Winslow Homer, FitzHugh Lane, William Michael Harnett, to Frederic Remington, are thought to have used photographs, either to study their subjects, or even as models, only Eakins seems to have been so profoundly involved both in photographic research and in taking photographs himself.

The hugely successful German artists, Franz von Lenbach (1836-1904) and Franz von Stuck (1863-1928), both of whom spent most of their professional lives in Munich (Lenbach would be most easily classified as a Realist, and Stuck a Symbolist), both used photographs they had taken themselves for their work, as well as photographs by others. In some cases Lenbach acted as the director, ordering, suggesting and posing. For instance, he made altogether something over eighty portraits of the German Chancellor, Bismarck, and for this purpose had what amounted to a research library of photographic portraits of this subject. A contemporary criticized Lenbach, one of the leading portrait painters of his day, for the glassy gaze, photographic and not realistic or artistic, which characterized the look of his subjects. The artist also projected photographs on to his canvas as a kind of preliminary underpinning to work from. There is one very famous correspondence of his own photography to a painting: the photograph he took of himself, his wife and two daughters, against the background of a white sheet. The pose thus caught is almost exactly retained in the oil painting (1903), including the rather odd background (for a painting that is) of the sheet.

Stuck too photographed himself in front of a blank canvas, palette in hand; he also photographed his wife and combined the two in a painting of 1902. Both these artists, courted, fêted, honoured, and efficient craftsmen – Lenbach's portraits praised for their intensity of interpretation, Stuck's imaginative symbolism now back in fashion – used photographs, often taken by

themselves and even more frequently directed by them, as a normal part of their working methods. They do not, however, seem to have been interested in photography for its own sake, but only as a means, a means to short cuts through more laborious methods. Certainly the use of photography markedly curtailed the necessity for portrait sittings, and presumably enabled the painters to be more productive and active than if they had not availed themselves of this practical help.

A fascinating collaboration with photography is that of the Austrian artist Egon Schiele (1890-1918), an artist of highly idiosyncratic, searing realism, who certainly seems to have looked intently at significant compositions by the Norwegian Edvard Munch. Schiele has at times been labelled an Expressionist, in part because of the extreme intimacy and emotional intensity of his images. But Schiele was never concerned to distort, to abandon traditional means, methods and idioms of image-making, as some German Expressionists in terms of artistic principle certainly were. An element of his style does owe something to Art Nouveau, known in its German manifestation as *Jugendstil*, with the nervous intensity of his use of the sinuous complexity of line and outline, and his expressive use of colour. His art shocked the Establishment more by its subject matter – portraits which were erotically highly charged, often sexually explicit – than by its methods.

Schiele's portrait subjects were almost invariably girls and young women, his artist friends and colleagues, and himself. His output of self-portraits was prodigious; an item of furniture to which he was literally devoted was his black-framed mirror. He was narcissistic, stylish, something of a dandy, a collector of objects that caught his fancy, and obsessively hard-working. Schiele shared probably all too fully in the anguished, self-questioning and somewhat cynical despair that was typical of the highly active intellectual life of Vienna in the dying days of the Habsburg Empire, and he was accustomed to gazing at himself for hours in the mirror. His terrifying self-portraits reflect an acutely self-aware anxiety which is both inescapable and remarkably devastating. In 1914 and 1915 he collaborated with two artist friends in photographs that are obviously carefully and very deliberately posed. Anton Trčka – a painter and sculptor as well as a photographer – took a series in March 1914. Some of Trčka's photographs echo existing work by Schiele; in others, Schiele himself is photographed in front of his own work. The images are unvaryingly serious and intense. In a number of instances, Schiele painted over and otherwise manipulated the photographic image and he signed a number of both the prints and negatives. One

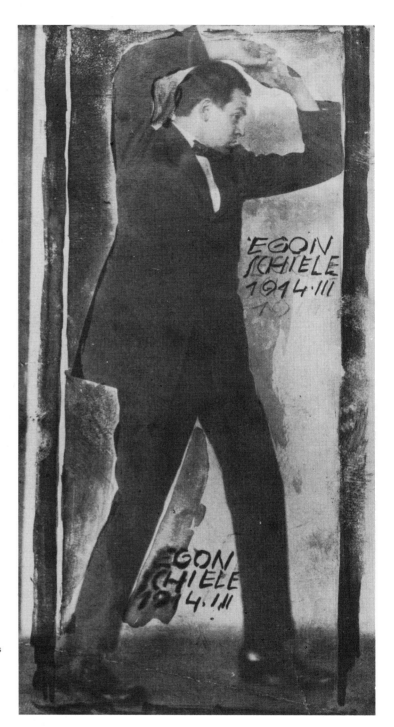

15 Anton Trčka
Egon Schiele, 1914

Schiele often drew and painted himself
and he collaborated with his artist
friend, Trčka – as in this exaggeratedly
posed photograph – who had taken up
photography with great verve. They
evidently regarded these photographs as
art works, working over both negatives
and completed prints, and positioning
titles and dates with elegant finesse.
Certainly the poses are careful and not
casual: Schiele acted, directing himself,
for Trčka's camera.

30

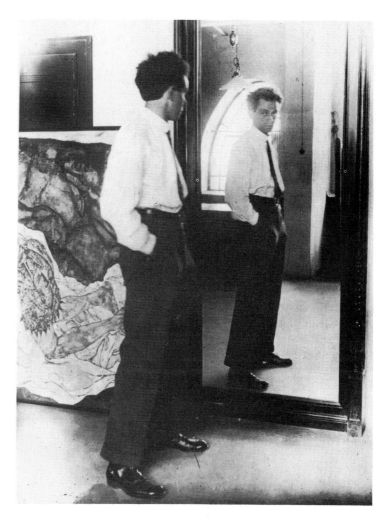

16 Johannes Fischer
Egon Schiele, c. 1915

This photograph of Schiele by another painter friend shows Schiele as he must so often have seen himself: gazing with unremitting intensity at his own reflection. There was a prominent mirror as of right in any room in which he worked.

Schiele scholar has therefore described these photographs as 'self-portrait photographs' even though the photographs were not actually taken by Schiele himself. Another artist and photographer, Schiele's friend Johannes Fischer, also took photographs of Schiele, in 1915, which are more concerned with Schiele in his studio; but Fischer probably took the double portrait of Schiele in which it seems the artist is gazing at himself. After Schiele's tragically early death during the great European flu epidemic of 1918, in which his young wife Edith also died, glass negatives were discovered in his studio. The photographs taken by Schiele himself include provocative photographs of his sister-in-law Adèle Harms.

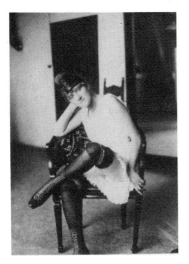

This young woman, Schiele's age, is implacable, serious, enigmatic; the photographs show Schiele's accuracy in physical portrayal, and yet also the distance between photograph and watercolour or drawing: the image Schiele made, rather than took, is far more highly emotionally charged with the eroticism, the sexual tension, that seems to have inescapably informed and affected his feelings.

If sexual tension and ambivalent feelings towards women are interwoven elements in the European Symbolist art of the last decades of the nineteenth century, and in the related decorative excitements of Art Nouveau, the Czech artist Alphonse Mucha (1860-1939) created a decorative art of almost enthusiastically innocent decadence. Mucha, a designer, illustrator, and polymath of the visual arts, achieved fame in France. Like many other artists of the Second Empire, Mucha utilized photographs as a replacement for the long sessions with live models; but Mucha is different from others because of the extent to which he took his own photographs from 1895 on, and in the way he treated photographs as designs, drawings or cartoons for his decorative work. He posed his models nude or draped, and created a repertoire of poses, a kind of visual library, from which he could retrieve what he wanted and needed for his illustrations: he evidently took innumerable photographs. Sometimes it seemed he used photographs too to fix something that in ordinary posing could never be exactly the same, such as the folds of drapery. Mucha, a highly professional artist with a very large and varied practice, evolved a highly charming art which took certain surface elements from Art Nouveau and Symbolism: not for nothing was his name made with his poster of Sarah Bernhardt.

Mucha, as a hard-working professional, like Franz von Stuck and other successful painters such as Lenbach, used photographs as aids and as short cuts which circumvented laborious live

17 Egon Schiele
Photograph of *Adèle Harms, c.* 1917

Schiele photographed his sister-in-law, Adèle Harms, in her stockings and in a somewhat similar but more stylized and more intensely erotic pose painted the *Reclining Woman with Green Stockings* (see opposite p.96), expressing in outward form inward longings, feelings and temptations.

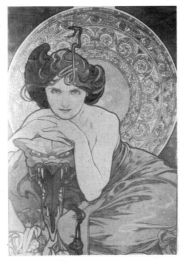

18 Alphonse Mucha
Emerald, 1900

Mucha was a wildly successful decorative artist whose work was so powerfully persuasive that the phrase 'le style Mucha' could be commonly understood. For several decades from the 1890s, in Paris, New York and Prague (his native city), Mucha carefully photographed models in poses that he would utilize for his decorative graphic work (see opposite). He bought his first camera in 1893. One of his studios, in

the rue Val de Grâce, was famous for its 'bizarre luxury'. Here, amidst a riot of props, models were carefully posed, rarely photographed in movement, but rather in statuesque stance for the many designs, publications, prints, and work in three dimensions – jewellery, statues – on which Mucha's fertile imagination was engaged. Mucha was certainly not particularly concerned with any perfection of photographic technique. These were working photographs, for a busy prolific artist.

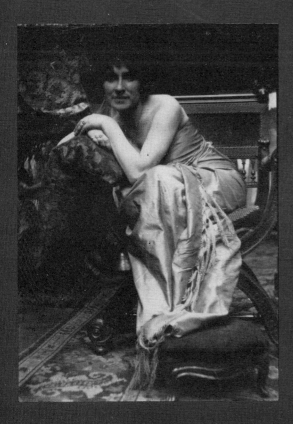
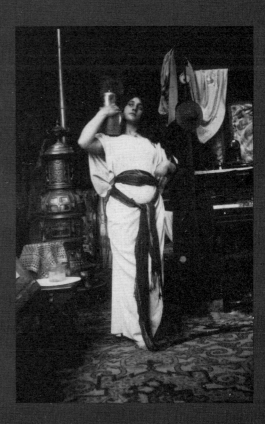

posing. He does not seem to have been interested in photography for its own sake: it is interesting to see how at times he squared up on photographs as he might have on drawings. And it would be safe to assume he took photographs himself so extensively because that became another short cut: as he knew exactly what he wanted he did the photographic work himself rather than commissioning others. Artists such as Schiele and Munch, whose art was autobiographical, used photography as an extension of their own deeply personal preoccupations. For an artist like Mucha photography was not a reflection of artistic vision, but an aid to realizing that vision in accepted media.

Artists of all persuasions and standing used photography as aid, method or inspiration and catalyst. Eakins, the foremost American Realist, whom many now feel is perhaps the greatest of American nineteenth-century painters, was a controversial figure because of his methods, liberal teaching, and the searching realism of much of his painting; and his use of photographs is characteristic of his enquiring, curious, experimental, tenacious, and determined attitudes to his art. The results of his photographs were aesthetically satisfying, even exciting, but the basis of his attitude as far as can be gathered was pragmatic. And so it was with the two German artists, Lenbach and Stuck, both in favour with the powers that be throughout their careers, who enjoyed the heights of conventional success.

Avant-garde artists and more conventional painters alike used photographs, often with the same intent. Perhaps one of the most unusual instances of the use of photograph is that of the German Expressionist painter Ernst Ludwig Kirchner (1880-1938). Kirchner was a brilliantly innovative artist who first trained as an architect, and whose ambition was nothing less than an entire rejuvenation of German art. In the event he and his colleagues, in an astonishingly fertile period before the First World War, did just that, simplifying shapes, exploring colour in new ways, using the images of primitive, ethnographic art as inspiration. There is an example in no less than three media of Kirchner's eye: a photograph of three old women (1924) used by the artist for both a sculpture and a painting, perhaps a unique instance in which a photographic composition, itself strong, has been transformed into both two and three dimensions. What is fascinating is that all three manifestations of the three old women share, although they look very different, certain strengths: firm composition

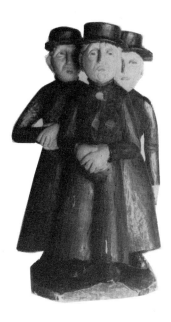

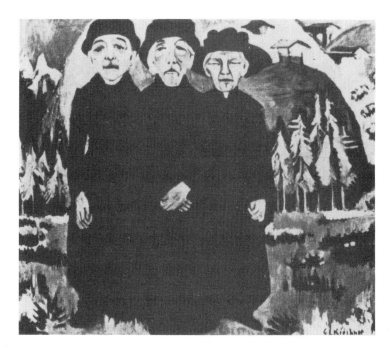

19, 20, 21 Ernst Ludwig Kirchner
Three Old Women, 1922

Here we may have an unprecedented
use of diverse media: the artist's photo-
graph of three elderly women, used by
him as the springboard for a painting –
in which the background has been both
idealized and generalized – and a
sculpture in painted wood, recalling the
famous late medieval and early Renais-
sance tradition of German polychrome
wooden sculptures. Kirchner wanted 'to
create a picture out of the chaos of the
age', and here he seems to be taking
something specific and making of it
something with undertones both folk-
loric and mythic.

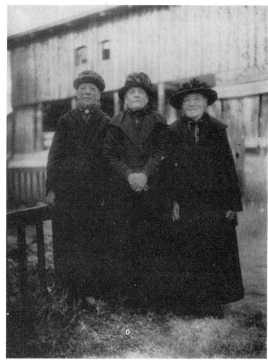

and the sense of looking beyond the ordinary to the significant, for something mystical and meaningful. Kirchner photographed a good deal in the 1920s, especially nudes in domestic settings and landscapes. These are parallels rather than correspondences with his art.

Another advanced artist, the Norwegian Edvard Munch (1863-1944), was profoundly interested in photography, used photographs, and took photographs himself. He was well aware that photography could be seen as a liberating force for painting. His own intense art – often with colour schemes and compositions that are vividly recognizable, owing as much to the mind's eye as to persistent observation and recording, and in effect almost psychic paintings of states of mind, inner feelings and emotions – demonstrates his ability to carry out his

22 Edvard Munch
 Photograph of Young Girl in Front of a Bed, 1906
23 Edvard Munch
 Young Girl in Front of a Bed, c. 1906

Munch is one of the great portrait painters, in particular of himself, creating an autobiography of the emotions. He also posed others for photographs and from an early period took a considerable number. Thus there are upon occasion very strong correspondences between photographs and paintings. Here we may see the ways in which the image is drawn from the photograph, but in a sharply edited version, the ghosts removed, and the woman herself is less mature and less clearly individualized.

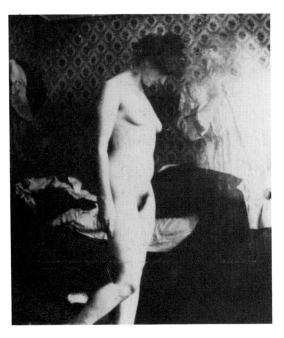

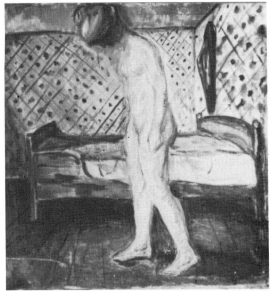

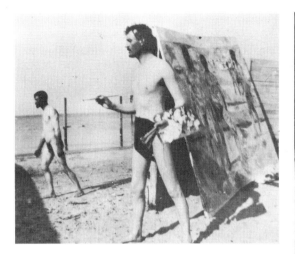

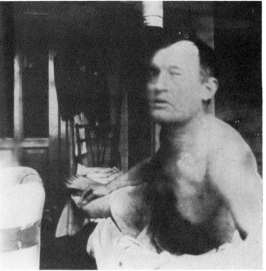

24 **Edvard Munch**
Self-portrait in Warnemünde, 1907
25 **Edvard Munch**
Self-portrait in the Sanatorium, 1908-9

Munch's self-portrait photographs, many echoes of which reappear in his self-portrait paintings, are strongly flavoured. The poses express varying moods: narcissistic, depressed, anxious, isolated and even heroic. For instance, when at Warnemünde in North Germany during the summer and autumn months of 1907, Munch posed himself heroically on the beach, the brush a weapon, the huge painting a battleground.

purpose. He wished, as he said, to paint living people who 'breathe, feel, love and suffer'. He himself had a turbulent and disturbed life, with periods of calm, and had been deeply disturbed by the early deaths of his mother and sister: illness and death stalked his family home in his childhood and adolescence.

Munch's own photographs are remarkable. They echo and reinforce in several different ways the emotional claustrophobia and intensity of his paintings. All his life he painted and drew himself, and in the early 1900s he began a series of self-portrait photographs which he intermittently continued throughout his life. Some were used specifically as models for paintings, too. He was a strikingly handsome man; but his expression remained aloof, distant and contained. Not even the latest photographs contain the ghost of a smile. Photographs were taken in restaurants, cafés, on the beach, in the

37

studio, at home, in friends' houses, and there are a number of deliberate double exposures. A photograph of a nude girl and another figure by a bed – a double exposure – made by Munch in Berlin was used by him as the basis for a painting done in 1907. He may well have found in his photographs, and occasionally in his paintings, the ghostly forms of the double exposure satisfying philosophically and emotionally, as his inner life was haunted by ghosts, phantoms, symbols, and apparitions. He declared at one point that he had no 'fear' of photography so long as it could not be employed in heaven or hell.

Photographs of Munch taken by himself sometimes blur his face and figure so that he appears as a substantial ghost. There is a double exposure of Munch in his studio where the painter, formally dressed in suit and hat, is ghostly, the paintings themselves substantial. Another self-portrait photograph shows Munch lying on a bed, half naked, in a sanatorium; the perspective is dramatically exaggerated. This was at the time he had had a severe nervous breakdown. Another remarkable photograph shows Munch, holding his brush almost like an elegant duelling weapon, half naked on the nudist beach at Warnemünde: he is athletically posed in profile, on the beach, his back towards the huge man-high canvas on which he is working. He directed various poses of men and boys bathing for photographs which he then utilized as compositional aids for several paintings of the same subjects. He photographed people to use as models, but he also used other photographic sources. He used popular and public photographs of the philosopher Nietzsche for paintings, and the portrait photograph, which has a curiously poignant, wistful quality, of Elizabeth Forster-Nietzsche (about 1905) which served as a basis for a portrait painting came from an anonymous source. Until recently this photograph of Nietzsche's sister was thought to have been taken by Munch himself.

Munch's self-portrait photographs are studies in loneliness and isolation, echoed in many of the paintings that followed from 1904 when he began photographing with such energy. Munch's photographs exist in their own right as memorably powerful, seemingly dispassionate examinations of the self, and while perhaps not narcissistic, must have a quality of self-absorption which seems part of the temper of the times, and yet still very modern. He photographed with imagination, and his talent for affecting composition was as much a part of his photographic work as of his drawings, paintings and prints.

While Munch was exploring nothing less than the inner uni-

verse, in terms of allegory and symbol fused with a highly personal reality, certain aspects of Impressionism were concentrating on the fleeting moment of pure, pleasurable visual sensation, the surfaces of things. Theodore Robinson(1852-96) was the artist who became the leading American Impressionist, for like the American painter and disciple of Degas, Mary Cassatt, he too went to France to work and study; unlike Mary Cassatt he returned with the lessons he had learned to work in America. On his second visit to France he settled first in Barbizon (1884), the setting for one school of French landscape painters, and then at Giverny (1888) in a move that had consequences for his art. For, at Giverny, his neighbour, friend and mentor was the great French Impressionist Claude Monet – also an enthusiast for photography.

Indeed, Claude Monet (1840-1926) painted some of his greatest paintings – including the vast decorative cycle of water-lilies – at Giverny, where he and his large family lived from 1883. Monet created a garden – a pond with water-lilies and bridges – and here he painted, outside and in the several studios built on the property. (The garden and house, recently restored, are now open to the public.) A good deal is known about Giverny because of the extensive photographic documentation undertaken by Monet, his family, friends, and visitors. Several volumes containing large numbers of photographs of scenes at Giverny have been published, but the photographs are usually without attribution. However, it is known that sometime after 1897 a darkroom was established underneath Monet's second studio, and there are photographs of Monet with his camera and taking photographs of his garden. One splendid photograph taken by Theodore Robinson shows him in sturdy working clothes, walking stick at the ready, at Giverny in 1889.

Whatever the relationship that existed between Monet as a photographer and Monet's painting has yet to be established; what is known is that Monet took many photographs and ensured that he, his work and his environment were extensively documented. In fact, although there have been suggestions that certain of his paintings were based on photographs from other sources, he does not seem to have photographed directly for paintings: what remains is an informative and varied dossier of Monet at work, in art and life.

Robinson had had an extensive academic training, at the National Academy in New York, and under Gérôme in Paris. For many of his paintings and watercolours he utilized photographs he had taken himself, and a quantity of such photo-

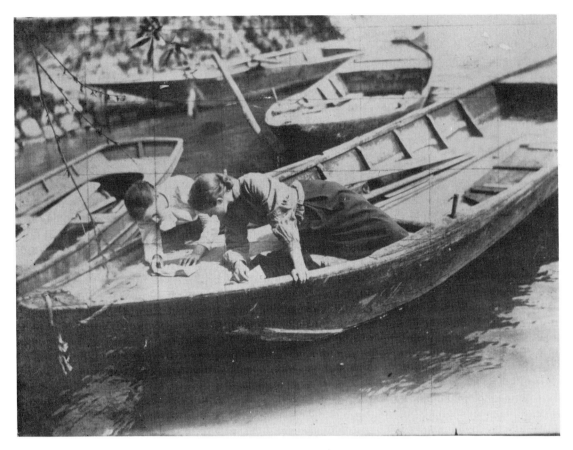

Theodore Robinson
26 Photographic Study for
27 *Two in a Boat*, 1891

Robinson used the camera as much as
an aid for painting as a glorified sketch-
book. The photograph for *Two in a Boat*
is squared-up with the technique used
by artists to transfer the drawn image to
canvas. However, much material has
been edited out in the transformation
from the photographic image, so that
the painting is less detailed – and more
dramatic, simplified and striking.

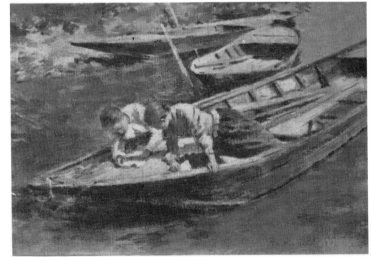

40

graphs was rediscovered in a hotel in Giverny in the 1940s. He usually followed the photograph he had taken in terms of broad, general composition. The main difference between photograph and painting in Robinson's hands is the simplification evident in the painting or watercolour: the photograph provided the structure from which Robinson extracted, refined, and very occasionally elaborated. Robinson had to work hard at his art, sometimes in a variety of jobs as assistant to other artists. Often in frail health; he was dead at forty-four.

He used the photographs he took for several reasons: obviously convenience entered in, although at one point he made the ambivalent remark that he did not know just why he used photography, but other artists did: it 'was in the air'. And he described how he had to extract what he could from the photographs he used, and then move on: 'I must beware of the photo, get what I can of it, and then go.' His method seems to have been the posing of the model for a photograph, and this method applied to paintings that used the human figure rather than unpeopled landscapes. Robinson it seems wanted to capture the fleeting moment, and declared that 'painting directly from nature is difficult as things do not remain the same; the camera helps to retain the picture in your mind'. Oddly, the period in which he took photographs, and in which he lived in France, is the period of his best painting. His attempts at being an American Impressionist in America were not as successful.

A highly complex involvement with photography was part of the art of the great French draftsman, sculptor, print-maker and painter, Hilaire Germain Edgar Degas (1834-1917) who used photographs creatively in his work, and also took photographs. But in the main, the photographs he took himself so memorably were not used directly for his work in other media.

Although not an original subscriber to the French edition of Muybridge's *Animal Locomotion*, Degas was fascinated by the photographs of horses in motion, used elements from Muybridge's photographs in his art, and made drawings based directly on Muybridge's photographs, and Marey's experiments. The use Degas made of the conventions of photography is, however, a matter of some dispute. He literally drew on photographs, upon occasion, and at least once drew on a photograph of one of his own drawings; his unusual use of space and perspective was influenced by the Japanese print, then coming into Europe, as well as by photography. Some of his images are based on

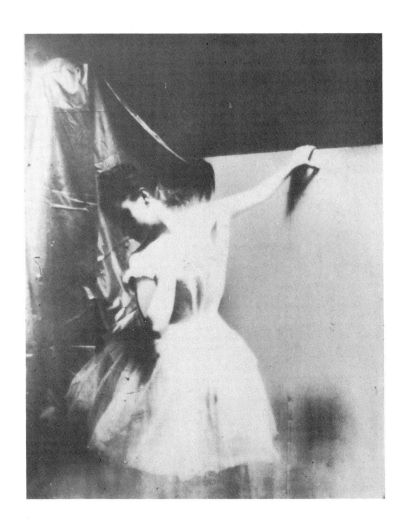

28 Edgar Degas
Dancer

photographs, and one of the reasons that in many respects
Degas' art seems still so immediate is the unusual informality
of his figure compositions, with figures close to the edge of the
painting, even cut off by it, compositions and perspectives that
seem similar to the conventions of the snapshot, of the
'instantaneous' photograph. A comment by the writer Paul
Valéry, who knew Degas, suggested that Degas was one of the
first artists, and one of the few 'to see what photography could
teach the painter – and what the painter must be careful not to
learn from it'. In Degas' art there is a sense, a very strong sense,
of life as it is lived, of life going on beyond the painting, and it
is usual for Degas to spread the incidents in his paintings across

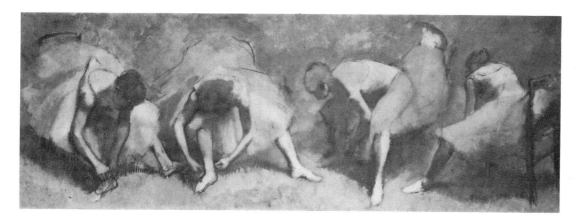

29 Edgar Degas
Frieze of Dancers, 1893-8

Degas' famous studies of dancers (see also opposite p.97) were based on acute observation at performances and rehearsals, many drawings and photographs (some thought to be by Degas himself). A thorough examination of all the photographs directly associated with Degas, used by him, taken by him, or posed by him, is overdue. But his involvement with photography was threefold: he occasionally painted from photographs; he took photographs himself (from the 1890s); and he posed friends and relatives for photographs. Degas once said that 'art is not what you see, but what you make others see'. However, with his own photographs we have a remarkabele chance to see what Degas saw, the kind of compositions he sought in the world around him.

the picture, and rare for him simply to focus on a central figure facing straight out towards the spectator. In the 1880s Degas and his artist friends gave a good deal of work to a photographer called Barnes who lived at Dieppe; Degas sent photographs too, to his young artist friend and follower Sickert. Degas was a passionate worker: he wrote to his friend the artist Paul-Albert Bartholomé, thanking him for a photographed drawing he had sent, and added that 'it is essential to do the same subject over again, ten times, a hundred times. Nothing in art must seem to be chance, not even movement.' He told a fellow artist, Berthe Morisot, that the study of nature is unimportant because painting is a 'conventional art'; it was better to learn the elements of drawing from a master such as Holbein. Other favourite sayings of Degas were that 'even when working from nature, one has to compose', and that 'no art was ever less spontaneous than mine'.

In the 1890s Degas became an active photographer himself, posing himself and friends by lamplight in shadowy interiors, acutely reflecting the same sensibility he brought to bear on his distinctive sensitive art. What is uncanny is how many aspects of his painting do resemble the devices and conventions of modern snapshots: for it would have been unusual in the

1870s, and even the 1890s, for the kind of photographs that Degas enjoyed taking to have appeared among the professional photographs of the day – just as it would have been for the pictorial devices that he employed in his paintings.

Certain paintings by Degas, however, are almost certainly influenced by photographs. The painting often instanced is the portrait of Princess Metternich, which was sold from Degas' studio in 1918; nearly twenty years later it was pointed out that the painting was a partial copy of a photograph, which showed the princess and her husband, the Austro-Hungarian ambassador in Paris in 1860. There is no evidence that she ever sat for Degas; the unusually formal nature of the painting is probably due to the kind of photograph on which it is based – a carte-de-visite photograph by the influential Parisian photographer who made a fortune making these small photographic portraits, André Disderi.

Degas owned a Kodak by the 1890s, and his niece referred to her uncle's Kodak eye. Degas was ruthless, single-minded, determined in his arrangements of friends and relatives for the photographs he took in the domestic surroundings of their homes. Contemporary comments by friends and relatives indicated that the compositions he employed in the poses he made his subjects take for his photographs echoed his paintings. Thus he explored in his photographs pictorial devices and compositions that he used in his paintings. Here, photography followed painting, not vice versa.

Outstanding photographs by Degas remain; one of the finest shows Degas' friends, Mallarmé and the painter Renoir, in Berthe Morisot's drawing-room, with Mallarmé's wife and daughter, and Degas himself, taking the photograph, reflected in a mirror. There are photographs of many another social gathering, of his nieces as young girls, of his housekeeper Zoë, and many self-portraits. He is said to have wanted to experiment with taking photographs by moonlight, but there is no evidence that he realized this ambition. Degas is credited with a number of photographs of the dancers whom he portrayed in sculptures, pastels, paintings and drawings, although there are no one-to-one correspondences; and he photographed landscapes in the late 1890s as well, sending them to be processed into large images. Two things are particularly interesting about Degas' photographs: the very human side revealed by accounts of his photography sessions; and his pleasure, enthusiasm and interest in making everybody pose. Just like his art, his photographs were contrived, the opposite of spontaneous. That sense of the

moment of life, of activity arrested for just a second – that correspondence noted between Degas' art and the 'instantaneous' photograph in spirit and intent – is based on thought and planning, not accident and serendipity. His photographs parallel his art, and are of enormous interest for the information and light they throw on his visual thought. Thus they stand as both social documents and aesthetic achievements; and they share something of the calm intimacy and psychological intensity of his masterly portraits in paint.

The pleasure principle is evident in the tremendous number of photographs taken by the French Intimist painter Edouard Vuillard (1868-1940). Vuillard was a homebody, indeed he lived at home all his life, and called his mother his Muse. He had a circle of warm, emotionally close relatives and friends, many of whom he saw every day, although in public life he was timid and something of a recluse. His sister was married to the painter and print-maker K. X. Roussel, and his great close friend and colleague was Pierre Bonnard (1867-1947), who also took photographs: Vuillard photographed Bonnard and Bonnard photographed Vuillard.

Vuillard and his circle were very close to the well-known Misia, a formidable and captivating woman who was married to Thadée Natanson, the proprietor of the literary paper *La Revue Blanche*. Vuillard was so much in their circle that he was known as the family painter, and they often formed subjects for his photographs as well as his art.

Vuillard kept a camera – a Kodak – at the ready: from the family albums several exhibitions have been made of the photographs he took, and his nephew-in-law, the painter and chronicler Jacques Salomon, has written charming accounts of Vuillard and his Kodak.

His family, his clients, his friends, his colleagues were the subjects for his paintings – and his photographs. The photographs are very near to modern feelings in their generous warmth and emphasis on personal relationships. The children are given a calm dignity of their own by their fond uncle, a formal grace evident, for instance, in the photograph of his niece Annette Roussel sitting gravely in her child's smock, and crowned not with a wreath of flowers but with a row of rag curlers.

Vuillard photographed his mother cooking and sewing. Again there is no exact correspondence between a photograph and a painting – these images were not made to use for work in other

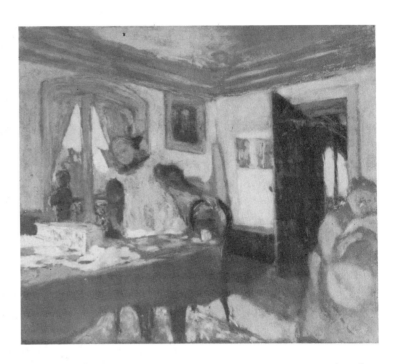

30 Edouard Vuillard
The Laden Table, c. 1908

Typical of Vuillard's tender attention to family life, and the informality with which he convincingly composed his pictures is this scene in the Vuillard family drawing-room in Paris. His niece Annette, daughter of his sister and the artist K. X. Roussel, is at the table, her homework spread out in front of her; her brother Jacques is at the window. Vuillard's mother is sitting at the right of the picture. Vuillard's own presence is wittily suggested, as on the wall behind he has shown his own portrait, done by the artist Felix Vallotton.

media – but simply the fascination in seeing how the same sensibility wielded both the camera and the brush. For instance, there is Madame Vuillard at her sewing machine, a photograph of 1926, and Madame Vuillard in the same pose, a painting of the year before. There is a whole series of photographs of Madame Lucie Hessel, another formidable lady acquaintance, including several in her wonderfully flamboyant hat, and one of Madame Hessel looking at her portrait in paint in the artist's studio.

Vuillard's methods were spontaneous: not for him the careful posing and arrangements of Degas. His life it seems fell into Vuillard visual patterns. The camera, the Kodak, waited on the sideboard in the dining-room for any propitious moment. Vuillard would wait until something happened, a gesture, an arrangement, that he wished to record, and then ask everyone to hold it for a moment. His mother usually printed the film, sewing while she waited for the developing process to take place.

31 Edouard Vuillard
Photographs of *Mme Vuillard,* 1906
and *Lucie Hessel,* 1912

Vuillard declared that he did not paint portraits – 'I paint people in their homes.' This was probably his home; he lived with his mother, although he had a wide circle of relatives and friends. The sketchiness of much of Vuillard's exceptionally intimate, touching painting is not photographic in appearance. But he was a dedicated, ardent amateur photographer. He used photographs sometimes to aid his memory, but the correspondences between Vuillard's photographs and paintings are due to shared subject matter – friends and relatives in his home and elsewhere. 'Painting had the advantage of photography, in being done by hand.'

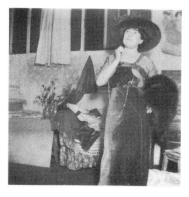

When Vuillard actually used photographs as an *aide-mémoire* for painting, he found their incorporation a struggle in a way that was not true of his preparatory sketches. Photography, Vuillard indicated, lacked the quality of being hand-done, the human touch. So photography was something Vuillard enjoyed and did actively but not something that supplanted or even reinforced his art: rather it echoes his natural preoccupations, recording the circle in which he moved and the places in which he had his being. The domestic stillness, and the variety of patternings in interior decoration and costume, are characteristic subjects for Vuillard in paintings and photographs.

Bonnard was also an ardent photographer, and he photographed with tender attentiveness his adored model, mistress, and later his wife, Marthe, the model for large numbers of paintings, pastels and drawings. The photographs quite naturally show Marthe in poses reminiscent, echoing and anticipating the paintings. Bonnard is reported as having enraged a fellow artist, Sérusier, by suggesting that colour photography would thoroughly mess up the future for painting, a remark that must have been ironical considering Bonnard's own passion for colour and his

32 Pierre Bonnard
A child of the Terrasse family, perhaps René, *c.* 1899

The intimate nature of Bonnard's photography is characterized by its subject matter, being devoted to family and friends. What is especially striking about Bonnard's outdoor photographs is a sensibility shared with his paintings and graphic work, in which gardens and parks become extensions of interiors, places in which people live socially.

33 Pierre Bonnard
Robert and Charles Terrasse, c. 1899

Here the family dog and various Terrasse children are photographed at play in the garden – with the same sense of the pleasures of informal and family social pastimes. Bonnard was also obviously acutely aware of the interplay of shadow and light, and the natural patterns thus intricately displayed.

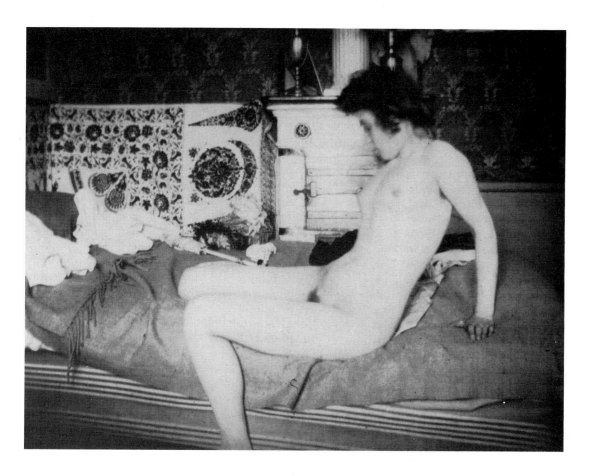

34 Pierre Bonnard
Marthe, c. 1900

Bonnard drew and painted Marthe, his
model and mistress, incessantly and
here he has photographed her with
charming informality on the bed. (See
also opposite p.96.)

unusually energetic painting career. Judging by the results, both
Bonnard and Vuillard obviously took photographs for pleasure,
as an extension of their natural visual curiosity.

Another colleague, the painter Maurice Denis (1870-1943), is
responsible for one of the most famous descriptions of pain-
ting ever given: 'Remember', he wrote in a manifesto published
in August 1890 as a 'Definition of Neo-traditionism', that a
painting 'before it is a war horse, a naked woman, or some kind of
anecdote – is essentially a flat surface covered with colours
assembled in a certain order'. This definition was used later to
justify Abstract Art, but of course what it meant here was that
painting was two things: the painting itself – its materials, its
form, its composition – as well as an image. Denis was pas-
sionate about the art of Cézanne, and made one painting in
homage to his acknowledged master: Denis himself, Bonnard,

49

Vuillard, Roussel, Odilon Redon, and the art dealer Ambroise Vollard are among those gathered round a still life of fruit by Cézanne which actually happened to be owned by Gauguin. Although Denis is not known as a photographer, some of the most interesting photographs of Cézanne have been taken by him; and another artist and photographer of Cézanne was Emile Bernard (1868-1941), a critic, theorist, and writer as well as a painter, and a champion of the art of Van Gogh. Bernard was actually allowed to watch Cézanne painting; and he was a mentor of Maurice Denis. It was to Emile Bernard that Cézanne wrote that famous phrase about how nature should be examined in terms of 'the cylinder, sphere and cone'. Bernard took memorable photographs of Cézanne, stalwart, determined.

The outspoken, long-lived Walter Richard Sickert (1860-1942) was a painter who used photographs liberally – already by the 1880s properly under the spell of Degas, he received some photographs sent to him by that artist – and he certainly thought photography should be used to facilitate portraiture in particular. The first documented use of photography for painting by Sickert was evidently for a posthumous full-length portrait commission of the notorious Member of Parliament for Northampton, Charles Bradlaugh, who had been repeatedly expelled from the House of Commons for atheism. Sickert told his friend and model Cicely Hey that 'artists *must* use cameras', but he shared in the widespread ambivalence which the use of photography provoked; for earlier than this imperious statement he described photography as an excellent occasional servant to the draftsman which only he may use who can do without it. His own self-portraits of the 1920s were painted from photographs and he certainly arranged the poses for some of the most telling self-images that he wanted to work from. In his later work he began to rely more and more on

35 **Walter Sickert**
The Servant of Abraham, 1929

Sickert's own attitude to photography was famously ambivalent and change-able. Whatever photographs he might have taken himself have yet to be the subject of scholarly examination, but he worked a good deal, particularly in the latter period of his career, from news-paper photographs, snapshots, and any

photographs that appealed. He also asked artist friends in his circle to supply him with photographs. Several famous self-portraits recall Sickert's own love of the theatre, or even theatrical ambitions sublimated in paint, conveying a certain peculiarly appealing and individual flamboyance. It is rumoured that his own photo-graphs were not particularly notable or distinguished, but besides using pub-

lished photographs as source material, he commissioned and collaborated in the taking of photographs. *The Servant of Abraham* is painted from a squared-up photograph taken for the purpose: Sickert invented the pose, his wife Thérèse Lessore, also a painter, took the photograph. In 1927, the same method had been used for another famous painting, the self-portrait called *Lazarus Breaks his Fast.*

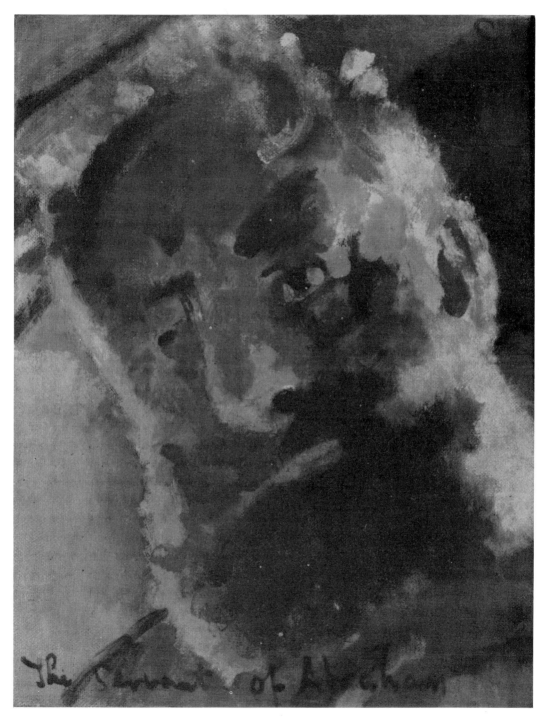

The Servant of Abraham

51

photographs – from many sources – as the visual preliminaries to painting, announcing that a photograph was the 'most precious document' that could be obtained by an artist. In one instance, the subject for a full-length portrait, Lord Castlerosse, had no sittings: he simply met Sickert and his wife at a lunch given by Sir James Dunn, who had commissioned the portrait of Castlerosse, and on that occasion *Mrs* Sickert took some snapshots. It is clear from his correspondence and from the recollections of friends that Sickert himself did take photographs, probably extensively, but there is some evidence that he was not at all outstanding as a photographer. Although his reliance on, and somewhat ambivalent approval for, photography as an aid for the artist were well known, what and which of his own photographs he used for painting are not.

With the help of these examples, we can see that from the beginning of modern photography, artists of all kinds and persuasions embraced the expansion of visual possibilities afforded by the new medium. But the nature of the embrace varied: for some it was secret, almost shameful. Some used photographs from any source as a visual aid. Some posed the photographs, ordered the photographs they wanted. Some took photographs for their art, as part of their work. Some took photographs for documentation. And some simply took photographs as part of their visual life, not as a source for their work in other media. There were also artists who were so involved in the process that they became photographers rather than painters.

Thus, almost from the very beginning of modern photography an immense range of possibilities began to be explored. The subject of the relationship between art and photography is so intertwined that the question of whether the visual view of the world in the nineteenth century was influenced more by photography than by painting is not clear. Nor is it clear that photography influenced painting more than painting influenced photography. Photography, however, for good or ill, was part of nearly every working artist's armoury: for documentation, reportage, visual source, and working tool – valued alike for professional interest, and for private pleasure.

2

MULTI-MEDIA ART

In the twentieth century the uses of photography became manifold, and photography itself ubiquitous. Photography as a method for making and disseminating visual imagery has had a very special place in the shared visual vocabulary of Western society.

Through newspapers, magazines, advertising – and art – photography is inescapable. Not only that: many of us have neither drawn, painted or sculpted, nor been drawn, painted or sculpted, and thus have not participated in the fine arts either as maker or subject. But almost without exception we will have taken photographs, and been photographed. Artists are hardly the exception to this habit, and have used photography just as much as any other members of society. We can see how the habit begins to take hold and to spread as technical advances make photography available and its equipment easy to handle, from the 1890s on, on a scale hard to imagine from its publicized discoveries in the 1840s. In the 1920s, the easily portable, high-definition camera in the shape of the Leica was to expand further the possibilities for photography.

It is also possible to suggest that one of the particular characteristics of twentieth-century art has been the ability to assemble disparate elements in collage, montage or assemblage, joining found objects to created imagery. In this photographs have played a great part, and indeed joined in the process by becoming themselves material that was consciously altered and manipulated. Thus in some hands photographs became a medium like paint. A contemporary writer reported seeing ready on the Russian artist Alexander Rodchenko's work desk his brush – and his camera.

Family photographs, even snapshots, arranged and used by artists for domestic reasons, not for their art, have an interest too for the insight they provide, the descriptions of a group of creative people that augment our understanding, give us what we

feel is a private glimpse. For this reason, the series of photographs taken by the German painter Gabriele Münter (1877-1962), the pupil and mistress of the great Russian painter Vassily Kandinsky (1866-1944) whose companion she was for a dozen years, is surprisingly absorbing. Kandinsky and Münter travelled extensively in Europe and Kandinsky was a pivotal figure in a group of highly innovative artists; he and his colleagues and friends often summered together in what was in effect an artists' colony. Kandinsky, trained in law and economics, abandoned an academic career in law in Moscow to study art in Munich: he even studied for a while under Franz von Stuck, Munich's successful 'painter-prince'. There is no reason to suppose that either Kandinsky or Münter used photographic sources taken by themselves for their paintings. Kandinsky's own art moved from an expressionist idiom to an innovative abstraction. In touch and connected with the groups of artists in Germany and in Russia who were turning the very notions of art and its purposes upside down and inside out, he wrote a powerful essay called 'On the Spiritual in Art' which was published in German in 1912 and read out in Russian in St Petersburg to the All-Russian Congress of Artists in the same year. Two years later, the avant-garde English artist Edward Wadsworth contributed translations from Kandinsky's essay to the experimental English periodical – so short-lived that it only had two issues – called *Blast*. The Expressionist artists with whom Kandinsky was associated were not concerned with conventional representation but rather an imaginative use of colour and a distortion of form which, while allied to conventional subject matter – landscapes, portraits – was felt to be more expressive of emotional states, of a truth beyond mere representation. While Gabriele Münter was in some sense documenting this circle with her camera, Kandinsky was creating new forms for painting, eliminating conventional subject matter, and becoming in the process one of the prime movers in the impulse towards 'abstraction', Abstract Art. The fact that he so looked the part of the sober, substantial bourgeois professional underlines the amazing nature of his artistic achievement.

The camera's ability to portray the external world of observed appearances and the pervasiveness of photography must unconsciously, obliquely, and even directly have helped and encouraged artists to look for other kinds of imagery. The great Russian theorist and artist, Kasimir Malevich (1878-1935), the originator of a movement in abstract art that he named

'Suprematism', wrote on what he called the non-objective world, a phrase markedly applicable to his own wholly abstract art of geometric form floating in space: here was nothing of the observed world, everything was invented from within the artist's mind.

From the 1870s on, 'isms' proceeded with terrifying and bewildering speed to be coined to describe the continuing changes in the appearances of paintings and sculptures, as well as the theories attendant on these new images. Paradoxically, the extreme nature of some of these changes, startling and incomprehensible to the public at the time, was brought about by astonishing diversity and astonishing determination on the part of artists who sought through their art to reflect and reform society, and therefore to reach in various ways a mass public. This was combined with the most esoteric researches, and in Russia, just before and during the Russian Revolution, in what has been called the Great Experiment, and in Germany with the didactic efforts of the Bauhaus, a teaching institution founded by artists in 1919, not only were new idioms in art and design initiated, with an abundance of theory and teaching practice, but remarkable things happened to photography in the hands of artists. Art and design were both to mirror and even perhaps to initiate social change.

These artists were versatile polymaths: all subjects and all media were open to their questioning eye. Many turned from the hand-crafted painting to typographical and graphic design, posters, designs for textiles, ceramics, architecture, performances – and to photography. In Russia the two outstanding practitioners of photography were Alexander Rodchenko (1891-1956) and El Lissitzky (1890-1941).

Rodchenko designed for the stage, designed furniture, painted severely refined abstract paintings, and was an experimental photographer of genius. He deployed odd perspectives, photographing 'commonplace things' from unexpected angles, in unexpected places and in unexpected situations. His camera was at the service of society, and he announced that 'the object-lens of the camera is the eye of the cultural man of socialist society'. He thought that it was the artist's duty to experiment, to discover and to find, as he put it, 'the new aesthetic, the new impulse and emotion suitable for expressing the new Soviet facts by photographic means in the language of art'. Indeed Rodchenko abandoned easel painting in 1921, not to take it up again until the mid-1930s.

In his photographs he used several characteristic twentieth-

36 Alexander Rodchenko
Photomontages for Mayakovsky's
poem *About This, c.* 1923

Photomontage or collage was a way of
making a work in its own right, which
could also be adapted for illustration
because of the unusual connections
which were achieved by allying dispar-
ate images together. Photomontage
artists were often not concerned about
the sources of photographs they
used:which were Rodchenko's own, and

which were culled from elsewhere, is
not clear.But the photomontages here,
not all of which were published –
Rodchenko made about a dozen – are
some of the most remarkable and
effective in the genre. They also ob-
liquely testify to the ways in which
artists worked together in this heroic
period of Russian art, turning their hand
to any form of expression which was
appropriate to what they wished to say –
sharing, did they but know it, an
attitude entirely similar to Man Ray's,

although artists resident in the West
were often more concerned with self-
expression – and in so doing, these
artists helped to abolish the hierarchies
among the fine and decorative arts. By
1926 the leading Russian writer and
critic Osip Brik (whose wife Lily was the
impulse behind Mayakovsky's poem,
and his great love) described Rodchen-
ko as 'once a brilliant painter, today a
committed photographer'.

century idioms and methods: that of montage and assemblage,
the collecting together of visual particles each of which recog-
nizably enhanced the meaning, in terms of subject matter or
formal composition, of the other. For artists anxious to per-
suade, inform and even to lead, photographic imagery held one
irresistible attraction. People accepted it as authentic (as we do
even today, with our greater sophistication, still not fully
appreciating observations made as early as Delacroix', that the
camera can falsify by seeming to tell the truth). By its very
nature, photography was approachable and accessible to people
who might be confused, irritated, or bored by 'high' art.

Rodchenko illustrated the works of the poet Mayakovsky
with photomontage; he also took a substantial number of
portrait photographs of the poet's friends, colleagues and
family. At the time that he was becoming more and more

56

interested in taking his own photographs, he sometimes participated with Mayakovsky who wrote the texts in posters designed with unusual typography and sophisticated graphics. He became an unusually active photojournalist as well, working from about 1926 on with the new portable Leicas that had transformed the possibilities for photojournalism. Rodchenko had become one of that select band of artists for whom photography was not simply a tool, a source for work in other media, nor simply a pleasurable activity related to the way in which we ourselves might take photographs, for documentation, and to serve our memories. For him, photography existed in its own right, informed by his sensibility and experience in other visual media. Photography for these artists was as dignified and important as any other medium for the visual arts whether mass-produced or hand-crafted.

During the 1930s when abstraction was tacitly forbidden in Russia and the era of Soviet Realism began in that stratified and terrorized society, Rodchenko excelled in reporting (sports, the circus, industry, and albums of visual images celebrating the Soviet army and Soviet youth).

From the 1920s he was typically involved in all the processes of photography, designing and building his own photographic workshop. While in 1923 he was content to deploy photographic imagery culled from many sources, a year later he began to photograph extensively himself, dissatisfied with the photographs he merely came upon. He decided that 'One must take several different photographs of an object, from different places and positions as though looking it over.' Rodchenko used double exposures, underexposure, photomontage, whatever technique would serve his purpose. He and his artist wife Vavara Stepanova collaborated on the designs for several issues of a magazine edited by the writer and playwright Maxim Gorky, called *USSR in Construction*, which in its domestic and foreign (Spanish, German, English and French) editions was a brilliant attempt at an optimistic description of life in the Soviet Union. A leading revolutionary writer announced that 'photography pushes painting aside', and the same critic, Osip Brik, ranked Rodchenko's achievements in photography as of crucial importance, partly because he had been a painter who moved away from 'painterly composition' for photography. Stepanova, Rodchenko's wife, declared that photography was the only medium that could provide the artist with the traditional method of drawing while allowing him to fix and record the reality which surrounded him. She labelled her husband the first

photomontagist (a title actually in dispute among the avant-garde artists of the day). Photomontage may perhaps be described as the combination of the most expressive elements from individual photographs; but Rodchenko also advocated another kind of serial composition, for in his portrait photographs he sought to capture human appearance in 'lots of snapshots taken at different times and in different circumstances'.

Throughout his photographs, and in his photomontage too, we can see how Rodchenko's dramatically refined sense of composition, so exquisite and powerful in his strong abstract paintings, informed his photographs, often taken from bird's or worm's eye view, with the same kind of spatial distortions and divergences from conventional methods of visual depiction as was evident in his experimental painting. 'We have to revolutionize people so that they'll see from all viewpoints and under any light', he noted with reference to photography, and criticized those who photographed the new, the unexpected, the foreign 'with museum eyes, with the eyes of the whole history of painting'. He determined to see something new in the ordinary, in the everyday: in so doing he made unusual and memorable photographs, part of a total attitude which saw art as integrated into life, and life as integrated into art.

Another remarkable Russian, El Lissitzky, was, like Rodchenko, an artist who worked with many different methods and materials: a teacher, designer, painter, architect, absorbed by

37 El Lissitzky
Entrance to the Soviet Pavilion at the International Hygiene Exhibition, Dresden, 1940

Throughout the 1920s and 30s international fairs and exhibitions devoted to all kinds of subjects and industries were also in many instances showcases for the best of modern design in all media. Here Lisstizky has turned his talents to the Soviet pavilion and publications at the International Hygiene Exhibition, Dresden. In the same year he also produced designs for the International Fur Trade Exhibition, Leipzig, and, perhaps most strikingly, had used newspaper photographs for the famous Pressa exposition in Cologne in 1928, where his photographic frieze embodied the motto: 'The task of the press is the education

of the masses.' He had also contributed to another famous and internationally influential exposition, 'Film und Foto', at Stuttgart, in 1929. The international character of advanced art in the 1920s, and the relatively free interchange of views and people, were as striking a feature of the times as the remarkable versatility of the artists who broke down artificially imposed barriers between art and design. For the Russians, individual vision was often at the service of the community. Conflicts, from the late 1920s on, between individual desire and need, and demands made by the State, were to produce tragedy for some.

38 El Lissitzky
The Constructor, 1924

Lissitzky is seen by himself with some of the symbols of the industrial age, particularly graph-paper and geometric and mathematical instruments. Yet the effect is highly individual, a memorable combination of symbols which are used to form a portrait of outstanding effectiveness and special character, both real and ideal.

writing, typography, graphic design, and photomontage. El Lissitzky trained in both engineering and architecture, studying in Germany before the outbreak of the First World War. Turning to art, he was a professor at the influential Vitebsk art school, a co-operative forcing house for revolutionary ideas in art. He was strongly influenced by Kasimir Malevich, first abandoning figurative art, and eventually, by the mid-1920s, leaving painting behind and becoming much more of a designer.

From at least the early 1920s, El Lissitzky had been passionately interested in the possibilities offered by both straight and experimental photography. One of the most potent and memorable images of the whole period is his own photomontage self-portrait, *The Constructor*, which is a combination of a straight photograph and some superimposed negatives: the setting for the artist's face, and his hand holding a compass, is an environment of grids and geometric forms, the vocabulary of Constructive Art. His high-domed forehead is the base, it seems, in which his open hand and brilliantly intense eye are rooted.

In the October Group, with Rodchenko and others in the 1930s, Lissitzky tried to use photography as a new creative

medium while also holding the view that 'no kind of represent-ation is as completely comprehensible to all people as photo-graphy'. Meanwhile, for the vast international exhibitions which were a feature of the inter-war period, each country extolling its own commercial health, sturdy society, and cultural achievement, Lissitzky created vast photomurals, the first probably to use photographic imagery on such a scale, in an idiom that has now become commonplace but must then have been startling and arresting in its unexpected immediacy and dramatic size.

Photography fulfilled three purposes. It could be used for experiment; it could be a hand-crafted medium in the hands of such as Rodchenko (who built his own darkroom and photo-graphic workshop, revelling in the photographic process itself) and Lissitzky; and the resultant images could be multiplied. Photography was convincing, seeming 'real', and thus an ideal medium for propaganda which was considered justifiable; and it could also, in its own way, reflect the constructivist principles of Lissitzky and Rodchenko's art. Lissitzky's so-called Proun prints and even Proun environments – Proun being an acronym for Project for the Affirmation of the New – were based on an idea of simultaneous perception, an idea not far from photo-montages with their shifting sense of scale. The layouts that Lissitzky and Rodchenko both created for the poems of Mayakovsky integrated photography and typography in new ways. Thus, in some senses, for both of these seminal, influential artists photography superseded painting. Yet it was their painters' eyes that made their photographs so recognizable, eyes not only for subject matter but for the imaginative organization of unusual, arresting compositions.

'Dada' was a high-spirited, anarchic, and satirical art movement, of exceptional energy and diversity, that started in neutral. Switzerland during the First World War and spread rapidly through Central Europe. It reflected an irreverent, anything-goes attitude, rooted in deep dissatisfaction and even distress at the social mores and economic injustices of society; it spread through linked groups of artists who often joined in collective efforts such as group exhibitions and publications, and it depended in part on that European institution, the café, which as an inexpensive and agreeable meeting place had no parallel in Britain and America as an intellectual forcing house. Although there were to be frequent debates amongst artists and art

39 Marcel Duchamp
Around the Table, 1917

Duchamp began as a conventional advanced painter: that is, an artist alive to the currents of the day as he moved from convincing representational idioms to a version of Cubo-futurism, interested in the fracturing of form and the representation of movement. Subsequently, his fame and influence have rested as much on his attitudes as on the objects, constructions, installations, paintings and drawings that he made – or discovered, as in the case of the 'ready-mades'. He was deeply involved in both Dada and Surrealism, and in film-making, in writing (also as an editor) and, almost casually, in photography. In appearance and personality he was, in piquant contrast to his questioning, innovative art, fastidious, elegant, restrained and reticent. His self-portrait, in which he appears five times – always the same, yet different in terms of position in the photograph's composition – neatly exemplifies the fertile contradictions in his work: the many sides of Duchamp have an ambiguous consistency.

historians as to who was first, when, where, and why with technical innovations, at the time such primacy was not considered that important and information flowed freely among eagerly energetic artists. Dada was for many of them a phase, a stage in their artistic development. Gesture, attitude and stance were all; the cult of the hand-done, the authentic original in the world of art was one of the facets of image-making that was exuberantly criticized. Nearly all Dada artists were masters of collage, the marriage in one image of disparate and pre-existing elements. Thus many used photography without necessarily taking their own photographs, and either used photographs they found from many sources, occasionally collaborating with

61

photographers, or took their own, without making a great distinction between these activities.

The French artist Marcel Duchamp (1887-1968), who spent much of his life in America, started as a painter and draftsman. Indeed three of his siblings were also artists – of a more conventional sort. He was the prime mover behind a concept of art which involved the use of what were to be called 'ready-mades', with at times the further proviso that the ready-mades were assisted, or rectified.

Ready-mades are as their name implies things, objects, which already exist: the implicit claim is that ready-mades, with or without treatment or manipulation by an artist, become art by virtue of being picked out by an artist and put into an art context, that is, an exhibition in a gallery or museum. Among the first famous ready-mades were a bicycle wheel and a bottle rack. Duchamp, who liked playing chess and might be described as treating both art and life as serious games, worked throughout his life in various media. Sometimes his art seemed contained in the restrained, reticent and slightly absurd style and way in which he lived. He worked in collaboration at times with the American painter, sculptor and photographer Man Ray; he wrote, edited magazines, made films. What Dada did, and where Duchamp's influence is almost incalculable in its importance, was to suggest that anything was possible as art. Duchamp used photographs as ready-mades, or as components in things that he made; but, more, the idea behind things being moved from one context to another, and thus being curiously metamorphosed into art, has certain aspects in common with the idea of the photograph taking something from the real world. Machine and method are almost irrelevant. What is important is eye and mind, concept and appearance.

The Austrian Dadaist artist Raoul Hausmann (1886-1971) claimed to have originated the technique of photomontage in 1918, on holiday in a fishing village on a Baltic island. He observed with interest the memorial certificates of military service hung proudly in every home. These combined a photograph of the soldier with coloured lithographs portraying military barracks, the town in which it was located and so on. 'It was a revelation: I suddenly realized that it was possible to create pictures solely out of cut-up photographs.' Hausmann described how he with other artist friends – several of them to become famous as brilliantly savage satirists of society, and one, John Heartfield, to work exclusively with photomontage – found the name for the new technique: '... with George Grosz, John

Heartfield, Johannes Baader and Hannah Hoch, we decided to call these works photomontages ... because of our aversion to "playing the artist"'. Hausmann and his friends regarded themselves as engineers, enjoyed wearing working clothes and identifying in some respects with the working classes. They wanted to assemble, to construct, their art.

Indeed one of the most famous objects of Dada is an assemblage by Hausmann, which has recently figured as an important object in exhibitions all over Europe, as the art of the 1920s has been subjected to fervent examination, and has thus become familiar to thousands. It is a wooden dummy head, like those used to model hats, which bears all sorts of objects upon itself, is crowned with a collapsible drinking cup, and has as part of its decorative appendages some old photographic apparatus. This emotive construction is called *The Spirit of Our Time*. The Dadaists, a questioning, irreverent, international group, always disputing and falling out with one another, as well as working hard together, claimed to use anything that came to hand for art: for photomontage, collage, prints, watercolours, paintings, three-dimensional constructions, even performances.

Hausmann, the son of a Viennese academic painter, with whom he had his first training, is characteristic of the group in his range of activities: criticism, polemical writings, organizing groups, group exhibitions, and his final abandonment of painting in 1923. From 1927 Hausmann concentrated on 'straight' photography and the numerous techniques that had been evolved, especially photograms, where objects, sometimes arranged and found by chance, were placed on light-sensitive paper: these are also called Schadographs, when executed by the German artist Christian Schad, and Rayographs when Man Ray hit upon the technique after this American polymath came to Paris in 1921.

Hausmann's photographs exhibit considerable sensibility; some of them, say of Charlottenburg Place, Berlin, even have an Impressionist feel, with their aerial views of cobbled city spaces and people criss-crossing the street. A photograph like *Mechanical Games* superimposes images and uses the same kind of wooden dummy head that figured in the sculpture, *The Spirit of Our Time*. In the main, Hausmann's photographs are sensitive, interesting in composition, and imaginative; but only rarely do they have the cutting edge of his work in other media, including photomontage.

A colleague of Hausmann's, John Heartfield (1891-1968), used photography to startling effect, creating with his photomontages a biting political art that has rarely if ever been

equalled, as savage in its comment as Goya's *Disasters of War*. He played purposefully on the ubiquity of photography, on its use perhaps as the painting of the poor, as someone said at the time of the Paris Commune in the 1870s. Heartfield's father was a poet, who was actually given a prison sentence for publishing blasphemy. Heartfield himself studied commercial art and painting, and first worked as a commercial artist: he became a Communist in 1918, and was a co-founder of Berlin Dada in 1919, when he was temporarily named 'Monteur-Dada'. Heartfield became a social critic through photography; in his use of photographic imagery he approached the savage nineteenth-century caricatures of Daumier and of Goya. First he relied on piecing together images he found by chance, in trawls through newspapers, magazines, and other publications. But soon he began to plan his photomontages, and while this planning did not mean that he took photographs himself, he collaborated with great care with photographers, who at times photographed specially made objects. Photographs were made for Heartfield based on precise drawings made by the artist of what he wanted; yet several photographers have recorded Heartfield's hostility to his necessary collaborators, who felt they could never achieve the results he obsessively, fanatically demanded. Oddly, however, he refused to become a photographer himself, instead combing the picture libraries for images, and at the same time ordering and commissioning work from photographers which he physically, intently supervised. One photographer recalled how Heartfield could ring him up in the early hours of the morning, to fix an arduous day's work. Heartfield abandoned brush and paint for the scissors, marrying photograph with photograph, often amplified with text, punctuated with a subtle, influential use of colour. What Heartfield did was to seize upon the power of the photographic image to convince its spectators that the photograph is telling the truth.

Kurt Schwitters (1887-1948) was a Dada artist who was also a poet, a creator of extraordinary two-dimensional and three-dimensional constructions and assemblages he called *Merz*. He was a master of collage, incorporating printed ephemera such as bus and tram tickets, matchboxes and the like, the casual confetti of urban society.

The Russian Lissitzky travelled extensively in Europe, and acted as a two-way transmitter of art activity; in 1923 he worked with Schwitters with photography in Hanover, and he made a remarkable photoportrait both of Schwitters and of the French artist Hans Arp (1886-1966). Arp is best known as a highly

distinctive sculptor, but he too had a Dada period, and a time when he experimented wittily with photomontage. Arp contributed photomontage illustrations to a book of Russian poems designed by Lissitzky, and he and Lissitzky collaborated on a remarkable little book *The Isms of Art* (1925) where Arp represented himself in a photomontage, a human figure in which the head was represented by a construction. A remark by Schwitters was included as well, that artist's simple text being the calm statement that 'all that an artist spits out is art'. In Schwitters' own magazine *Merz* he published photograms by the Hungarian Moholy-Nagy and the expatriate American Man Ray. Of course in his own collages Schwitters used photographs alongside material from the 'real' world. In the highly influential exhibition in Stuttgart in 1929, 'Film und Foto', Lissitzky created the Soviet exhibition (his skills with both design and photography were to find in some respects their greatest fulfilment and their most immediate influence in dazzling, dramatic and brilliantly publicized exhibition work in the great international expositions, both cultural and commercial, so prominent in European life until the Second World War). Schwitters exhibited his own photographs and photograms at 'Film und Foto'.

The frantic nonsense of Dada was a response to a troubled, terrifying world, the world of the First World War and the succeeding startling contrasts of the 1920s, a time of liberalism and repression, social reform and social unrest. But there were other responses that were possible as well as this serious, savage, witty, and stimulating nonsense.

One such, which paralleled the efforts made in Russia educationally during the early and optimistic phases of the Revolution there, was Germany's Bauhaus, effectively founded by the architect Walter Gropius in 1919, an educational experiment which has been of almost incalculable influence. The Bauhaus had three incarnations, in Weimar, in Dessau and in Berlin, where it was shut down by the Nazis in 1933. The Bauhaus was the centre and focus for new ideas in architecture and the applied arts, seeking a unity between functional needs and the decorative arts. It exerted its influence throughout the 1920s by means of its teachers, its design workshops in all media, and a series of no fewer than fourteen Bauhaus books, edited by Gropius and Moholy-Nagy.

Gropius promulgated the idea of the craftsman-designer having both an essential and a leading part in industrial mass-production. The teaching staff became a roll-call of innovative artists who not only worked in architecture, art and many areas

40 László Moholy-Nagy
*Photogram, c.*1925

Moholy was deeply interested in the exploration of 'pure' form and in the potential of film and photography. He felt strongly that art 'exists for the community, and goes beyond the boundaries of specialization. It is the most intense and inward language of the senses, and there is not an individual in society who may give it up.' He practised what he preached, exploring methods, techniques, materials and imagery. From 1922 he experimented with photograms. Here something like a gyroscope forms the basis of the composition.

of design but were also leading theorists. There was no separate photography workshop at the Bauhaus until 1929, when the institution was settled in Dessau, but photography had had an important role in the basic design courses and had been used from the foundation of the Bauhaus the decade before.

László Moholy-Nagy (1895-1946), a Hungarian of dazzling ability and inventive powers, wrote a Bauhaus book in 1925 called *Painting, Photography, Film*, in which he described how photography extended the limits of painting's depiction of nature, using 'chiaroscuro [extremes of light and dark] in place of pigment'. Moholy explored with zest the technical range and possibilities of photography: photograms (camera-less photography), X-rays, double exposures, overprinting, microphotography, enlargements. He thought of photography as a means rather than an end, and wittily extended the possibilities of using spatial perceptions and distortions which were convincingly possible in photography. Yet as a 'straight' photographer he was equally brilliant and perceptive. While in England for a few years in the late 1930s on his way to America, where he attempted to revive the Bauhaus in Chicago, he illustrated a number of typically English institutions, collaborating with several writers, including the poet John Betjeman, in essays on Oxford, Eton, and London street markets. Bernard Fergusson (Lord Ballantrae), the author of the text on Eton, recorded Moholy's delight in his Leica camera, and also his refusal to be pleased with any image in which the human subject was aware of being photographed.

Moholy was a polymath: book-designer, film-maker, sculptor, painter, commercial designer, stage designer, theorist, writer, and teacher. He expanded the possibilities for photography with wit and enthusiasm, as well as an unusually wide-ranging intelligence. Moholy professed the superiority of photography over imitative painting, and declared that the illiterates of the future would not be those ignorant of writing, but ignorant of photography; he was in agreement with Gropius' own goal of a marriage of art and technology, and finally proclaimed a unity in image-making: 'neither painting nor photography, the motion pictures nor light-display can be any longer jealously separated from each other' (1944). Indeed photography could free the painter from certain chores, that of, say, imitating the real world, so that painting could pursue new relationships in terms of space and colour.

Among the teachers at the Bauhaus was the Austrian Herbert Bayer (b. 1900), who first studied at the Bauhaus in 1921 in

Weimar, under Kandinsky; for three years (1925-8) Bayer himself taught at the Bauhaus, especially in the areas of typography and layout. When he left the Bauhaus in 1928, the time when Gropius and Moholy-Nagy also left, due to personal and ideological differences, Bayer pursued a highly successful commercial career, first in Berlin and then in America. In America his design aesthetic has been remarkably pervasive and influential through his alliance with great commercial concerns from the advertising agency, J. Walter Thompson, to the Container Corporation of America, and he has been notably involved in the development of the town of Aspen, Colorado as a resort and cultural centre. Bayer has continued to paint and photograph throughout; he exhibited 'straight' photographs and photomontages at 'Film und Foto' in Stuttgart. His photographs have a surprised oddity, an oblique charm, and an elegant, ironic, surrealist quality, sideways on to the firm good taste of his work in other media – almost as though he could let himself go a little in his photographic work – which has resulted in some highly memorable images.

Christian Schad (b. 1894) is an artist who is probably correctly credited with the first rediscovery (1918) in the course of the early days of Dada of camera-less photography, in his case a technique named the Schadograph in a typical and rather excruciating pun (from *Schatten* meaning shadow in German) by the Romanian poet and leading Dada figure Tristan Tzara. What is curious about Schad is that his early experimental photography parallels in convoluted abstract imagery prints he was making at

41 Christian Schad
Schadograph, 1938

This is a very early example of a technique in which objects were placed on or near sensitized paper. It was photography without the use of a lens or camera, and was a technique exploited effectively by both Man Ray and Moholy-Nagy as well, among others.

the same time: in both series the spectator will find room for the imagination, as the images seem of disconnected, perhaps even mechanical, fragments accidentally assembled together. Nothing could be in greater contrast to the thickly painted, emotionally strong paintings both realist and abstract that Schad was working on during the period, nor to the paintings for which he is best known. His smoothly painted portraits of the 1920s portray the figures of a tormented, questioning society in which the normal is barely separated from the freakish, and are part of a movement called Neue Sachlichkeit, the New Reality, or the New Objectivity. Great attention is paid to surfaces, to a dead-pan rendering of the objectively observed. The effect is hallucinatory, mesmerizing, and yet we are kept at a distance from the people who form the subjects of Schad's searing portraits. At the same time there was a parallel in photography, for the so-called New Photography in Germany was creating international interest.

One interesting figure is Florence Henri, born in 1893 in New York of French-German parentage, who studied painting under modern masters in Munich, Paris and Berlin, finally coming to the Bauhaus in 1927 where she became so interested in photography, as well as skilled, that she exhibited over a score of photographs in 'Film und Foto'. She was exceptionally telling in odd still-life photography – reels of cotton on a glass shelf, for instance – and in memorable portrait photography with an edge of strangeness. From 1929 Florence Henri lived again in Paris where her imaginative use of the camera has been influential. She never made her name as a painter, but as a photographer, and a highly professional one, working in advertising and illustration work as well as for herself. But her extensive and rigorous training by artists, not only in painting, typifies the kind of dialogue between painting and photography that is characteristic of the twentieth century when photographs do not imitate painting, but the liberating influences of abstraction revivify the photographic vocabulary as well.

Photography was a way to make a living. The American Man Ray (1890-1976), one of the most charming experimental artists and photographers, worked in many areas and indeed started his working life as a draftsman. He photographed his own paintings for documentary purposes, photographed his friends, and when he moved to Paris in 1921 began an exceptionally vigorous career in both commercial and experimental photography.

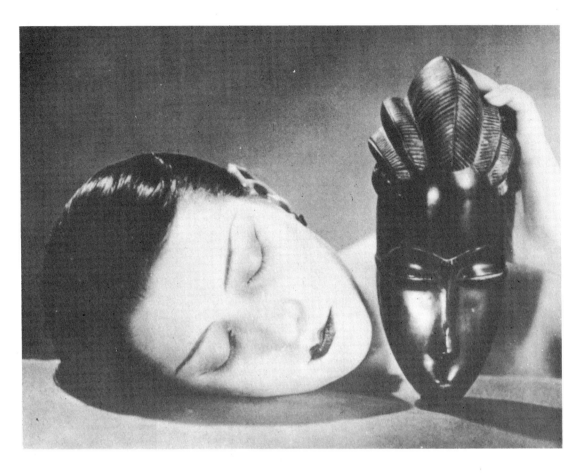

42 Man Ray
Kiki with African Mask, c. 1925

Man Ray's scope for visual inventiveness was remarkable even in a remarkable age. And because he used his outstanding abilities as a photographer to support himself, acting at times as a fashion photographer, whose work was published in *Vogue*, many would have seen his work without associating it with that of an avant-garde artist. Kiki of Montparnasse was Man Ray's companion for half a dozen years. She was a singer, a painter, and a model for artists; she modelled for several of Man Ray's most famous photographs, including *Le Violon d'Ingres* of 1924, in which her back doubled as the body of a violin; a triple pun – the body as a musical instrument, and the reference to Ingres, whose paintings of odalisques were famous, and who was known to have been a devoted amateur player of the violin. Even in this apparently simple composition, *Kiki with African Mask*, the photograph can be 'read' in several different ways: the human face contrasted with the sculpted face; and Kiki with her make up and perfectly arranged 'sculpted' hair, as contemporary woman in a social mask as real as the real mask, echoing rituals in both modern life and the apparently primitive life in other societies. It may be taken, too, as a witty reference to the importance of primitive art as source material and inspiration for modern art. The image also reads as a contrast between light and dark, Western and primitive society. This photograph was done for *Vogue*.

Man Ray had a wonderful, fertile wit, and an enquiring, ceaselessly curious mind. His own version of camera-less photography he called 'Rayographs' and he too was encouraged in his accidental discovery of the technique by the ubiquitous catalyst

the poet Tristan Tzara. Man Ray announced that he did not photograph nature but his fantasy; and the camera was but a tool, like the brush. 'I would photograph an idea rather than an object, a dream rather than an idea.' His techniques accentuated this purpose. One of them was a complex chemical process of developing, called solarization, which emphasized the outlines of form. He exaggerated other techniques as well: overexposure, enlargements, all sorts of improvizations.

Man Ray was influenced by Marcel Duchamp, the great French iconoclast, and one of the most fascinating experimental photographs is that by Man Ray of the *Dust Raising* of 1920, which is a photograph of part of Duchamp's most remarkable work, a huge construction of glass, *The Bride Stripped Bare By Her Bachelors Even*, turned here into a remote extraordinary imaginary aerial landscape. Man Ray's autobiography records Duchamp's weariness and fatigue at the mechanical drudgery involved in making this work, and how Man Ray offered to photograph it, going to get his camera, and leaving the camera for an hour-long exposure. Duchamp titled the resulting photograph. What a strange collaboration: an element of an art work in progress, the art work itself the enigmatic product of one of the most enigmatic and influential artists of the century, Duchamp, photographed by Man Ray so that part of it underwent an almost accidental metamorphosis. The episode is an instance of the free co-operation and discussion among artists, the combination of accident and discipline, and the purposeful improvization that have invigorated the open-minded, open-ended art of this century, open to so

43 Man Ray
Surrealist Object, c. 1933

This photograph is of a sculpture by Salvador Dali, the *Buste de femme rétrospectif*, which is (literally) loaded with art historical references, a linking of symbols and echoes. Man Ray collaborated with many an artist, most particularly with Duchamp, whose work he photographed, and who made work to be photographed.

many new techniques, materials and media. Perhaps, Duchamp remarked to Man Ray, photography would replace all art.

On the one hand, Man Ray photographed for *Vogue*; on the other, his own photographs encompassed the possibilities for avant-garde photography. He not only made Rayographs, but photographed things that happened by chance, for example an overturned ashtray with all its rubbish of ashes, matches, and cigarettes like a strange battleground.

One of his best-known paintings shows a pair of female, lipsticked lips floating in a blue, cloud-filled sky: it is called *Observatory Time – The Lovers* (1932-4), and its genesis is an example of the interactions of happening and image. His mistress, Kiki of Montmartre, impressed her lipsticked lips on his white collar; from this came a series of photographs of her mouth; but he was not satisfied until he photographed the lips of the American beauty, Lee Miller, who had acted as his assistant and was in her own right a gifted photographer. Finally, using Lee Miller's lips as model, he laboriously executed a painting: he would have preferred to do it as a photograph, as the painting was drudgery compared to the instantaneous nature of photography, but neither the colour processes then available, nor the necessity for enlargement, would give him the image he had in mind. Thus we can see that the method mattered very little to Man Ray: he was always interested in making images that corresponded to the ceaseless flow in his mind's eye, and would use any technique that could give him the result he desired. He also felt strongly that photography revealed things that the unaided eye would not register. This is something Moholy felt strongly too, for Moholy often found his photographs revealed things he had not noticed or even looked for at the time of taking the photograph. Thus he at times treated his own photographs as though they were found objects revealing a beauty not consciously sought for, but found after the fact.

Man Ray was another polymath: film-maker, draftsman, writer, maker of 'poetic objects', painter and photographer; he moved with ease between media, between the cerebral worlds of the Surrealists, and the commercial worlds into which he occasionally made forays to make his living as a portrait and fashion photographer, remaining however a remarkably free spirit. Often, of course, he constructed things he could photograph, or made remarkable montages: a work resonant with a sense of past and present is *Le Violon d'Ingres* (1924) in which Kiki is posed in a way reminiscent of the famous odalisques of Ingres;

superimposed on her back are the two S curves incised into the wooden body of a violin, recalling Ingres' own famous hobby of violin-playing. And there is the famous portrait of Tristan Tzara (1921), monocle in eye, cigarette in hand, sitting on a ledge, feet on a ladder; behind him a gigantic nude, insouciant, imprinted on the wall, posed with calm indifference, as the poet is indifferent to the axe and clock poised above his head. Man Ray's imagery teems with ideas, with suggestiveness, while often being formally arresting in composition. Painting with light was his preoccupation with Rayographs; even earlier he had experimented with his own versions of *cliché-verre*. Duchamp simply said that Man Ray's achievement was to 'treat the camera as he treated the paint brush, as a mere instrument at the service of his mind'.

It is only recently that international attention has again been turned to the quite unusual range of activity among Polish artists. An exceptional Polish creative artist was Stanislaw Ignacy Witkiewicz (1885-1939), the son of a famous painter and art critic; he spent the First World War in Russia (partly in military service), and committed suicide at the outbreak of the Second World War and Poland's occupation. Witkiewicz was a theorist, a very active painter, who searched for what he regarded as pure form until he abandoned the search. He was also – as has recently become apparent internationally through the work of Tadeusz Kantor, a Polish painter and actor, and his art-theatrical troupe – a dramatist of the first order. His surreal, savage and haunting plays have been performed throughout Europe in recent years, by Kantor's Cracow theatre group, Cricot 2, and Witkiewicz' anarchic imagination, highly socially critical, has reached an international audience. In the 1920s and 1930s Polish art activity was highly advanced: indeed in Lodz, a Polish industrial town with an important textile industry, one of the first museums in the world dedicated to contemporary art was founded in 1929. In 1931 Lissitzky and Man Ray organized an International Exposition of Modern Photography in Cracow. In the post-war period too, Polish film, art and theatre have been highly energetic and innovative, in spite of (and some might say because of) the political constraints.

Photographs by Witkiewicz exist which he took as early as late adolescence, and he made many masterly and imaginative portrait photographs. Photography was a passion: he even accompanied the anthropologist Bronislaw Malinowski (one of the significant group of Polish intellectuals of high attainment in many disciplines who formed a loosely linked group of col-

leagues and friends in the years before the First World War) on an expedition to New Guinea as the expedition's artist and photographer. In many of his photographs he concentrated on faces; portraits had an almost obsessional fascination for him. He also photographed tableaux of a surprising Surrealist kind that he orchestrated himself with friends and actors. He photographed landscapes, too, which occasionally served as the basis or notes for painting in his early painting days.

Some painters photographed parallel with their painting activities, and the Belgian Surrealist René Magritte (1898-1967) was one such. His paintings are exceptionally forceful juxtapositions of objects presented with a dead-pan clarity, gaining force from contradictions presented with a kind of bland impervious certainty. Most of Magritte's photographs date from the 1930s, and they have some odd affinities with Witkiewicz' staged photographs from much the same period, in the sense that Magritte's photographs too were staged, but in a casual manner, arranged with friends, in particular his wife Georgette, his lifelong model. The results exhibit, presumably on purpose, an undeniably amateur air, and also the same nuances of unexpected formality as his paintings. Thus, a group of men in city clothes by the sea; people in masks; a man holding a chess or chequer board in front of his face (a photograph called *The Giant*); a man and three women lying on a pebbled beach making a pattern, the photograph titled *The Star in Stone*, or *Rock Star*. Magritte's photographs are a quite riveting echo of his preoccupations in paint. They seem banal snapshots, just as his paintings seem ordinary, until one takes into account the subtle games-playing and nervous edge, the unexpected presented with a totally straight face. But the photographs are a little more light-hearted than the paintings.

Paul Nash (1889-1946), the English lyrical Surrealist painter, was an ardent photographer. He used some photographs as notes for paintings, but he also photographed extensively, finding in observed landscape strange and unexpected forms. Nash was a gifted writer of clarity, a highly competent and intelligent critic, as well as a print-maker, painter, watercolourist, and designer.

Nash was given a camera – a Kodak – by his wife for his first visit to America; he orignally began taking photographs as documentation, as reportage for himself, and his progress with the medium might be phrased as document to image. When he began he did not think photography an art, but that there were 'certainly artists in the medium of photography'. He did use

44 Paul Nash
The Park Wall, *Ascott Manor*,
Oxfordshire

Nash took a photograph of the peri-
meter wall of Ascot Park, Stadhampton,
Oxfordshire in about 1929 and recorded
that he began using photographic imag-
ery in other media (probably initially in
watercolour) in about 1932. Nash felt
that 'the secret of a place lies there for
everyone to find, though not, perhaps,
to understand'. He looked for the 'inner
life' of his subject and his landscapes, in
photographs or paintings, seem to live.
(See also opposite p.97.)

photographs that he took as sketches, and there are many
parallels between photographs by Nash and finished paintings
and watercolours; and he, like Moholy and others, was fas-
cinated by what the photograph could discover in a scene that
might be ignored by the glance of the unaided eye. His was a
sophisticated and feeling intellect, and by 1932 he declared in
print, in a review of the German photographer Karl Blossfeldt's
publication *Art Forms in Nature*, that modern photography was
not only parallel to the course of modern art, but influenced
that course.

By the mid-1930s he could remark ruefully that he was a
little concerned that his reputation as a photographer might
outstrip his reputation as a painter. However, only a handful of
photographs by Nash were actually published in his lifetime.
Some were shown at the International Surrealist Exhibition in
London in 1936, where his work in other media was also dis-
played; Nash was a committee member for this immensely
influential and startlingly publicized exhibition, when European
artists flocked to London and were photographed in bizarre
poses and costumes for the newspapers. Both Dada and Surreal-
ism relied on and are linked by their expectations of the unex-

75

pected: and the feelings Nash had for photographs revealing beauties normally hidden, overlooked or ignored were expressed by him with vivid clarity. The major painting *Monster Field* (1939), which has as its chief character an astonishing dead and partly dismembered tree lying on its side like the corpse, the remnant, of a beached extraterrestrial creature, is one image for which Nash used photographs as well as preliminary studies. So is one of his most famous war paintings, *Totes Meer* ('Dead Sea'), which uses to hallucinatory effect a dump of dismembered, wrecked German aircraft at Cowley, near Oxford. Drawings and watercolours were also developed from the photographs. Nash was at the time an official war artist. He referred to the set of photographs he took of the aeroplane dump as 'rather extraordinary' and saw the results as something in their own right as well as documentation, writing to a friend, though, his view that people did not understand how photography could be used for painting except as a method of cheating. This is an attitude still prevalent: in 1981 this writer received a highly indignant letter from a group of art students at one of England's leading art schools complaining that a group of well-recognized and well-reviewed painters used photography in their work and that this was a method of fudging the fact that these painters did not draw properly and could not draw properly. It is a widely held view still that it is in some way cheating to use photography, although using photography as a method, as with the American painters who are called Photorealists, because it is not only openly acknowledged, but integral to that process, method and attitude, naturally escapes these strictures.

Although in his lifetime Nash resisted offers of publication for his photographs, there was a striking episode in 1940 when he asked Kenneth Clark, then not only director of the National Gallery, but also director, Home Publicity, Ministry of Infor-

45 **Paul Nash**
 Totes Meer (Dead Sea), 1940-1
46 *Wrecked Aircraft, Cowley Dump, Oxfordshire*, 1940

This painting has been called the finest of all his paintings, of either the First or Second World Wars. The visual ideas in it were carefully built up and constructed from a number of photographs Nash took of the wreckage of German aircraft collected together in a dump near Oxford, at Cowley, and he wrote to Kenneth Clark that the whole looked to him like a sea, 'but not water, or even ice, it is something static and dead. It is metal piled up, wreckage.' Significantly, perhaps, there is also a moon, as in *Pillar and Moon*; but here the moon is a crescent or half moon. Nash worked up watercolours from his photographs; he wanted to exhibit photographs and watercolours together in 1940, but the project came to nothing as it was felt that the photographs would be misunderstood. 'No one understands how photography can be used [for art] except as a method of cheating.'

mation, and instrumental in the choice of war artists, to show his photographs in an art exhibition. For the War Artists' Exhibition at the National Gallery in 1940, Nash wished to show his photographs together with the drawings which were based on the photographs, and Clark refused because of what he felt to be the widely held still prevalent belief in the separation between art and photography in the public mind at least.

Nash's paintings, however, are never straight transcriptions of his photographs. Invariably an imaginative element enters in, something made-up or heightened to exaggerate mood and effect; oddly, his photographs themselves also never seem simply transcriptions of the observed world. His photographs are almost always unpeopled, but in so far as they are often of ancient monuments, of natural configurations which are remnants and memories of an ancient human past, of gardens, roads, farms, the human presence is imaginatively implied.

The very popular American artist Ben Shahn (1898-1969) had a somewhat unusual career because of the extent of his social commitment, his subject matter, which was often highly political, combined with his eclectic use of traditional and modern art idioms, and his extensive activity in a variety of media: painter, draftsman, graphic designer and photographer. Shahn's family were Lithuanian Jews, who emigrated to America when Shahn was eight; his father was a radical, and a carpenter and woodcarver. Shahn was himself apprenticed to learn the trade of commercial lithography.

He may still be best known for his controversial series of drawings, gouaches, and even eventually murals on the subject of the trial of the Italian-American philosophical anarchists, Nicola Sacco and Bartolomeo Vanzetti, who were executed in Massachusetts after being convicted of murdering a paymaster:

47 Ben Shahn
 *Untitled, New York City, c.*1934
48 *Vacant Lot*, 1939

Although Shahn photographed extensively, and worked as a photographer, he often used photographs from published sources as bases for paintings. *Vacant Lot*, however, is very directly connected with his New York photographs of the blank walls seen on many a street, often pressed into service by New York children for street games. In Shahn's work a social conscience, a sense of optimism, and eventual success – with patrons of every political hue – all form a curious contrast to a sense of alienation often visually evident in his paintings of city life. And here, too, there is another contradiction: that of a painting in tempera, a notoriously painstaking and difficult medium, and the 'instant' photograph. Shahn was involved not only in photography and painting, but in print-making, designs for posters, and government sponsored murals. His visual thinking was on a scale both miniature and gigantic. The painting, as we can see, has been edited from the material supplied by his photograph.

49 **Ben Shahn**
Sacco and Vanzetti, 1931-2
50 Contemporary photograph of Sacco
and Vanzetti

One of Shahn's most famous series of
works was devoted to the trials of
Bartolomeo Vanzetti and Nicola Sacco,
two Italo-Americans executed in
1927 after trials which caused scandals
and controversies. They became a cause
for those convinced of corruption in the
American system of justice, for the
political ideas held by Sacco and Van-
zetti, and their racial backgrounds, were
said to have prejudiced any chance of a
fair trial. Shahn had to work entirely
from newspaper photographs and his
imagination for this series.

Shahn was actually in Europe at the time of the trial, and based a
good deal of his imagery on newspaper photographs. A later
series of works was based on the trial of the San Francisco labour
leader Tom Mooney. Shahn travelled extensively in the 1920s in
Europe and North Africa, and with great dedication he famil-
iarized himself with Western art history, assiduously visiting
museums, and omnivorously absorbing influences, starting
with the Italian primitives and early Renaissance painters; he
was as passionate about the art of such diverse modern figures as
Rouault and Paul Klee.

Shahn was a gifted teacher, a polemicist, and a liberal who had
no difficulty in reconciling what might have seemed contra-
dictory impulses and occupations: in early days he supported
himself as a commercial lithographer, in later days he worked in
advertising, and was pleased to discuss being a commercial
artist.

He photographed for much of his life until, near the end, the
impulse to photograph inexplicably deserted him; in the 1930s
he had at times thought he might even become a full-time
photographer. Once, he recalled, he was introduced to some-
one as Shahn the painter, and was then asked if he was related to
Shahn the photographer, an anecdote that delighted him.

For Shahn had participated in one of the great photographic
enterprises of the century, as one of the photographers emp-
loyed by an agency of President Roosevelt's New Deal, the Farm

Security Administration (FSA). Among the other photographers were Russell Lee, Dorothea Lange, Carl Mydans and Walker Evans, all working to make nothing less than a 'picture record of America', notably here, as the FSA agency title implies, that of the huge and barely perceived number of depressed agricultural workers, many of whom were forced into a migratory life by the terrible drought of 1932-6 which caused, from Texas to the Dakotas, the Dust Bowl. The photographers' job was to record in pictures the life of the rural poor. Shahn described several times how wholly absorbing he found this work. He used a canny device – the right-angle view-finder –so that his subjects would not pose, for they would not know they were being photographed. And once he came upon photography he used it as an aid to memory, to make, as he put it, 'documents' for his own work; the image itself was more important to him than its quality, the camera remembered details the eye forgot, and above all he was concerned to fix the 'extraordinary aspect of the ordinary'. Shahn worked for the FSA from 1935 to 1938. Critics have remarked on his hybrid vision: partly through his own eyes, partly through the camera. He had a file of something like 3,000 photographs he had taken: from this file he would recall and retrieve details and compositions he used in his later work in other visual media.

For about two years in the early 1930s, Shahn had actually shared a studio in New York's Greenwich Village with Walker Evans, and they worked together too for some summer months on Cape Cod. Evans denied that the photographers' work for the FSA was social protest (even though these desolate images were highly influential at the time, leading in certain cases to direct political action, and they have remained as an unusually potent narrative of the 1930s). Evans announced, with stark simplicity that the photographs were a record of 'what's what'. Shahn himself moved with ease it seems between imaginative documentary – that is the imaginative reconstruction of episodes and events such as the trial of Sacco and Vanzetti – and even symbolic compositions, fresco murals in which segments of ordinary life were put together to form an imaginative narrative that would appeal to the people frequenting community centres, post offices and the like, and paintings which were vignettes of city life or symbols after the war of people rebuilding their lives amidst domestic ruins. Innocence and the innocent victim were themes of Shahn's work: and innocence, the unguarded, were themes of his photography too.

The American painter and photographer Charles Sheeler

(1883-1965) had two careers parallel to each other. In about 1912 he took up professional photography, after extensive training in applied design and as a painter (his first painting exhibition was in 1908), and he showed paintings in the famous avant-garde art exhibition, the Armory Show in New York in 1913. For considerable periods of his life, Sheeler earned his living as a photographer for museums, galleries and collectors; he worked for Condé Nast publications (*Vogue* and *Vanity Fair*) in the 1920s, giving then little attention to painting, and he exhibited his photographs at the seminal and influential 'Film und Foto' exhibition at Stuttgart in 1929.

Typically, his subject matter was architecture, industrial, urban, and domestic. In his photography Sheeler looked for the best way of showing what he described as 'immediate facts' while in his paintings he searched for the best way to use 'natural forms' so as to enhance the design. He used architectural details isolated from his photographic studies of the stark, austere and formal architecture of Pennsylvania barns and farmhouses, their simplicity prefiguring some of the tenets of modern architecture: several years later, in the early 1920s, he based paintings on these unpeopled scenes of domestic architecture, in which form and structure were isolated from emotional content. Sheeler was the author of a number of outstanding photographic essays, including architectural details of Chartres Cathedral (1929) and also the Ford Motor Company plant at River Rouge, Detroit, Michigan (1927), with the latter supplying much material for later paintings. For a collector he photographed African masks (1918) and, as photographer in residence for the Metropolitan Museum in New York, Assyrian sculpture (1940s). His wide range of photographic subject matter was in part dictated by the

51 Charles Sheeler
Untitled (River Rouge power plant Stacks) from the *Ford Plant* series, 1927

This is a view of the south side of Power House No. 1 with its eight smoke-stacks, and at least one drawing of the same subject exists. This powerhouse was part of the Ford Motor Company's complex of factories at the River Rouge by Detroit, the largest industrial complex anywhere at the time, a site of over 2,000 acres, at which 75,000 people worked. By 1929, all stages of automobile production, including an automated assembly line, took place on this site. From the time when he was employed by Ford (as was Diego Rivera) to produce a series of documentary photographs of the River Rouge complex, Sheeler adopted American industry as a major subject for his art. He felt that photographs should be given an importance equal to painting and music as a way of communicating ideas. He affirmed that photography should be valued for what it could do – recording with sharp-edged exactitude, and finding in nature combinations of forms which otherwise we would miss seeing. Photography should not be criticized for not being painting –and *vice versa*.

needs of his employers, but his treatment is unified by a strong interest in the emotive power of form. When he himself chose what to photograph, the subject matter was man-made: a landscape of architecture – and machinery.

Sheeler never simply transcribed photographs into paint; rather he used details, perspectives and elements of photographic vision in such a way that interesting tensions between the conventions of photographic 'reality' and painted 'reality' were set up. He put it another way himself: he is supposed to have said that he felt that photography was 'nature seen from the eyes outward, painting from the eyes inward'.

Sheeler was an artist who was labelled with several others a precisionist, with a new American 'ism', Precisionism. But the group, if such it were, was itself not in the least precise, with no manifesto. Rather it was an historical convenience to relate together artists linked in several ways: technically by the overall clarity of their work and, in painting, a smooth impersonal surface; and by their concern with monumental but realistic subjects, architectural, mechanical, industrial, and urban. It also embodied one commonly held view of America. On the one hand, there is the wilderness, waiting to be captured and cultivated; and part of that capture was the documentation of uncharted America in the nineteenth century by maps, photographs and paintings. On the other hand, there was the city and the machine. There was the urge to show the power and might of new industrial America, symbolized not only in her factories but in the skyscrapers of New York. Sheeler indeed had paintings commissioned by the influential business magazine, *Fortune* (which also commissioned many well-known photographers, including Walker Evans); he had collaborated with the great American photographer Paul Strand on a film, *Mannahatta* (1921), which was first shown publicly under the title *New York the Magnificent*. (It was a silent film, with sub-titles and title from the writings of the poet Walt Whitman.) The film had a series of overlapping and discontinuous imagery which owed much to both experimental photography and experimental art.

The interesting creative paradox in both Sheeler's art and photography was the specific absence of the immediate human presence, introduced only very rarely, almost as an incidental to indicate scale. The art that he most sympathetically photographed – African masks, antiquities – was of the human form, but stylized, primitive, powerful, and old. The architecture he photographed was devoid of the human crowd, and in its monumentality often beyond the human scale; little was domestic, with the

51 **Charles Sheeler**
Rolling Power, 1939

Sheeler both photographed and painted industrial scenes, architectural interiors, and such objects as the great transatlantic passenger boats. The huge objects which spoke obliquely of human power, and directly of industrial mechanized power, are apparent in both photographs and paintings, but the paintings are usually on a surprisingly small scale.

notable exception of his photographs of Pennsylvania farms and houses, and Colonial Williamsburg: here he extracted from this starkly simple architecture forms for paintings. Analysis of his compositions would show a fascination with overlapping lines – 'lines of power' – and the geometry of machinery. A refined analytical simplicity informed both his paintings and his photographs.

An early colleague of Sheeler's was the American painter Morton L. Schamberg (1881-1918) who died in the flu epidemic of 1918, and whose first one-man painting exhibition in New York was held posthumously, in 1919. Schamberg first trained as an architect, and then at the Pennsylvania Academy of the Fine Arts, at the same time as Sheeler, with whom he shared a studio and later a house, as well as European travels. Schamberg's own paintings were hard-edged abstractions, based on mechan-

ical forms. Schamberg too exhibited paintings at the famous Armory Show in New York in 1913, and he too supported himself by work as a photographer. Unlike Sheeler's however, Schamberg's photographs were portraits of people (and were a source of income), made interesting by his striking sensibility and ability to extract the essentials of form, rather than by any overt link with the subject matter of his paintings. He shared a photographic business with Sheeler, but his specialization, portraits, did not feed into his preoccupations in terms of his paintings, as Sheeler's architectural interests did.

Another prominent artist associated with the Precisionist movement in American art was Ralston Crawford (b. 1906), whose paintings of industrial architecture often deployed what seem to be photographic devices. He was also a distinguished photographer, but most successfully in areas which were dramatically divergent from the subjects of his paintings and watercolours. While Crawford's fine-art preoccupations were with forms which even tended toward the totally abstract, based on the solid geometry of industry, he has photographed extensively among people and their environment, his best known series being devoted to New Orleans music, notably jazz musicians: altogether, something like 2,000 photographs recorded New Orleans life. In his art the most memorable work has remained a poetic evocation of technology. His keen analytic eye for form has affected his photography, naturally, as has a rich human texture, almost in antithesis to many of his primary concerns in painting.

It has become customary to think of the modern period as a time when many philosophies and attitudes coexist, a time both of eclecticism and pluralism, and of course a time of unprecedented ease of communication. In America, the leadership of the photographer Alfred Stieglitz (1864-1946), whose influential publication *Camera Work* (1903-17) and his gallery, 291, embraced all the visual arts, ensured a remarkable communication between photographers and painters, and painter-photographers: Stieglitz encouraged, for example, among a host of artists, both Sheeler and Schamberg, and although he himself was not a painter, his sympathetic concern with all the visual arts was a potent catalyst. Stieglitz' wife, Georgia O'Keeffe, is an outstanding American painter. Her artistic sensibility may well have influenced contemporary American photography – and vice versa.

The new breed of professional photographers increased apace,

with advertising and a variety of new picture magazines and other publications providing new outlets for artists and photographers. Amateur photography was open to all, and while many photographers aped artistic conventions, versatile artists opened up the possibilities for photography.

In the hands of such as Moholy it could become a surprisingly abstract art. Moholy was more interested in ends than means (a legend is that he actually ordered a painting done by telephone: in fact he did order, under meticulous direction, a series of enamel paintings produced by industrial processes). The Dadaists liked both the accidental nature of assembling scraps of material from the real world – the shock of uniting disparate elements – and the surprise of making unsuspected connections. Whether they took their own photographs, commissioned photographs, collaborated with photographers, or simply used found photographs quarried from a variety of sources seems not to have been a matter of principle, simply a matter of practice: whatever came to hand. Schwitters, for instance, did take photographs, but is associated far more with the use of photographs as but one element in his famous collages. The Berlin Dadaists all used photographs extensively, several, such as Hannah Hoch, working exclusively in photocollage and photomontage, combined with drawing and other devices and techniques. George Grosz, the witty, biting satirist, used photographs as one element among many, while John Heartfield, as we have seen, took photomontage to a pitch of political satire, invective and forceful criticism of society in striking visual terms that have never been equalled, using others' photographs and at times those taken under his direction. All relied on the spectator's unconscious acquiesence to the idea that a photograph was of something real, therefore both authentic and truthful. (In centuries past, after all, a meticulous illusionism in painting had been an aid to convincing the faithful.) For instance, the Dadaist and Surrealist Max Ernst(1891-1976), not an extensive photographer in his own right, juxtaposed photographs and photoengravings and other printed material to make convincing tableaux and scenes which were absurd, irrational and nonsensical, but momentarily convincing. The topsy-turviness of dreams was visually authenticated with these new techniques.

Meanwhile artists such as El Lissitzky and Rodchenko used photographic imagery in a variety of ways, both experimental and documentary, but always at the service of ideas, for they viewed experimental and 'straight' photography as possible

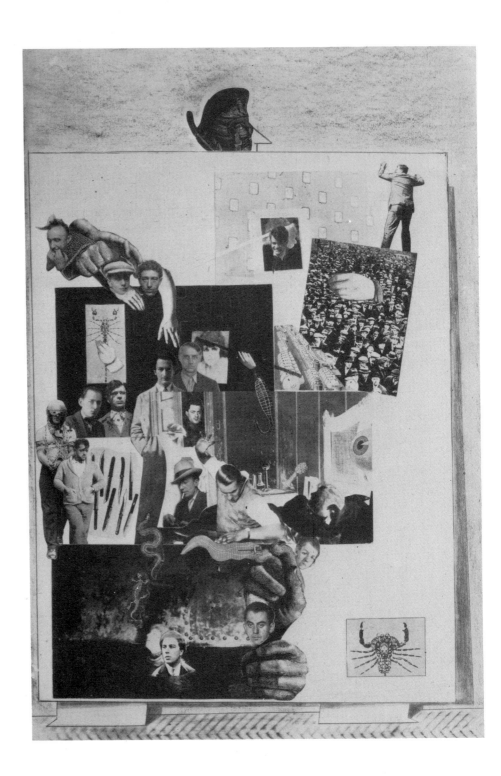

instruments for social change, and therefore as a kind of visual vocabulary which was particularly valuable because of its mass appeal. Painters like Shahn, Schamberg and Sheeler were commissioned to take photographs, and it was a useful way to earn a living. A few, like Sheeler, are equally well known as photographers as they are in the role of painters.

The whole tempo of the times helped to diminish at least temporarily the value of the hand-done as a guide to artistic worth. Something fundamental happened to the craft of art in the age of mass-production. In various ways the artist as polymath re-emerged, ready to explore photography as a creative medium in its own right. When painters took up photography in this period they helped to free it from imitations of painting. The artists themselves no longer depended on a carefully accepted hierarchy of acceptable subject matter and acceptable technique and acceptable media, yet it was their authority as artists that led to the opening out of creative photography as a medium in its own right on equal terms with other visual media. And these artists who may be known as much for their photographs as for their work in other media do not always share the concerns of professional photographers. When they had to earn their living as photographers, of course they did: but in their own work in photography they were often daringly experimental, as in their work in other visual media.

53 Max Ernst
Loplop introduces members of the Surrealist Group, 1931

Loplop, looming behind, is an enigmatic, slightly scary figure, a creature bird-like, mammal-like, and humanoid, who emerges in much of Ernst's art as something between a guide and a presence. Here a group of photographs and other printed elements are combined in a work that celebrates the temporary regrouping of the Surrealists in Paris. There are collaged photographs – a kind of sophisticated scrapbook in patchwork – of sixteen Surrealists, including Dali and Man Ray, as well as anonymous figures. For Ernst, photography was simply one source among many. In his receptiveness to materials from the past and the present, and in his indifference to differentiating or labelling sources, he typifies some important aspects of twentieth-century art practice. For many artists the use of photography was natural, unremarkable and undocumented. They would be indifferent as to the authorship of the photographs they used. As with Man Ray, Dali, and Christian Schad, all media – sculpture, painting, drawing, printmaking, collage, frottage, assemblage, and ready-mades from the real world – were open to the artist to use as he wished.

3

THE ARTIST AS ARCHIVIST

There is no evidence so far that the highly eminent Victorian painter, Sir Lawrence Alma-Tadema, Royal Academician and holder of one of Britain's highest honours, the Order of Merit, took photographs himself. Famous for exquisitely concocted scenes of everyday Greek and Roman life – he redesigned his own house in St John's Wood (formerly the home of another well-known painter, James Tissot (1836-1902)) as a Pompeian villa – Alma-Tadema prided himself on his archaeological accuracy. A decade before he settled in England he was friendly with the successful Belgian photographer Dupont, and according to Alma-Tadema's biographer, Professor Swanson, Dupont suggested to Tadema that he photograph Tadema's paintings 'in progress' so that he could subject them to examination through the medium of black and white photographs which would highlight awkward passages that needed more work. In the course of Alma-Tadema's life he acquired many photographs, purchasing large selections of archaeological and scenic photographs of the ancient world, which he used at times to verify details in his work. He also used photographs of his own work to detect errors of detail, or passages which needed further attention. Well over 150 albums of photographs owned by Alma-Tadema have survived. Although he did not take photographs himself, he used them in a way then perhaps novel, now almost commonplace among artists: to provide reminders of necessary details, as a kind of source material, and also to document his work in progress.

The great French sculptor Auguste Rodin (1840-1917) had a highly complex attitude to photography. He too used photography without taking photographs himself, as far as is known, but modern rediscoveries in the Rodin archives suggest that Rodin played a much more active role in the photographing of his sculptures than has been hitherto supposed. Rodin was already famous, but achieved outstanding international suc-

54 Auguste Rodin
The *Monument to Balzac*, 1897
(Photograph by Steichen, 1908)

90

55 Auguste Rodin
Young Girl Kissed by a Phantom,
1880s? (Photographer unknown)

Rodin had an ambivalent attitude
towards the vexed question of whether
photography was an art, but had no
hesitation about using photography *for*
his art. His arrangements of his work in
his studio made a composition in which
the sculptures acted as characters in
some mysterious narrative. He also used
photography to highlight the dramatic
effects his romantic-naturalistic
sculpture could so easily demonstrate,
and thus photography could be used in
an interpretative manner. In yet another
approach, we can see by the drawings he
made on the photographs of his own
work that photography could be used as
a method of research and investigation
for the artist who was continually
thinking about the exploration of
plastic values in his work. By directing
and collaborating with the
photographers whom he commissioned
he used photography as an assistant,
another pair of eyes, for his sculpture.
For art historians, the legacy of
contemporary photographs of Rodin's
work has provided an exceptional series
of insights into how the sculptor viewed
his own art.

cess, nearly unprecedented in modern times, after the very big
showing of his own work which he organized at the time of the
International Exhibition in Paris in 1900, in a specially built
pavilion by the Pont d'Alma.

Curiously, Rodin echoed the sentiments of Delacroix in
relation to photography. Rodin was always interested in photo-
graphy and indeed had been a subscriber to Eadweard
Muybridge's *Animal Locomotion* in 1887. But Rodin felt that
photography by its nature captured the frozen moment, while
art could suggest motion, animation and movement; that is,
while art might be physically less accurate than photography,
what it could suggest would be more animated, real and true.

Rodin did however see photography of his own work as
extremely important for his reputation, in publicizing his
achievement. He himself had an important if inadvertent effect
on the history of photography, too: for the influential Edward
Steichen (1879-1973) saw a reproduction of Rodin's famous
monument to Balzac in a Milwaukee newspaper, and recorded

56 Auguste Rodin
Seated Ugolino, 1877 (Photograph
by Bodner or Pannelier, 1900)

that it stimulated his own desire to go to Paris where such artists lived and worked. Steichen himself became one of the foremost photographic interpreters of Rodin's work. He was, with Rodin's active interest, to make a series of remarkable photographs of that statue of Balzac. In 1908, Rodin moved the white plaster-cast of his Balzac out into the open, and suggested to Steichen that he photograph it by moonlight; Steichen spent the whole night photographing the Balzac, with varying exposures. When Rodin saw the prints Steichen made he declared, according to the photographer, that the world would understand 'my Balzac through these pictures'. Rodin himself sat to the most famous portrait photographers of the day, including Steichen, whom he considered 'a very great artist'.

57 Auguste Rodin
The Kiss, 1898 (Photograph by Druet)

Rodin was not the hand behind the camera, but his work was among the most photographed of the day, and photography spread his fame internationally. In a way, Rodin acted as the producer or director of the photographs that were taken. Typically, in the pavilion which housed the major exhibition of his work he devised in 1900 in Paris, scores of photographs of his work taken by Eugène Druet were not only on exhibition but on sale. After this, there were numerous exhibitions of photographs of Rodin's work.From the 1890s Rodin had exercised enormous care and supervision over the photographs of his work, his requirements were stringent, and evidently his instructions were often very exact: prints and plates that did not please him were destroyed, and the photographers were contractually obliged to follow Rodin's directions as to composition, positioning and lighting.

In the archives of the Musée Rodin, there are over 1,000 photographs. Rodin not only liked having photographs made of work in progress (which as his fame increased, and public commissions came ever more frequently, was also a useful way of keeping commissioning bodies informed of progress) but he sometimes used photographs of work in progress to work on as though they were drawings or models, showing to himself on the photograph what further work he would undertake: not so unlike the information that Alma-Tadema asked for from photographs of his paintings. Rodin also had his finished work photographed frequently in varieties of positions, and arranged the sculptures in his various studios for photographs just as a director might move actors about on a stage.

Rodin was not very interested in documentary photography: serious art for him meant interpretation, meant the inspiration of feeling; what he called 'mere exactitude' was not enough. He also felt that the possibilities for photography had not been fully exploited, so his attitude was an interesting one of disparagement on the one hand, a belief in the (exclusive) merits of fine art, and on the other a feeling that photography could aspire to the status of an art. Thus he was ambivalent, and yet with his own ruthless visual intelligence exploited photography for his own art: as a vehicle for publicizing his own sculpture, and working closely with the outstanding photographers of the day to achieve that end, to such an extent that his participation could be called a collaboration.

It is perhaps natural that sculptors above all should be interested in how to photograph their work. A wall-hanging painting by definition is not seen in the round whereas a

sculpture is. Lighting, and the angle from which a work is
viewed, are of paramount importance for sculpture. The Italian
Medardo Rosso (1858-1928) has been described as photo-
graphing his own work as an 'aesthetic imperative'. Rosso was a
most unusual artist, who made Rodin's acquaintance in Paris
about 1884, and the extent of their mutual influence is a matter
of speculation still. Each claimed to be the first 'Impressionist'
sculptor. When Rodin died in 1917, the poet Apollinaire
declared Rosso now to be the 'greatest living sculptor', yet
curiously in modern times there has been little written about
him. Lately, with the increasing interest in Symbolist art,
Rosso's own techniques, which included using wax over plaster
to produce a melting, fluid effect, have aroused increasing
interest too.

Rosso wanted to portray daily life, he wanted an effect of
spontaneity, and his work has even been called sculptural
snapshots. His sculptures are emotionally captivating, and his
anti-academic attempt to portray the look of a moment is
exemplified in such melting works as *Impression of an Omnibus,* in
which a head-and-shoulders of three people are linked together.
A frozen moment, indeed, was just what Rosso – unlike Rodin –
sought to achieve. In his own way, as much as Daumier and the
Impressionist painters, who after all also portrayed ordinary
life, its recreations, and its pleasures, Medardo Rosso was after
the look and feel of daily life, and was admired by the much more
overtly revolutionary Futurist painters and sculptors because of
his attempts to show atmosphere, vitality and movement in
sculpture.

Rosso, who had a hard struggle, even supporting himself by
making funerary monuments in genres and idioms he may be
supposed to have been personally antipathetic to, regularly
showed photographs with his sculptures (he also liked showing
his sculptures with paintings by others, enjoying the further
sense of animation and vitality that the reflections of colours
from the paintings gave to his sculptures). In 1904, for instance,
when he showed at the Salon d'Automne, Paris, he installed three
large photographs: an enlargement of the old woman from
Impression of an Omnibus, Rodin's *Balzac*, dramatically cropped; and
a photograph of a cast of a large male head; in 1905, in his show
in Austria, he exhibited a significant number of his own
photographs of his work. Rosso also made sure that his
sculpture was only reproduced from his own photographs as he
felt that only his interpretation was accurate, because the
sculptures themselves had as inspiration impressions from one

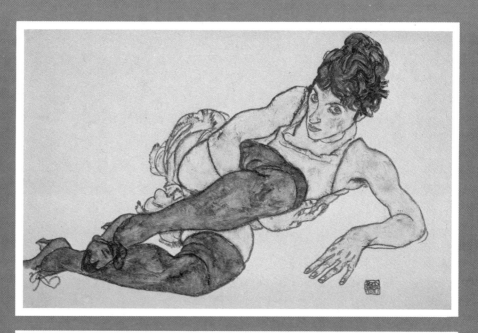

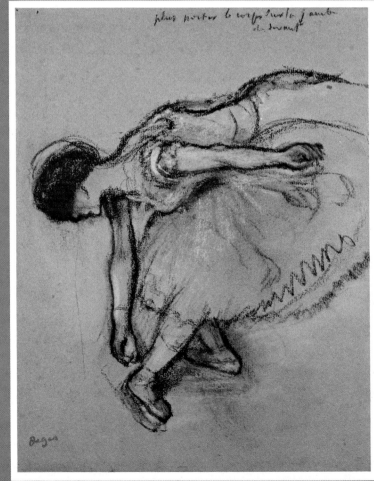

light and one angle, a transitory reality captured by art: and the photographs of his work should faithfully reflect that feeling. What is paradoxical is that his sculpture most characteristically and daringly concentrated on a dissolution of form in order to convey, through something fixed, the sense of something fragmentary and changing; and only he could faithfully translate into photography his own sculptures which depended so much on reflections of light and shade for their sense of vitality and life. The main version of *Impression of an Omnibus*, five half-length figures, was destroyed in Rosso's lifetime, and ironically only exists at all through the medium of his own photographs. Oddly he did not think sculpture was three-dimensional, or that it needed to be seen, or was designed to be seen, all round. Rosso in a sense tried to do with sculpture something that few others attempted: to suggest momentary (not monumental and fixed) appearance. Thus he sought control over how his sculptures were shown: they were to be lit only in a certain way, seen from the front; thus it was natural that he should feel so strongly about how his sculptures should look when reproduced photographically that he took his own photographs.

A fairly recent event in art history has been a dramatically increased awareness of the extent to which the pioneering Romanian sculptor, Constantin Brancusi (1876-1957), who spent most of his life in Paris, used photography. Brancusi worked briefly for Rodin, and some of his early work has an affinity too with the impressionism of Rosso. Brancusi photographed his own sculpture, and in the early 1920s built a darkroom in his studio for this purpose, with Man Ray helping him select suitable equipment. (Man Ray called Brancusi the 'divine machinist'.) Brancusi controlled his own environment with an unusual exactitude, and the effect was spare, stringent, determined. Indeed he left the contents of his studio to the French nation. His studio has been reconstructed with his sculptures and work in progress in it, as authentic a reflection as possible of what it would have looked like when Brancusi was alive; it is a freestanding building in the great square outside the Centre Pompidou, the French National Museum of Modern Art. The photographs Brancusi took of his own work have been called a 'visual journal'.

He began to photograph his own work in the 1920s, and explained to his friend Man Ray that a photograph taken of his work in New York earlier was beautiful but not really truthful, not an authentic representation of his work, implying that photographs taken by others did not accord with his own views

C Paul Nash
Pillar and Moon, c. 1938-40

D Edgar Degas
Danseuse, 1880s

97

58 Constantin Brancusi
View of the Studio, 1925

The Kiss, a stone carving of which there are several versions, may be seen standing on a table to the left; *The Sorceress* is the wooden carving which occupies the centre of the photograph. *The Chief* is behind and to the left. Photographs by Brancusi, developed and printed by the artist, served several purposes. Part of the impulse was documentary, and part was to study his work from different angles, often on different bases. But his arrangements were made with the care of a still-life, so that the studio became a work of art in its own right, an assemblage which has survived in many changing aspects through the artist's photographs, in which each sculpture – now seen on their own in museums throughout the West –

contributed to a whole, a silent, still drama in which each was an individual character. Every new arrangement was like another performance, evolving as the script – the characters themselves – changed.

of his own work. In his photographs he recorded the stages certain sculptures went through.

Brancusi's sculptures were often translated by the artist into various materials. There are, for instance, at least eight versions of his simplified, refined, streamlined portrait known as *Mlle Pogany*, done over decades: coloured marble, white marble, bronze in various colours. With his photographs, in closely related series, he experimented with different kinds of lighting on his work, and it may be assumed that the same kind of sensibility that translated and transposed a given sculptural form into different materials was also deeply interested in photographing the same form in different lights and different positions. He photographed two distinct but related subjects: his own work seen subject by subject, object by object as individual portraits of his sculpture; and the entire studio environment which in some way Brancusi must have regarded as an ensemble, as a whole art work, as he wished it preserved, and as it was where he received visitors and lived among his work.

Something like sixteen different variations exist of the sculpture *Bird in Space* by Brancusi; and photographs of *Bird in Space* in different kinds of light – daylight, light filtered through glass, artificial light – are in a sense yet further variations. The total number of his photographs is substantial: over 550 original negatives, and about 1,250 prints made by the artist are in the Brancusi archive at the National Museum of Modern Art in Paris. And it is fascinating to note the exclusion from his photography of almost any other subject than his work and his studio.

59 Constantin Brancusi
Mlle Pogany II in profile, 1920-1

One of Brancusi's many views of his polished bronze sculpture of 1920.

98

99

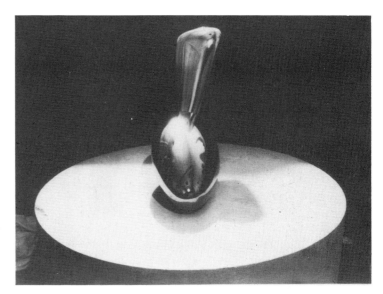

60 Constantin Brancusi
Leda, c. 1925

This is a unique polished bronze casting of a 1920 marble; it was photographed by Brancusi several times, from different angles, arranged for mobility on the centre of a double-drum table which acted as a base for the sculpture.

The photographs are just as inclusive in another way: Brancusi took the photographs himself and he developed them and printed them himself; and the subject matter was the sculptures of Brancusi, Brancusi's studio, and sometimes Brancusi himself. It was a complete world – of Brancusi. Brancusi had the same all-inclusive attitude towards his sculptures: he carved them himself, and he cast them himself. In his photographs he did something else, too. He grouped together individual sculptures, sometimes creating, at least for the photograph, a group sculpture: thus a photograph called *The Child in the World, Mobile Group of 1917* (Brancusi had begun taking photographs in 1905, but dramatically expanded his photographic activities in the 1920s) consists of three carved wooden sculptures, *Little French Girl, Cup II, and Column.*

He often photographed his finished sculptures on varying kinds of pedestals at different heights. He also showed them in their surroundings of raw materials, that is, uncarved stone and wood, great rough chunks of material which bore within their unshaped forms sculptures yet to come. He photographed his sculptures from many a different angle, reflecting light, and he printed photographs in different sizes.

There are several series he did of *Mlle Pogany*, sometimes contrasting several sculptures of her, near to one another in the atmosphere of the studio, sometimes simply changing the po-

61 Constantin Brancusi
Working on *An Endless Column*,
a self-portrait, *c.* 1924

sition of one version to provide sequential views, rather like stills from a film. Altogether, the photographs of Brancusi may be looked at in several ways: as his own meditations on his sculptures; and as something he wished to share with his public, for these were not private meditations. It is as though he organized in visual terms his own commentary on the potential of his work. He was occasionally given to making poignant strong statements about his own work, and one such was the exhortation to spectators not to search for obscure formulae or mystery: 'I give you pure joy. Look at the sculptures until you see them.' His photographs show not only the various ways in which Brancusi saw his own sculpture and the carefully arranged working environment in which he lived, but the ways in which spectators could be encouraged to enter his world.

Henry Moore (b.1898) was inspired to photograph his own sculpture too because he was dissatisfied with the photographic work of the professional photographers. As he had to collaborate and explain to the professional what he wanted, he decided quite logically that he might as well do the job himself, as he knew what he wanted: position, lighting, what structure, plane, mass or volume he wished brought into prominence. Moore has said that he is a sculptor partly because he wanted to be sure that he had made something that existed completely in itself, as a whole entity. For this reason, too, the photographing of sculpture is of crucial importance: a way of realizing the shape of the sculpture through modelling by light. Photographs he has taken remind him of the reality held in his mind about the object he has made; although he cannot recall specifically working from photographs

62 Henry Moore
Reclining Figure, 1933

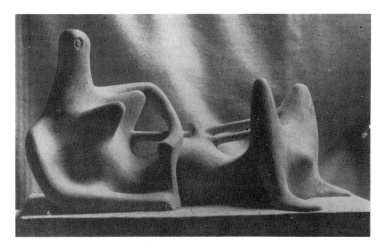

63 Henry Moore
*Corner of Studio at 11A Park Hill Road,
Hampstead, c.* 1936, with Figure,
1933-4 in foreground

64 Henry Moore
Figure, 1933-4

Henry Moore took his own photographs of his work for decades as he felt, after observing photographers he had asked to photograph his work, that the artist himself was best placed to understand how the sculptures could be seen. And as the 1930s were a great period of carving in stone and wood for Moore, his own studio 'still-lifes' make an interesting comparison with Brancusi's studies of his studio. With *Figure*, 1933-4 we can see a sculpture photographed in isolation, as well as recognizing it among its peers in the corner of the Hampstead studio.

for sculpture, in principle he would do so if it were convenient.

What he has done, though, for many decades dating from the 1920s, is to photograph his own work. Moore has not been interested in the printing process (regarding that as mechanical) but in the two other processes: the setting up of the shot – that is, the appropriate arrangement in terms of position and lighting for the sculpture that is being photographed – and subsequently the taking of the photograph, the visualization of the image. He has done so in order to convey to others, as a kind of commentary almost, the essence of a given sculpture. Quite unlike Medardo Rosso, Moore does not believe in or practise a sculpture which has a key view; sculpture is to be seen in the round, but of course photography can memorialize details from many angles. Photography for Henry Moore has been a tool, a way of reproducing his work which is under his control. He only stopped taking his own photographs when it became no longer practicable to do so. However, he works in close collaboration with the photographers of anthologies of his work.

Sculpture exists as three-dimensional objects, moulded in

65 Henry Moore
Mother and Child, 1931

reality by the play of light and shade on form. It is therefore natural that certain sculptors would see so clearly that photography was a process which required their intervention and collaboration. Photographs of sculpture act as two-dimensional reproductions of a three-dimensional art work which is markedly altered by changes in light and position. Medardo Rosso, Brancusi, and Henry Moore are not known as photographers of subjects other than their sculpture. Their photographs must be seen therefore as interpretations and meditations on their own work, a diary without words, a visual record, a journal through photographic images, which lets us see through the artist's eyes his own creations.

One highly unusual involvement of a sculptor with photography is that of the American Kenneth Snelson (b. 1927) who, like several of the more significant American innovative artists of the post-war period, studied at Black Mountain College, North Carolina, where he worked with that imaginative engineer, Buckminster Fuller. (Black Mountain has had a significant number of important artists as students and teachers.) Snelson makes structures, large drawings, so to speak, in space: dramatic, graceful, refined. They are imagined with a combination of geometry and intuition, and the mathematics means that complex structures are held together by stress in a highly original manner: engineering is married to aesthetics. Snelson himself has described his sculpture as an attempt to reveal the patterns of physical force, those patterns of stress and tension usually of course not visible. The creatures that result, made from a collection of polished metal tubes, held in permanent equi-

66 Kenneth Snelson
Brooklyn Bridge, 1980

As Snelson's extraordinary sculptures
extend in space, so do his panoramic
photographs.

librium by steel cable, are curiously animate, lively, and for all
their vigour, appealingly serene. Snelson has worked exten-
sively on sculpture for outdoors as well as indoors, and some of
his outdoor work occupies a very large space with an airy delicate
presence. He also takes highly unusual panoramic photographs
with an early twentieth-century camera which he carefully
restored himself (Snelson's father was a photographer, and
Snelson himself worked for a while as a motion-picture camera-
man). The panoramic photographs are of streets in Paris,
London and New York, and of his own studio. Snelson is in
control over the process, using a machine he built himself for
printing. Cibachromes and silver prints are his preferred
processes. His expressed wish has been to show everything in
'ultimate detail': to this end, he has photographed well-known
landmarks – the Paris Opéra for instance – and the ordinary
aspects of city life, its streets, anonymous buildings and, in New
York, the bridges. In a panorama, everything has the same
weight, the same importance, there is no central actor, and this is
an interesting correspondence to Snelson's sculpture which
stretches in all directions, each element of intrinsic importance.
Thus Snelson's photography, which of course in appearance is
utterly different from his sculpture, can be interpreted as an

105

investigative tool, related to his artistic concerns. His rare, rotating camera and the images he can extract by using it have an unusually strong three-dimensional quality; silvery tones are the dominant ones in his sculpture, and there is perhaps a correspondence in his use of silver prints; and with Cibachrome he can use colour.

Sculptors such as Henry Moore, and Rodin in his active collaboration with the photographers who came to reproduce his work, use the camera to investigate their own work, to reproduce it, to examine it, and their involvement is an exceedingly practical one. Only they have a subjectively profound understanding of the relationship of their work to light and shadow, what masses, elements, aspects of their sculpture, they wish pointed out in the photograph, and it is for this reason they became so actively involved in photographing their own work. Snelson however photographs in terms of his visual investigation of the world: he does not photograph his work as such, but as part of his work as an artist. Recently his photographs have been exhibited as works in their own right.

There is one curious footnote to the use of photography for and by sculptors in the extraordinary and short-lived phenomenon of photosculpture, a technique used in Paris in the early 1860s by a sculptor called François Willème. A studio was built which enabled the subject – for the purpose of the technique was to make available at reasonable prices portrait sculpture – to be photographed from twenty-four angles simultaneously. Craftsmen then followed the outlines of the silhouettes thus obtained, translating them into a block of clay, and the eventual result was a highly accurate reproduction of the subject in whatever material was chosen for the final sculpture. However, the mechanical aspect of the methods of photosculpture, and the lack of the personal vision implicitly considered indispensable to the production of art, were probably responsible for the demise of photosculpture through lack of support from potential clients. Paradoxically, the eminent portrait photographers of the nineteenth and twentieth centuries are known not only by name, but by their style, and Félix Tournachon Nadar, perhaps the most famous nineteenth-century portrait photographer of them all, who has given us the look of the eminent personalities of France, was of course himself an artist who turned photographer.

4 PHOTOREALISM

Artists become photographers, and photographs begin to inform more and more directly the making of paintings.

Of course, sometimes this has happened in indirect ways. Salvador Dali (b. 1904) is one of the most popular artists of this century; some of his imagery, such as his limp watches, have become part of the shared visual vocabulary. His fame rests partly on his deliberately provocative behaviour and statements, but even more, out of a large production of paintings, drawings, prints, and designs, on the haunting, meticulously executed paintings of his Surrealistic period in the 1930s. Dali described these paintings as 'instantaneous and hand-done colour photography'. It is typical that Dali used illusionist painting techniques in his imaginative, mesmerizing compositions to counterfeit or simulate with a use of sharp overall focus the precision and versimilitude that people expected of photography. The paintings of this period are not big, and while larger certainly than home photography snapshots not too far removed from the double spread of an open book or tabloid newspaper. The scenes and vistas are so vast, and the imagery so potent, that it is a surprise to see how small these paintings are.

Dali did make films with his fellow Spaniard Buñuel; and without feeding his own photographs into his paintings has suggested with his remarks the idea of a photographic vision in painting. This attitude has borne surprising results with a wide variety of painters who use their own photographs as notes, drawings and sketches in the first instance, and who also capitalize on the ubiquity of photography for the spectator response to their paintings. Where once photographers relied on the conventions of painting to authenticate their vision, now painters rely on the idiom of photography to reinforce their paintings. In America particularly, a number of painters – and a few sculptors –have been grouped together under the label Photorealism (the French call it Hyper-realism). Super-

ficially in any event, the paintings of some of these artists look, especially in reproduction, like painted photographs. The works themselves, though, are often replete with surprising ambiguities. The artists themselves, too, are not always sure whether their photographs are working notes, or objects in their own right.

However, photorealism is a group label that identifies a very disparate grouping of artists, almost all American, not all of whom use photographic imagery as their basis for working: the sculptor Duane Hanson, for instance, begins by making moulds of (live) nude models, proceeding to such excruciatingly realistic and lifelike clothed models that it is almost a commonplace in museum and gallery exhibitions for spectators to greet a Duane Hanson sculpture, or acknowledge it as alive before a second later realizing their mistake. Other so-called Photorealist artists, such as Philip Pearlstein, do not work from photographs, their own or others, but from life and from the model. Nor do the special idioms of the photographic vision pervade their work; it is only that Photorealism seemed the most appropriate label to convey the feeling of authentic realism that was such a feature of the new work that began to impinge on the consciousness of the art public in the 1960s. Oddly, the difficulty in defining the movement, which commentators have linked to Abstract, Conceptual, and particularly Pop Art, has led to a host of labels, among which are Hyper-realism, Radical Realism, Super-realism, Sharp-focus Realism, and even Laconic Literalism. For our purposes, the label Photorealism is used to identify those images based on photographs, and even more specifically here photographs taken by the artists themselves. For many 'Photo-realists' who do use photographs use them from a wide variety of sources.

Pop Art is another label covering a complex movement, again primarily in American art, which antedates Photorealism and which gained an initial impetus and creative impulse from work being done in England by such influential artists as Richard Hamilton and Eduardo Paolozzi: indeed the very term Pop Art is generally credited to the English critic Lawrence Alloway, who subsequently, living in New York, has been responsible for a variety of major contemporary exhibitions. As the term implied, Pop could be taken two ways: as art that meant to be popular, or art that took its imagery from popular or common things, from the real world. This led to such diverse expressions as Roy Lichtenstein's huge paintings based on comic strips, James Rosenquist's gigantic paintings of recognizable fragments from

the real world often put together in bizarre juxtapositions, Claes Oldenburg's soft sculptures of items like hamburgers, and Andy Warhol's imagery which is based almost exclusively on photographs. The Photorealists took this habit of incorporating the real world one step further by interposing again, it seemed, one mediator between the spectator and the real world – the photograph.

Photography itself, or rather, the photographic image and way of seeing (indicated in such phrases as Sharp-focus Realism) formed the basis for some characteristic Photorealist work, and recently there have even been exhibitions of the photographs taken by the Photorealist painters. The photographs were used primarily to gather information for paintings, watercolours and prints. Some of these photographs are divided by the artists concerned into grids and otherwise marked with the techniques used by other artists for their sketches before transferring the image into another scale or medium; that is, the artists treat their photographs as drawings.

Robert Cottingham (b. 1935) is an outstanding American Photorealist who worked for some years as an art director in a

67 Robert Cottingham
Lao, 1978
68 Working photograph

Cottingham is an active photographer, who works from photographs – slides and transparencies – which are often radical close-ups of façades of ordinary shops, buildings, or movie theatres, as well as from drawings derived from photographs. (See also opposite p.112.) The final painting does not necessarily resemble one photograph, but will be a subtle, well-designed assemblage using a quantity of visual information first perceived through the artist's camera. The formal and dramatic qualities of Cottingham's paintings are curiously isolated from their subject-matter, except in as much as the commonplace nature of his chosen fragments – the shop signs of all kinds on building façades – is universally understood. The views are fragmented, the original message (to call attention to the contents or services of the building which the signs adorn) shattered. Deliberately or no, his interest in complex form and colour makes the ordinary strange, the familiar exotic, and alerts the spectator to the subtleties of what is all around us, the street furniture and decor we barely notice in real life. Like Estes, Cottingham takes city reality and turns it into his world; he is so successful that it is possible to look at the neon tubing making up building signs and to see a Cottingham rather than the message of any particular sign.

major American advertising agency. A characteristic subject, surprisingly complex, is the neon signs that decorate theatres and other façades. He often takes his photographs with a telephoto lens, and indeed varies the lenses he uses, and then uses the subsequent images as a base. The photographs will often capture what the eye cannot see – especially a detail. Cottingham will capture the scene that interests him, but he is not interested in a wholly literal transcription; even so, much of the basic composition is created when he selects what he wants to photograph.

Some artists, notably Chuck Close and Richard Estes take photographs that stand in their own right, as images unconnected with subsequent paintings, while at the same time they continue to use photographs for painting.

Richard Estes (b. 1935) is almost exclusively concerned with the city scene. He photographs that which he wishes to paint,

69 Richard Estes
Woolworth's

Estes' subject matter is somewhat similar to that of Cottingham's. Yet his treatment of it and its appearance are vastly dissimilar. Estes takes many photographs as a basis, because one photograph does not give him all the information he needs, so his paintings are the synthesis of them all. A complex process of selection and editing has occurred in the metamorphosis from the image revealed in the photographs to the image in the final painting. The paint is typically very tactile, with many variations in the textures and depths of its actual surface and there is an almost overwhelming amount of visual material in an Estes painting, though the effect is one of order and rationality. His paintings actually make the spectator more aware. There is an overall sharp focus, which the eye's binocular vision and the camera's monocular vision are not capable of achieving. Thus Estes' paintings create an illusion of their own, and are built up of a mosaic of sharp fragments brought into a whole by the artist. The fact that he often suggests the activities of a shadowy interior as well as the brilliant glassiness of a bright city day on the streets, is an indication of the many perceptual and conceptual layers of his work.

often from several different angles, extracting what he wants for his finished painting, so that often the painted image is not a transcription of just one photograph but of several. It is almost, in concept, a kind of collage, in which editing has taken place several times: in the initial choice of subject, the varying photographs, and the extraction from these photographs for the painting. Particularly striking and complex are the scenes of glass-fronted buildings and shops, in which we may at times begin to glimpse people, as in the shadowy but monumental figures enclosed in the interior of a restaurant. Estes employs his own photographs as a guide; the painting is naturally on a considerably larger scale than the first photograph or photographs, and the paintings do not reproduce, as some other Photorealist painting does, the utterly smooth surface of a photograph. In fact, Estes' paintings do resemble photographs when seen in reproduction, but are unmistakably divergent in actuality. The subject matter for which Estes is best known has

70 Chuck Close
Linda Pastel, 1977
71 *Chuck Close in his Studio,* 1976

Close is fascinated by the photographic process, yet his art consists of drawings, pastels and paintings, invariably portraits, and often of people he knows very well. He is uncomfortable with the idea of the commissioned portrait, thus the initiative of choice of subject is his,

rather than the subject's. His exceptionally elaborate method of working, indicated by the study of the artist at work, has much in common with the sophisticated procedures of Minimal and Conceptual Art. The arduous nature of the procedure of translating the photographic basis of his portrait studies to another medium (after meticulously accurate measuring), on paper or canvas, makes the means part of the

end. The lengthy, painstaking process becomes all-absorbing. More, the difference in scale and material produces a true metamorphosis of the photograph. Photographic distortions are kept, and often because of the large scale, exaggerated. Thus, Close's art reminds us of the coding and transforming processes involved in any kind of image-making or communication.

been the unglamorous back streets of New York, the humble New York neighbourhoods. Estes' portraits of the city in which he lives have a sensibility in common with earlier photographs, the documentary photographs of New York by such American photographers as Berenice Abbott and Walker Evans, now prized as images which are more than documents. Estes begins his interpretations with photography, and then reinterprets the imagery he finds in the photograph for his paintings: 'I'm not trying to reproduce the photograph. I'm trying to use the photograph to do the painting.'

Chuck Close (b. 1940) is a practitioner of a startling form of Photorealism. His primary subject matter is portraits, which in the final paintings are huge close-ups of the face and sometimes the upper body as well. He specifically instances his use of photographs as sketches and studies, and does not like to be labelled a Photorealist. Yet he deals specifically with photographic idioms, noting that the human eye is very flexible, while the camera gives a 'one-eye' or monocular view of the world. He has welcomed the visual information the photograph provides, and has declared that 'just as many different kinds of paintings can be made from a photograph as from life'. Unlike Richard Estes, who uses traditional methods of painting with a brush, as well as a mixture of acrylic and oil paint, Chuck Close has typically used an airbrush for his paintings. He uses as his base photographs he has taken himself in his studio, the camera about six feet away from his subject, the subjects not in any way artfully posed, but as bland and full frontal as a passport photograph. From 1972, in both paintings and drawings (also large scale), Close has used a grid system and a system of small squares which are readily visible and not smoothed over in the finished work. Indeed, this indication that an image is coded for transfer from photograph to painting and drawing is integral to the work, as is the lack of any overt interpretation of the original photographic portrait other than the leap in scale. A final painting, just head and shoulders, may easily be nine feet high by

E Audrey Flack
 Marilyn, 1977

Flack takes numerous photographs, elements of which are worked into paintings which often rely for their effect on the subtle shock of their subject matter – plastic fragments, mass-produced ornaments, gifts, souvenirs, useless oddments of the 'consumer society'. Meticulous attention is focused by the painter on trashy, vulgar, brashly-coloured objects of all kinds, the ornate and formal arrangements echoing the Western tradition of the still-life: a tradition perfected in the middle-class newly affluent mercantile sections of society in the golden age of Dutch painting, the seventeenth century.

F **Lucas Samaras**
 Photo-Transformation, 1974

G **Robert Cottingham**
 512, 1970
H Working photograph

seven feet wide. In some paintings, in which the grid which is their structure has been obscured, a number in the title indicates the number of separate painted squares. Close has linked himself to the work of Minimal artists, artists whose paintings and other works are severely refined abstractions and reductions with no trace of the real, observed world in the final images. This may seem a paradox in view of his subject matter. But evidently he sees his true subject matter as the actual *process*, of painting and drawing, as 'the distribution of paint on a flat surface' as he has phrased it, perhaps in unconscious imitation of the famous dictum of the French artist Maurice Denis in 1890, already quoted, in which he exhorted his colleagues to remember that before a painting was a scene, an anecdote, as he put it, a 'war horse, a naked woman', the painting was 'essentially a flat surface covered with colours assembled in a certain order'. Denis later vehemently denied that this remark, in a manifesto published as a 'Definition of Neo-traditionism' in Paris, implied any lack of importance for representational subject matter in painting, and he resented its being used as a justification for Abstract Art: he meant rather that subject matter and its realization were of equal importance.

Thus coming full circle, Chuck Close uses a justification of painting for its own sake to discuss his own work, although what in fact gives it much of its considerable impact is his use of something we are all interested in, the human face, as the image which is formed by his careful rendering of light and dark, sometimes in colour which manually imitates colour-separation printing. But he photographs his subjects (including himself) in a deliberately dead-pan manner; he has refused to make portraits

I **David Hockney**
Early Morning, St Maxime, 1968-9

Although Hockney's attitude to photography has changed from time to time (he is unusually and agreeably articulate about his sources and unafraid of inconsistency), several paintings are frank photographic transcriptions. Other photographs were taken as a visual diary, and a photograph taken with no painting in mind might spark off an idea for a painting. Of this painting he has said, 'I took a photograph of the scene and I was so impressed with it that I just painted it like that ... I simply reproduced the photograph, but of course you have to simplify it when you paint it.' And

therein lies, of course, some of the art. But it is fascinating that Hockney has been reported to say that this is his worst painting.

J **Jan Dibbets**
Panorama Dutch Mountain, 1971

Dibbets makes images from photographs, questioning conventional notions of 'reality' by playing on the expectancy of viewers in relation to the authenticity of the photographic image. Typically he uses a series of images – either in separate works on the same theme, or containing within a particular work a sequence of related images – so his work is also richly suggestive of the

passage of time. In his use of a panoramic effect his art also suggests the idea of the viewer scanning the image, and thus he relates his art directly to a human scale and human vision.

These photographs were taken on a Dutch beach, in winter, with a tripod-mounted camera, the angle changing by fifteen degrees of the circle for each photograph. The fact that both artist and viewer, consciously or unconsciously, see what they may wish to see rather than an objective truth is neatly suggested by the title *Dutch Mountain*, for we all know Holland is famous for being flat. By his arrangement of the photographs Dibbets allows us to see the flat seashore 'made' into a Dutch mountain.

of the famous and the well known: his subjects remaining his friends, the titles of the paintings being their first names. The friends are neither outstandingly beautiful nor freakish, although the huge scale has an element of the grotesque. His paintings have been defined as 'portraits of photographs of his subjects – never of the subjects themselves'. His method is to reproduce manually in a painstaking, time-consuming process what could be done with ease mechanically. Thus in a sense he confounds the spectator with the hand-done photograph.

The shock of his work lies partly in the spectator's realization that the artist's concern is not actually with his visible subject – people – but with the photographic image. Thus, these paintings are not about people but about photography. It has been argued that the method of this artist, his interest in say process, in the grid left visible, has much to do with Minimal Art, while the scale of his work, which gives his ordinary subjects status, has something to do with Pop Art, which gave to ordinary things outsize importance. Close's major retrospective exhibition at the Whitney Museum of Modern Art in New York also exhibited, along with paintings and drawings, his outsize Polaroid photographs, photographs in their own right.

This is a development paralleled by other contemporary artists, including perhaps the most famous – or notorious – American artist of his day, Andy Warhol (b.1928). Warhol is widely quoted as a dead-pan commentator on the more superficial mores of an affluent society which takes surface appearance for profound fact. His remark on instant celebrity –everyone can be one for fifteen minutes – captured the public imagination. The group of artists (and others) who have gathered round Warhol, some of whom execute work for him, are known as The Factory, and Warhol himself has said that his paintings and prints are concerned with the 'symbols of the harsh, impersonal products and harsh materialistic objects on which America is built'. He also claims to think that anybody should be capable of doing his paintings. His portraits, on which he has increasingly concentrated, are mechanical silk-screen reproductions of photographs sometimes in single images, often in serial form, like the sequential images from photographic booths, or for more sophisticated photographers, the contact sheets from which images for further reproduction are selected.

Warhol's vividly coloured serial portraits of the famous, the notorious, the rich, are easily recognizable as photographically based; there are other hints of mass-production in the way in which the same image is treated in different colours, as though

the face is rolling off the production line in different colour-ways, like patterned cloth or the bodies of motorcars. You can have Liza Minnelli with a background of scarlet red – or pristine white; and David Hockney against soft pink or tender green; you can have Ethel Scull (a well-known art collector) no less than thirty-six times in one composite portrait, the pose and colour varied. In keeping with Warhol's ethic, it does not much matter who took the photograph he uses. In many instances the photograph comes from already published sources, in particular with celebrities, and the portraits of Jackie Kennedy, Elizabeth Taylor, Marilyn Monroe, and Elvis Presley, to mention a few, are of figures united not only by their fame or even notoriety, but

72 Andy Warhol
Portrait of Ethel Scull, 1963

One of the points about Andy Warhol's Factory – his films, photographs, paintings and prints – is that although everything is attributed to Warhol (only begetter, catalyst, inspiration, author), various people have been involved in their creation in a loose association almost impossible to categorize.

Portraits are the major motif in Warhol's work, and their photographic source is always evident. The portraits may be of myths – Elvis, Marilyn, Mao – or of real people known to the artist, his friends. Thus this portrait, based on the multiple exposures obtainable in an automatic photo-booth, is in a sense a typical, ironic, dead-pan Warhol collaboration. For these are auto-portraits of Ethel Scull, a leading New York art

collector and hostess, which have been alchemically metamorphosised into a portrait inimitably Warhol. Even Warhol's published photographs are not necessarily taken by him, but the impulse is unmistakeably his.

also curiously perhaps by the public tragedies of their private lives. These people are known to a huge worldwide public through the media, through photography and films: thus the photograph, or repeated image, may even be viewed as a still from a film. The garish poster-colours Warhol favours emphasize the artificiality of the second-hand image: we know these people, or feel we do, because their images are endlessly reproduced. Using a reproductive process is a double or triple take in which Warhol imitates the crudeness of the original reproduction, certainly as reflected in newspapers and magazines. Publicity and newspaper photographs formed the basis of many of his portraits; those of Marilyn Monroe, for instance, are based on a publicity still from the film company Twentieth Century Fox. Warhol is also a photographer himself, and a book of his photographs, simply called *Andy Warhol's Exposures*, announced that he wished to take the right people at the wrong time, to be in the right place at the wrong time: his subjects were always celebrities although not necessarily in their own right (that is they were celebrated not because of their own achievements, but because of proximity to achievement). Warhol uses photographs for his paintings as well as the prints which are simply scaled-up silk-screen reproductions of photographs; he seems indifferent to the source of the photograph being used, whether it is a found photograph, a photograph he has asked for from one of his portrait subjects, or a photograph he has taken himself. Because of this indifference to the photographic source,

73 Andy Warhol
Bianca Jagger at Halston's House, New York

Warhol's *Exposures*, a book of his comments, gossip and photographs, is highly expressive of his view: 'a good picture is one that's in focus and of a famous person doing something unfamous. It's being in the right place at the wrong time.' Bianca may be shaving her armpit, for example, or she may be posing, but she is famous for being famous – so famous people may now be famous for being around Bianca. Warhol's photographs, whether taken or inspired by him, illustrate well the social milieu, the entourage, and the environment of the 'instant celebrity' he has made famous. The people in *Exposures* are well known for being well known, or are people of genuine achievement, all mixed together in a kind of social group.

116

the source is usually not documented. Whether indeed Warhol himself or a member of his entourage, The Factory, took the photographs credited to Warhol in the book of his photographs and in the exhibitions that have been held of his photographs as photographs (and not as paintings or prints) is also not clear. The main difference between Warhol paintings, prints and photographs is that the last are black and white conventional photographs which have their subjects in social situations, at each other's houses, in clubs or aeroplanes, at fashion shows or parties, while the portraits (paintings and prints) of people usually set the subject in limbo against a brilliantly coloured or white plain background. Also the Warhol photographs – not the paintings and prints – are often painfully candid.

The Yorkshire-born British artist David Hockney (b. 1937) figures, finger in mouth, in one of Warhol's portraits (1974) and his expression – enquiring, mildly curious, a look of innocent sophistication – almost triumphs over Warhol's deliberate cultivation of the bland. Hockney is a versatile and highly engaging artist, as well known for his theatrical designs, prints and drawings as for his paintings. Hockney's art is exceptionally appealing, in part because it incorporates much of the way he lives – a gregarious travelling man, intermittently attached to France, to California, to New York. As a travelling man, he has taken to the camera, probably in the beginning just as a tourist might.

He bought his first 'good' camera in 1967, and started to take photographs of things he might want to use in paintings, in California. He has shown his photographs as part of working processes: a typical Hockney photograph, a gentle witty tease, is a photograph of a table bearing fruit, as well as Hockney's drawing of the fruit he has carefully arranged for the still-life drawing – and the photograph: so the photograph is of both a Hockney drawing and its subject. By the beginning of the 1980s Hockney self-confessedly had something like 150 big albums of his own photographs, although he also has several times in interviews described how 'thin' he finds the photographic medium.

He does not project photographs he has taken on to the canvas, unlike the techniques of many of the Photorealists, but rather draws from them freehand. Only very occasionally has he transcribed a photographic image, most apparently in a series of paintings of the late 1960s for which he drew from photographs: *Early Morning, Sainte Maxime* is one, with a rather hectic colour scheme, and *Scholl* another. He has publicly discussed his

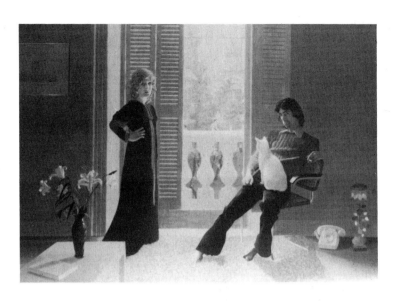

74 David Hockney
Mr and Mrs Clark and Percy, 1970-1

Hockney paints biography, autobiography, and fantasy. He has created a marvellous series of double portraits of his friends – like this painting, which is also a summary of Hockney's working methods. It is painted from photographs, posed and otherwise, and drawings from life. In the final painting (several poses and atmospheres had been experimented with and discarded) one of Hockney's own prints hangs on the wall, from a series called *The Rake's Progress*. Ossie Clark was a fashion designer for Quorum; Celia Birtwell, his wife, a textile designer; and Percy was their cat.

uncertainty about the result when he more or less simply transcribed his photography, a procedure quite different from using photographs as aids. This uncertainty may stem from the fact that, again unlike many of the Photorealists, Hockney may normally photograph as an aid, but not compose his photograph with an eventual painting in mind which will faithfully echo the main elements of the photographed subject as an entirety. Hockney's own photographs, however, exhibit very often the same kind of intelligent, gently sardonic charm as his paintings. What Hockney is critical of is using photographs instead of looking directly at the observable world. He has described photography as an 'interesting art' but indicated that it can all too easily be misused, either by being relied upon too much, or by replacing entirely direct observation. As a polemical artist who has led, through the medium of articles and interviews, something of a crusade for the crucial importance of drawing from life as an integral part of art training, Hockney has tended to play down the use of photographs in his work. He does in fact rely much more on drawing, and has only rarely based a painting exclusively on

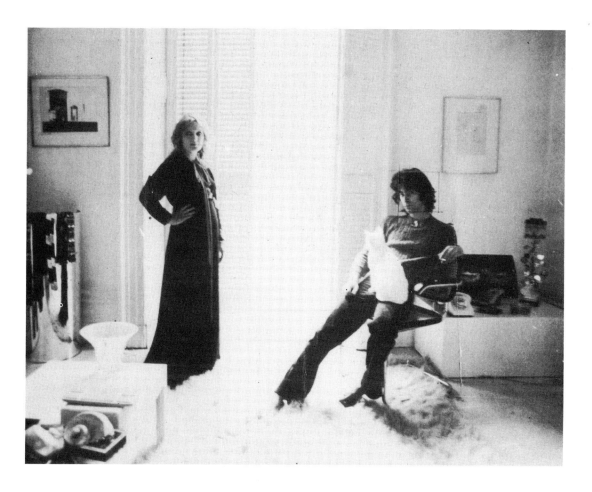

75 David Hockney
 Working photograph for *Mr and
 Mrs Clark and Percy*

photographs. But there are probably very few subjects in his
work, at least contemporary subjects, that he has not taken
photographs of, and probably subsequently used some photo-
graphic elements as drawings for the finished paintings. Normal-
ly photography is an active part of his working process: for
instance, for *Mr and Mrs Clark and Percy,* a double portrait by
Hockney and one of the most popular paintings at the Tate
Gallery in London, he posed his friends in various ways, and took
numerous photographs in black and white and colour, as well as
doing many drawings, of details and whole compositions, before
executing the painting.

Interestingly, the Tate possesses some of the drawings for and
related to the painting in its main collection, and owns a number
too of the related photographs, which are, however, not

119

considered as images in their own right but are part of the Tate's archives. Hockney has used photographs for his work, including many Polaroid photographs, for a considerable period, and has documented the process. However, the hand-done remains of paramount importance as a concept for him, and the use of drawing is crucial: as he remarked in 1974, describing himself as an amateur photographer, 'if the art of drawing is going to disappear completely one day, all representation of an image will end up as primitivism or photography.'

Hockney moved from an imaginative, witty fantasy to a kind of art which in reproduction often did look very photographic in origin; with his theatrical designs and his new paintings of the 1980s he is moving back to credible fantasy, while at the same time he keeps on drawing continually – and photographing. He has not been shy about describing his working processes and many films have been made showing him at work. Thus it is clearer with Hockney than with many what he thinks of photography and its uses. Andy Warhol, on the other hand, who has exploited to brilliantly in his paintings the photographic idioms and printing techniques, as well as having exhibitions of his own photography, ironically plays on the audience's desire for the artist by mystifying his chroniclers as to what he himself has actually done: the whole concept of The Factory, the entourage, the collaborators, obscures Warhol's own role as direct physical maker although he is the indisputable catalyst and inspiration. However, the vast majority of his prints and paintings have a photographic base; his casual treatment of his chosen 'stars' of past and present of whom he makes portraits is precisely what our age deserves.

Robert Rauschenberg (b. 1925) is a vigorous polymath and iconoclast, who has been a liberating influence in American art. He is an assembler and incorporator. He and Jasper Johns lived and worked in the same building in downtown New York for a number of years, a mutual support society although the appearance of their art is very different. Rauschenberg declared in 1959 that he found a pair of socks no less suitable to make a painting than wood, nails, turpentine, oil, and fabric. Many of his so-called 'combine' paintings and/or sculptures incorporate a host of real objects: *Monogram*, a free-standing combine (1955-9), one of the most famous of his works, uses as its central figure a real stuffed Angora goat that Rauschenberg found in a shop in New York. Rauschenberg's art exhibits a strange intense feeling for collaboration: collaboration with friends, colleagues (he has designed extensively for, and even performed with, Merce

Cunningham's dance troupe; was a seminal member of EAT, Experiments in Art and Technology, an organization of artists and scientists that sought collaborations between science, technology and art (1966); and often participated in Events and Happenings), and, it may seem, collaboration with inanimate objects. Thus it may come as no surprise to discover that Rauschenberg's earliest visual interest incorporated photography, in which we may view the real world as collaborator.

Rauschenberg began taking photographs at Black Mountain College, and photographs by him were his first works ever to be acquired by a museum, the Museum of Modern Art, in 1952. He also uses photographs in other ways: early works include the kind of direct photograph much favoured by the experimental photographers of the 1920s and 1930s, taken perhaps a step further: the *Female Figure (Blueprint)*, about 1949, was made with his wife, and was a fascinating version of the monotype. A naked woman lay down on a big piece, more than enough to incorporate her whole body, of blueprint paper; a sun lamp shone down; and when the paper was printed (developed) what remained was an impression of the female figure. These blueprints were shown in an exhibition called 'Abstraction in Photography', at the Museum of Modern Art (1951),but only one survives, Rauschenberg having destroyed the rest. In the 1960s Rauschenberg embarked on an elaborate series of prints – in many respects he is one of the most advanced print-makers, in terms of possible technology, the size of prints and materials used, of the whole modern period – and paintings (really distinguished from the prints in terms of the use of canvas and paint) which incorporated silk-screened photographic images. The photographs, fragmentary or whole, are of recognizable scenes and people, but Rauschenberg has deliberately turned his back on narrative or story telling: there is no plot in his images, rather he sees the spectator as making up, by free association, whatever story he wants. His own most famous and often quoted remark is that 'Painting relates to both art and life. Neither can be made. I try to act in the gap between the two.'

Rauschenberg has instinctively reacted to the age of information and the age of affluence by using on a very grand scale the techniques already invented earlier this century, of assemblage, collage, and montage. Again in his paintings and prints the authorship of the material he uses has not seemed important. He may or may not incorporate his own photographs. For a big series of prints, *Stoned Moon*, which was inspired by Rauschenberg's visit to Cape Kennedy for the first manned moon launchings

121

76 Robert Rauschenberg
Visual Autobiography, 1968

Rauschenberg was commissioned by
Broadside Art (an organization which
wanted to make billboard techniques
available to artists for 'visual journal-
ism') and he used text and photographs
from various sources to make a visual
autobiography. The result was three
lithographs which both obliquely and
directly comment on Rauschenberg's
life and times, and are also microcosms
of his techniques of creative assemb-
lage.

(1969), quantities of visual material including photographs were
supplied by the space agency, NASA.

His only self-portrait appears in the guise of a photograph,
which in turn is incorporated into a work called *Untitled (Self-
Portrait)* of 1965, which is a collage, with direct and transfer
drawing. Detailing Rauschenberg's many different ways of
working and using a variety of materials in an unusually varied
manner indicates that photography is but one medium among
many for him. He has varied the use of the concept of the real
to imply not verisimilitude nor imitation of the real world, nor a
photographic vision which implies that that which we see really
has existed, but rather an incorporation into art of fragments of
the real world – from rubbish to newspaper photographs. This
carries out on a scale more adventurous in physical scope, yet
curiously lacking in satirical edge, that which was initiated by
the Dadaists forty years before Rauschenberg got to work.

His own straight photographs are rarely exhibited indepen-
dently but in 1980-1 a series of international exhibitions herald-
ed a new interest in his own photographs. Those from the
earliest period are the strangest, and were the product, as
Rauschenberg said, of a conflict between curiosity and timidity.

The use of the camera allowed him to stare, to be legitimately curious; also at this period he had not chosen between photography and painting. His later spate of photographs for their own sake (1978-80) was an expansion of his attitude to the real world, where he seems almost to compose his photographs in a Photorealist manner, although not for use in paintings. In between, his own photographs appeared occasionally in his paintings and prints, and were almost exclusively bland photographs of New York, neutral in appearance, often taken from his New York studio window.

The British artist Richard Hamilton (b.1922) is, like Robert Rauschenberg, fascinated by the incorporation of the 'real' world into art, but the 'real' world as already interpreted by the media: the way the camera sees, the way we receive information, the idea of popular culture, and the possibilities for art. Like Rauschenberg he is also a master technician, and has experimented with a large number of print-making methods. Richard Hamilton was a pioneer of English Pop Art, a development which has been almost smothered in many textbook histories because of the later dominance of American Pop. The situation is further confused because English Pop Art, which created a host of images both ironic and admiring, took much from American popular culture in the immediate post-war period, when America seemed to represent some kind of apotheosis not only of the consumer dream of consumer goods but a new, vibrant society in contrast to fatigued, war-worn and cynical Europe. A characteristic of both American and English Pop Art is the use of the collage; a characteristic (not exclusive) of collage is the use of the photograph, and perhaps one of the most potent of collages is Richard Hamilton's *Just What is it that Makes Today's Homes so Different, so Appealing*, which was made to act as poster and for the catalogue of the influential exhibition 'This is Tomorrow', 1956. Held at the Whitechapel Gallery, London, it was a show devised by a number of artists and architects who had linked together in the Independent Group at the Institute of Contemporary Arts.

Richard Hamilton has himself defined the kind of attitude that allows him to embrace with enthusiastic interest and verve the entire repertoire of visual imagery as his material: 'Fine art is the medium in which I work; the mass media is often the content of the painting.'

The mass media often means of course the photographic image, and Hamilton has used a huge range of photographic sources, which are often double-edged, as when the subject of the

77 Richard Hamilton
Cosmetic Series, 1969

Hamilton is one of the most intelligent, aware, and omnivorous artists of our times, whose enormous contribution has been, among other things, to seize on all the possibilities of using the media, of the actual techniques offered by modern printing processes and, in part, to make these the subject of his art. He is absorbed by processes: the processing and coding of information, the clichés and idioms of advertising, the way information is given by newspapers, the need to present images, the imagery of postcards, and the use of photographs. In the *Cosmetic Series,* the idea of glamour is explored in ways which firmly indicate the artificial nature of the product, the stage setting being the photographer's studio in which the elements of the product – the idea of glamour – are brought together to be projected by means of photography. Photographic collage is used elegantly to indicate the fragments that are being brought together.

124

photograph is a celebrity, especially a celebrity known to the public through a photographic or filmic image, as was the case with Marilyn Monroe in a series of works called *My Marilyn*, based on a group of photographs with marking on them made by Monroe herself in terms of approval and disapproval; and Bing Crosby in *I'm Dreaming of a White Christmas*, based on a still from the film *White Christmas*. Many of Hamilton's prints have as their basis, before further and complex manipulation through printing processes, a photographic postcard, itself already a photograph. Hamilton has been fascinated by the use of Polaroid photography as well, first coming across a Polaroid camera in the hands of the American artist Roy Lichtenstein. His own acquisition of a Polaroid encouraged him to ask as many of his artist friends as possible to take photographs of him, a rather unusual case of collaboration between artist and camera. Hamilton thought that the resultant Polaroid image would not be stamped with the sensibility of the photographer, but was surprised to find, for example, that in Francis Bacon's case the image came out with a marked semblance in Hamilton's eyes of Bacon's painting. Using the Polaroid taken by Bacon of Hamilton, Hamilton then made a print, called *A Portrait of the Artist by Francis Bacon*.

The involvement of Hamilton with photography and photographic processes has been rich and complex as he is fascinated by the processes through which visual and cultural information reach the spectator. In certain instances his own photographs have been exhibited with little intervention or manipulation; in other instances he has manipulated and used photographs from a wide variety of published sources, from postcards to periodicals.

The paintings of Francis Bacon may hardly seem, with their masterly use of the blurred figure, and their well-known re-invigoration of motifs from other artists – Velazquez' masterpiece, the portrait of Pope Innocent X, being one such source – to qualify for a label like Photorealism. Indeed, Bacon's work is energetic, despairing, vigorous, and highly emotional, dependent often on brilliant colour, and occasionally heavy textures. Above all its substantial impact is intertwined with notions of the interior life of the emotions, emotions which colour our apprehension of the objective world. As, somehow, we disassociate, no doubt incorrectly, the idea of photography from the idea of rampant, dominant subjectivity, the expressive emotion of Bacon's art seems far from the notions of Photorealism.

And yet there is a connection. Those famous paintings based on Velasquez' portrait were based on reproductions; Bacon has

not attempted to see the original. With the mouth open, apparently in a soundless scream, it is based in part on a still of a screaming woman from Eisenstein's film, *Battleship Potemkin*. And Bacon's work is permeated by photography. He has said that he is always haunted by photographs: as points of reference, as 'triggers for ideas'. And he has worked extensively from photographs of many kinds, including series of highly analytical photographs, from Muybridge's studies of people in motion, to a technical book which describes in text and photograph the positioning of the body for the taking of X-rays, the latter a neat metaphor for those who think of Bacon's own art as an X-ray of just those emotions so often hidden from sight.

Bacon has worked from photographs of his own work. A famous early painting of his, *Figure in a Landscape*, was based on a snapshot of a man sitting on a park bench. And there is another direct connection: when doing portraits of people he knows, Bacon has not taken photographs himself, but commissioned the taking of photographs of the subject to work from. These photographs themselves become part of the studio, worn, trampled upon, crumpled. He has stated that he prefers to work on the portraits of people he knows, from two sources: his memory, and photographs. Thus he engages in the process of dissolution and redefinition. The mutilation necessary for the dissolution that precedes redefinition is something Bacon prefers not to practise in front of the live subject. Some of the most telling photographs of Bacon himself which have been published are those he took of himself in the automatic photo-booths to be found anywhere. These photographs too have been added to the detritus of his studio, which evidently is in its collection of items – books, photographs, things the artist is interested in – like a combination of compost heap and garden soil, from which anything may be extracted to act as catalyst or inspiration. Among this rich, apparently partly arbitrary collection, are photographs, of which some have been commissioned and a few taken by the artist. But most come from many other sources. Bacon has himself described his acutely personal painting, speaking perhaps of his view of painting in general, as well as his own art, as 'the pattern of one's own nervous system being projected on the canvas'. But photography – his own, and others – informs his painting to a marked degree.

Artists involved with the use of the photographed image may, as we have seen, use photographs from a multitude of sources or take their own. One of the most successful of contemporary German artists, Gerhard Richter (b. 1932), does both, and is a

fascinating figure as he draws on several conventions, sometimes simultaneously. The photograph, Richter declared at the beginning of the 1960s, took him by surprise, and he decided that the photograph had neither style nor composition and it made no judgements. The photograph, he maintained, was pure image, and reversing at least in words the normal procedure, he found that he wanted to use painting as a vehicle for photography, rather than photography as an aid for painting. In other words, he wanted to make photographs through the techniques of painting, aiming presumably for that kind of neutrality which he had indicated he had found in photography. It seems in retrospect a curiously naïve springboard, photography's supposed neutrality, as photography's striking subjectivity becomes more and more apparent. Neutrality seems confused with familiarity, with taking something for granted, which is what we all do with the photographic image, in a way still not possible with the hand-done quality of most paintings (both Op and Pop Art contained in part some of the possibility for shocking spectators not just because their subject matter – optical illusion, trickery, magic and pattern on the one hand, and material from popular culture on the other – but because of a deliberate and highly successful attempt to disguise in individually created paintings the hand-done look).

Richter's early technical experiences – he worked as both a commercial artist and a photography technician – certainly seem applicable to his painting career which has been unusually productive and active. He had his first public exhibition in Düsseldorf in 1963 – in fact a piece of public performance, Richter as a 'living scupture', which took place in a department store, and was called *Demonstration for Capitalist Realism*. He had been a poster artist, and studied extensively at the Dresden Academy of Art, before moving to West Germany and continuing to study. He began making black and white paintings, the imagery of which was similar to that of blurred photographs, in 1962, during the period he was studying at the Düsseldorf Academy of Art, where he later became professor. Richter has been described as exploring the emotionless objectivity of the photograph in his paintings; certainly the smooth surface of his paintings, his immaculate, unobtrusive techniques lead the spectator to acquiesce in this 'objectivity'. Richter's declared subject (among several) has been the photograph and the way in which photographs transcribe observed reality: he has been as interested in blurs, close-ups, and objects out of focus – in the amateur mishaps of photographic transcription – as in the sharply focused image often

127

typical of a competently executed photograph. Richter has for his work customarily assembled a good deal of visual source material, about which he does not seem to differentiate in any hierarchy of values or worth. Thus, for his paintings that are about and from photographs, his source material has included a large proportion of 'found' photographs – press photographs, advertising, postcards, reproductions, photographic portraits from the past – as well as his own photographs, in particular photographs in colour of landscapes.

While Gerhard Richter has argued with ambiguous ambivalent sophistication that he wanted a painting to be a photograph, the diverse group of artists, mostly American, categorized together as Super-realists exhibit a complex attitude to photography. Several significant figures, such as a Malcolm Morley (b. 1931), the British artist who has lived in America since the 1950s, treat found photographs as motifs, doggedly copying small sections one by one, in a way in which the system and process used by the artist become the paramount concern, rather than the resultant image. Time and again artists who worked with photographs as their sketches, or drawings, either working from the photograph or projecting slides on to the canvas, and typically using an air brush so as to avoid the hand-done look of individual brush strokes, disclaimed any kind of social comment in their choice of imagery.

A small but significant number of Photorealists used found photographs, but most, several of whom we have already discussed, either used their own photographs from the beginning of their work with photographs, or came to do so.

Thus Audrey Flack (b. 1931) has used news photographs, but having turned to Photorealism to make accessible imagery – accessible to the public that is – recognizable, she has also taken to composing with her camera, in particular striking still-lifes made from ordinary, trivial, even vulgar oddments and ornaments, costume jewellery and the like.

Robert Bechtle (b. 1932) began his career as an abstract painter – and Photorealism has several potent elements of reaction in its make up, one certainly being a reaction to the prevalent mood of critical, intellectual and establishment approval for the New York School's dominant idiom of Abstract Expressionism, an emotional even metaphysical mode of abstraction, in which feeling, and the use of the gesture, were paramount. A number of painters, liberated from allegiance to abstraction by the new choices of acceptable subject matter opened up by Pop artists, turned to Photorealism.

78 Robert Bechtle
60 Chevies, 1971

Bechtle is absorbed by the most American object of all – the automobile. Typically the scene will be set in suburbia.

Bechtle takes his own photographs, and does not want them to look too professional, completing their look in his paintings, which are concerned with what he knows, a California middle-class life. He edits as he takes his photographs, beginning the process of composition at that point.

Tom Blackwell (b. 1938) was also at first an Abstract Expressionist painter, and his particular subject after his change of direction has been car and motorcycle engines, whole machines, and occasionally city scenes. John Salt (b. 1937), another expatriate Englishman, is devoted to car wrecks and car parks full of abandoned, used cars, and he too takes his own photographs so as to avoid the gloss and competence of the professional photograph; and he paints cars because in America they are so dominant. Ralph Goings (b. 1928), who has painted both in California and on the East Coast, paints the life around him, and his eagerness is to render into paint from photographs,(his own), the rich yet somehow random order of the environments he observes, an order dictated by time so that the way in which things and people are placed – in a fast-food diner, for instance – is for functional rather than aesthetic reasons. He is equally casual in taking his photographs, which are his working sources. Many of the Photorealists point out that to paint directly from the scene they want, from the life, would be too complicated: there is simply too much visual information in

129

79 Ralph Goings
One Eleven Diner, 1977

'Realism', derived from photographs, is the realism of the objects of ordinary life.

the scenes of modern life, much of which may be ignored by the casual glance, yet is of course captured by the camera.

Don Eddy (b. 1944), like Richard Estes, works from his own photographs for city scenes, and often from more than one at a time: Estes' photographs will be concerned with one scene, but Eddy may take many photographs for one image which will then be a composite scene. He uses black and white photographs, which he develops himself; colour comes later as he works on the painting, and evolves from his feelings about the painting itself. His own photographs are his working tools. He would undoubtedly agree with Estes in terms of working practice. Neither of them reproduces photographs but uses them as working drawings – as source material, and as if they were working from the life – and they edit, reinforce and change emphasis as the painting seems to need to evolve.

Many of the Photorealists are primarily concerned with objects, with the plethora of material culture that has evolved in the modern world. What better way to collect as much information as possible about city scenes, manufactured objects, than through photographs, beginning the process of depiction through the exercise of choice, however casual, as they aim the viewfinders of their cameras?

Photographic inspiration for paintings has also consciously been used to help persuade people to look at 'art'; because

80 Don Eddy
Glassware I, 1978

Working with reflections has been one
of the more interesting aspects of
twentieth-century Realism, a reflection
of the shiny surfaces – glass, metal,
chrome, mirrors – characteristic of
modern consumer goods and glass
buildings typical of big city architecture.
It is also an interesting echo of the
interest in reflections of the Western
tradition of the still-life – where cutlery,
glass, and domestic implements are
often exploited for their reflections, to
animate the composition – and of the
use of mirrors in self-portraits. Here we
have the idea of the reflection carried to
an almost overwhelming degree. The
profusion of the goods, in this case
glassware, so obviously ranked and
arranged for display, for sale, is also a
pattern of the affluent society. This
painting is a resonant example of Eddy's
work. Silverware, too, has provided him
with just as richly reflective and dazzling
subject matter. In published interviews,
Eddy has chosen to distance himself
from his subject matter, but it is
difficult to believe the choice is as
arbitrary as he has indicated.

photographs are so familiar, several artists who use them have
felt that what they do is clearer to their public because of the
photographic sources.

However, those artists who have declared that they avoid art history by this change of traditional subject matter, and the conscious and undisguised use of photographic imagery, have a genial saboteur in their midst. The Photorealist John Clem Clarke (b. 1937) arranges his friends in poses reminiscent of Old Master paintings, photographs the resultant tableau, and eventually translates the whole into painting.

Two things are strikingly apparent in looking at the work of artists called Photorealists. If reproductions of paintings, and the photographs which have provided the source, are published, both photograph and painting look similar. But in reality, their appearance is very different. Most of the painters, who begin an editing process with a photograph itself, continue it in the painting, which may be a composite scene, and is certainly an edited one, consciously or not. And texture and incident are not wholly avoidable. The scale of course is often very different. Some of the unexpected appearance of some Photorealist painting is the sheer gigantic scale, life size or more at times: in any event, the scale is always larger, and usually much, much larger than the orginal source material. That so many Photorealist painters – the majority – take their own photographs confirms the fact that editing and choice, control from the beginning of the process, are part of their work practice. What the paintings share with their photographic sources, and what reveals those sources, are the sharp focus; the wealth of detail; and upon occasion the kind of accident, mistake, blurring, chemical incident, that is part of the photographic process.

Charles Sheeler, the American painter and photographer, who deployed the influence of photography for creative use in his painting, always considered himself first and foremost a painter, although he was a professional photographer who used his photographic work not only for his paintings, but in its own right to support himself. Sheeler made a distinction between his painting and photography that is important still for the artists who use their own photographs as source material for their paintings. Photographs 'take' the reality perceived through the camera lens: editing may come later. The painter already has at his disposal, faced with the blank surface on which he will build, the redisposal and disposition of the elements he wishes to use for his composition. This is clear with the Photorealists, whose work seems superficially to preclude both style and choice. However, the choice of subject matter – mundane life, in the main – is as crucial as the determination of the Impressionists to choose ordinary life and even suburban scenes for the subject

matter of their painting. Realism in art and the depiction of ordinary scenes (not simply genre or anecdote, a story, but some kind of reality) is a movement which has paralleled the growth of photography.

Several of the Photorealists have announced they wished their painting to be accessible, and many have wanted to use the photographic idiom because it is both pervasive and convenient. However, the movement is far more artful than is commonly supposed, and choice and selection as well as painstaking technique are integral to its success. A significant number of its practitioners – whose practices and attitudes are different and who share only the use of photographs as a highly visible source for the material and appearance of their paintings – turned from using found photographs to taking their own.

In Britain there have been some curious variants among artists using their own photographs for their work. A loosely organized group of English artists, called the Ruralists, have produced a fascinating variant on Photorealism. The Ruralists, as their name implies, tend to take as their subject matter British country life, with an emphasis on themes which range from Shakespeare to a fascination with heroes (a very Victorian preoccupation) and the Alice in Wonderland view of Lewis Carroll. Several of the Ruralists are ardent photographers which they have no difficulty in reconciling with their ultimately romantic view of art, the search in the rendering of the observed world for some meaning and emotion beyond what is first seen. The Ruralists have repudiated the idea that they are nostalgic. But their great interest in Victorian art and design includes Victorian photography. Graham Ovenden not only takes photographs but has written extensively on nineteenth-century photography, and David Inshaw is an active photographer. In the collages of Graham Arnold, another member of the group, Victorian photographs are sometimes used, but Inshaw and Ovenden can find through their own photography a brooding quality that is shared by their work in other media. Their paintings and drawings do not look photographic, but share an attention to subject matter – the countryside, people in the countryside – and a curiously highly charged sense of strong emotion. The photographs are complementary to their work in other media, and are sometimes used as sources.

As we have seen, Hockney is an insatiable photographer, but relatively few of his paintings are created straight from photographs and very few of his paintings look like transcribed photographs. However among the reasons spectators may feel so

81 Brendan Neiland
Skylight, 1981
82 Working photograph

Brendan Neiland is an English artist
whose subject is the city scene of parked
automobiles and glassy skyscrapers. He
has always taken many working photo-
graphs, from which fragments are util-
ized for the final image, an air-brushed
painting, or an artist's print. Reflections,
atmosphere, light are his subjects; his
early paintings appeared purely abstract,
but once the spectator was given the
clue that the subject was fragments of
the reflective, brightly coloured, metal
bodies of cars, the image was recogniz-
able. He is a painter who sensitizes the
spectator to the environment. With a
touch of lyrical irony, the grids of his
buildings recall the grid used by artists
as a technique for transferring an image
from drawing to painting.

at ease with Hockney's work are the gaiety and wit of his
paintings and an unusual marriage of fine art and photographic
conventions.

The British painter Brendan Neiland (b. 1941) also uses
photographs, his own, for his paintings, which are exclusively
about fragments of the city environment. His early work was
concerned with the reflections in the shiny painted surfaces of
cars; his later work has been concerned with the ubiquitous
glassy buildings that are such a feature of modern cities. Unlike
Estes and other Photorealists he is unconcerned with the detail
of people, domestic and commercial clutter. His concerns are
with colour and light, and much of his work can be read with ease
in abstract terms, in which the markings on buildings are seen as
grids supporting a complex surface in which a sense of the bustle
of city life is caught; in his early paintings one might even need a

Boyd and Evans
83 *Crumpled Car, Nebraska. 7.7.78*
84 *Monticello, Florida. 8.4.78*

Photographic sources, used as the compositional basis of paintings in a highly sophisticated and seamless system of collage, have been characteristic of Boyd and Evans' work. (Incidentally, a fascinating echo of the nineteenth-century 'art' photographer, Henry Peach Robinson's practice of printing up tableaux from different negatives to make one composition.) A surreal yet lyrical character, an odd nostalgia, and an element of narrative may all be found in Boyd and Evans' compelling paintings. It is only recently that they have turned to exhibiting photographs in their own right, in particular as the result of a lengthy visit to America during which they travelled widely. The same ability to find the strange in the ordinary has surfaced in these photographs, yet without any overt tendency to distort – the strange is presented in a straightforward manner. Boyd and Evans have an uncanny ability to find compelling compositions and a sense of 'otherness', of something odd, strange, and haunting, in perfectly ordinary scenes, and are among the few artists or photographers to work effectively with colour.

clue to the subject matter to read the paintings as representational. Reflections are transient; thus Brendan Neiland uses his camera to record both colour and form, to use as reference. Knighton Hosking (b. 1944), another gifted British painter, creates images which look abstract, but he too uses photographs in an unusually imaginative way, producing semi-abstract landscapes in which forms appear in a mysterious atmosphere, and in which surprising textures and muted silvery colours attract the spectator. He uses a photographic source which he refines again and again, so that the source is partially buried in the accretions of the work itself. Finally, to show the range of work that is produced, there are the paintings and photographs of Fionnuala Boyd (b. 1944) and Leslie Evans (b. 1945), husband and wife who have worked together since 1968. They take photographs for their paintings; the elements are then arranged into a gently surreal scene which has a particular conviction due to the photographic conventions it imitates. Recently Boyd and Evans, especially after a lengthy trip to America, have been taking photographs and exhibiting them in their own right, and life in a sense has come to resemble art. For the photographs in their singularity have come to look like the subject matter of Boyd and Evans, paintings which are often composed from several elements.

These individual British applications of artists' photographs for paintings seem unified by a gently surreal touch, and a lyrical softness, even mystery, which makes for paintings very different in appearance to the glossier, harder concern of much American painting with the materiality and immediacy of the tangible world.

Photography in its complex relationship with other methods of image-making has insinuated itself into the look of painting, but nowhere perhaps has the relationship been more openly proclaimed between one medium and another than in the work of artists who not only use their own photographs as sources for their painting, but in some instances have found it suggested that the subject of Photorealism in painting is the photograph itself, or photographic vision. However it is clear that the varieties of approach transcend any common technique. As photography once tried to imitate painting, so painting has in some respects absorbed photographic idioms.

5 THE MEDIUM IS THE PHOTOGRAPH

The practice of photography is nearly universal now, the photographic image ubiquitous, its convenience indisputable. The aspects of the medium: its accessibility, its implicit authenticity, and the ease of its use, have led to some curious and interesting expansions of its role in the hands of avant-garde artists.

In the early 1960s, new ways for artists using photography began to evolve. A body of work began to grow up which was perhaps misleadingly labelled Conceptual Art. What began to matter was not so much the actual work, but the idea it embodied. (All art of course by definition embodies an idea; but for many artists working in the affluent sixties, surrounded by advertising and other seductive imagery of all kinds, a kind of rigorous puritanism intervened where they became, it seemed, more interested in the expression of an idea than in the attractiveness, aesthetic worth, physical presence of that expression.) Conceptual Art was seen by some of its practitioners as political, as embodying a stance against exploitative art galleries, art as commodity, as objects that were bought and sold. Needless to say, Conceptual artists did make things that were shown in galleries, and bought and sold.

However, this attitude of mind did produce two other ways of thinking about and making art that had consequences for artists using photography. One was the increased analytical and critical attitude towards society, and towards the role of art in society, and the other the analysis of the means of communication in visual terms. The latter is paralleled in academic circles and universities by the studies of linguistics, structuralist philosophy and other disciplines which attempt to analyse dispassionately the way very emotive parts of human culture such as language are put together and work. Photographic language itself is analysed, but often by people who are labelled artists, and photographs taken by people labelled artists are often used to form visual essays

which are then displayed in art galleries and sometimes published as books. As we can see, the connections between a critical analysis of society, say, or a specialized segment of it such as the art world, are not very far away from a critical analysis of communication, the structure of language, and the use of photography. The impulse for these visual activities did, however, come in the main from the art world, which also used the conventions of documentary photography in new ways.

At the same time as Conceptual Art seemed to imply some criticism of the idea of art as commodity, meanwhile managing to fit very nicely in the system it was criticizing, another body of artists was making great sculptures and manipulating landscape in the wilderness, and the kind of art they were engaged in rapidly became labelled Land Art, or Earth Art. The materials used were real: that is stones, dirt, wood, earth, as found in real places. Sometimes real materials are brought to the art gallery. Sometimes in remote places sculptures are made using elaborate earth-moving equipment, sometimes simply by moving material about manually, and sometimes using a kind of high technology. Examples here range from Robert Smithson's *Spiral Jetty*, a spiral of earth winding its way into the Great Salt Lake, Utah, to Walter de Maria's *Lightning Field* (1971-7), a field of lightning rods in south-west New Mexico. Naturally, much of this work is documented, and therefore shown in the cities which have the audience for advanced art, by and through photographs. Parallel to this is activity which can only be rendered accessible by means of some kind of documentation, in which an artist may take a walk in a remote place, the memory of that activity being communicated by means of the artist's labelled photograph of the event. In a sense this is a highly sophisticated version of the tourist photograph: instead of the snapshot of Venice's canals, the artist provides a captioned photograph of a remote place in the wilderness to which he has journeyed, and where he may have made from the materials he found there some kind of arrangement of wood, stone, or earth.

In all these instances the photograph is used, by artists who may have been through the most rigorous, classical art school training, for art forms beyond painting and sculpture, although they may work in more conventional media too. Yet other artists work with the manipulated photograph. Very often this means that artists can work in terms of publication, carrying the idea of the book as art work a stage further: their pieces – whether verbal, using words, or using images, often photographs – can appear as one-off art works, as prints, or as books in

limited editions. Sometimes the art is even specially commissioned pieces – a word that can mean art work – rather than articles appearing in the specialist art magazines and journals.

The photograph thus becomes the art work, yet it may also be illustrative of an event engineered by the artist. It is souvenir, memory, and art work in its own right. And the photograph may even be deliberately questioning many visual conventions. The number of artists working in this way throughout the west is now so vast that only a very partial selection can be made to show both variety and quality.

John Hilliard is a British artist (b. 1945) who studied sculpture at St Martin's School of Art in London, and has declared that his first interest in making photographs was from his sculpture, needing documentary evidence about it. First he found that the photographs began to stand in for his sculpture. Then he became increasingly interested in the photographic process, how people interpreted photographs and how they used them. He is interested in presenting 'fixed' information, a frozen tableau, but in different ways. Recently he has begun altering the images in terms of the printing processes, but his first works altered our perceptions of photography by sequences of the same image. For instance, in *Sixty Seconds of Light*, twelve images of a clock face, marked in seconds, are taken at twelve varying exposures, the clock face lightening from a sharply defined black and white image to one which is nearly white. Early on, he also created a set of seventy photographs of the controls of a camera reflected in two mirrors, titled *Camera Recording Its Own Condition (Seven Apertures, Ten Speeds, Two Mirrors)*. In other re-

85 John Hilliard
Camera Recording its own Condition,
1971

Hilliard worked first as a sculptor and started using photography to document his work in three dimensions. He became fascinated with the process of photography, how photographs represented 'reality', and how they could be manipulated. He has used sequential photographs which exploit different ways of printing, or suggest the passage of time, or which, by the use of different captions, indicate different events with closely related images. He has referred to the possibilities of presenting 'fixed information in markedly different ways'. Here we see different methods of printing the same image. In *Camera*

Recording its own Condition is a group of seventy photographs in which the controls of a camera are reflected in two mirrors: differences in apertures and speed programme the image, the 'camera-induced variables' acting perhaps as metaphors for vagaries in individual perception.

139

markable photographic series, sense was changed by words: similar, though not in the least exactly so, swirling clouds in a series of four had the following captions: Steam Rising; Fog Swirling; Cloud Descending; Smoke Drifting. The small Hilliard publication containing these images, called *Elemental Conditioning*, also showed another series of a figure lying on the ground, almost totally covered with a cloth. The captions Crushed, Burned, Fell, Drowned, coincided with visual information that would affirm the conclusion as to the fate that had overcome the body lying apparently lifeless on the ground. Hilliard is now consistently concerned with photographic language and its interpretation.

He is one of a significant group of British artists who, although their work is very different, have been linked together by the prominence they give to the use of the photograph. While Hilliard's work may be interpreted as about the language of photography and by extension about language, visual and other, the work of Richard Long (b. 1945), who also studied at St Martin's, uses photographs as documents of quite another kind.

Richard Long is a sculptor who makes sculpture from found materials, that is wood, stones, even pine needles, which are formed into simple shapes. Also regarded as a kind of transient, ephemeral sculpture taking place in time are the long walks that he has taken nearly all over the world, on several continents. These journeys are programmed, that is, they follow a plan, a time. There are two kinds of journeys, or rather two sorts of events, which may take place on the same journey. In one a sculpture is made on site by using whatever materials are available, resulting in pieces commemorated in photographs with such titles as *A Line in Bolivia, Kicked Stones*; *A Line in the Himalayas*; *A Circle in Iceland*. These are photographed by Long, and the way the activities are communicated to his public is through these photographs. Walks in themselves without the element of this discreet, discrete intervention in the landscape are commemorated in two forms: sometimes by a map with the route drawn on it and titled so that we understand how many days the artist has spent walking, and sometimes by photographs. For an example that indicates the conscious ritualistic element in Long's relationship to landscape, there is a photographic piece that tells us of a westward walk on midsummer's day from Stonehenge at sunrise to Glastonbury at sunset. Long himself is not much given to statements, although he has written that he feels his photographs are facts 'which bring the right accessibility to remote, lonely or otherwise unrecognizable works.

86 Richard Long
*Circle in Africa Mulanje Mountain
Malâwi* 1978

Here we may witness the simple inter-
ferences, always using natural materials
to hand, that Long sometimes engages
on in the landscape through which he

travels. The only way we may see these
activities is through the artist's own
photography. Perhaps interference is
too strong a word: it is the geometric
nature of Long's natural configurations
– lines and circles – that indicates their
human origin. Yet he makes artifice
look natural. He has put it simply and

persuasively himself: 'My photographs
are factual documents which bring the
right accessibility to remote, lonely,
short-lived or otherwise unrecognizable
works. I like the idea that some
sculptures are seen by few people, but
can be known about by many.'

Some sculptures are seen by few people, but can be known about
by many.' All of Long's work is concerned with the landscape,
and he has been called a romantic. Certainly he has tried to
create a new kind of visual relationship with landscape, com-
bining in his activities the making of sculpture – on site, and only
as permanent as weather and time will allow, or recreated
continually in gallery situations –and the idea of journeys and
even explorations. One of his very earliest works, for instance,
exists as a photograph of an English meadow with a new path
through it (presumably now disappeared) and simply called *A
Line Made by Walking*. Thus Richard Long's art is concerned
consistently (although appearances and methods vary so widely)
with man's interaction with landscape. He uses his photographs
as part of that activity and action, to present an immaculate
record of marks, trails and paths made in landscape, or to
commemorate a journey. The photograph extracts, refines and
records his activity; it also becomes the art work because it is the
permanent object that can be displayed, exhibited, catalogued,
bought, and sold.

Hamish Fulton (b. 1946) is another British artist who studied at St Martin's and whose photopieces commemorate journeys; unlike Long he started as a painter, and he does not make sculptures from found materials which are shown in galleries, nor does he intervene in the landscape that is the subject of his photographs. Rather, his photographs and their captions sum up the essence of the journey itself. An exhibition of his, for instance, was simply titled 'Selected Walks'. A given photograph will be an image to convey the artist's own feelings about his own activities, acting both as the art work and as the record of a transient event. The title of a 1980 work is *North Wind*, and the caption for the photograph reads 'North Wind October 7 1980, A One Day Walk In A Gale, Snaefellsnes Iceland'. A more elaborate caption for a handsome misty landscape reads: 'Mankinholes On the Pennine Way' to begin with, and then is elaborated thus: 'World within a World, A Walk from the Top to the Bottom of the Island, Duncansby Head to Land's End, Scotland Wales England, A complete Walking Journey of 1022 Miles in 47 Days, August 31 – October 16 1973, On the Ground Beneath the Sky.' Such photographs are exhibited, they are the art work. Selections from them are also published; the photo-

87 Hamish Fulton
No Horizons, 1976

The text under the handsome photograph of sky, with great clouds and birds, reads 'A One Day 50 Mile Walk Southern England Early Spring 1976'. The spectator's awareness of the artist's activity is thus sparked off by a combination of the visual image and the text. Yet the visual image is not an illustration of the activity, but a vehicle which conveys the feelings aroused by the laconic description in words. The title of the piece indicates the amplitude, even the euphoria, induced by sky-scapes – no horizons, no boundaries. The exhilaration of enjoyable physical effort is communicated, too, in the combination of image and text: though a one-day fifty-mile walk might seem full of effort, the spaciousness of the actual image suggests feelings of exultation and the birds fly effortlessly.

graph just described, for instance, was published in a book of his photographs, appropriately called *Roads and Paths*, subtitled *Twenty Walks 1971-1977*. Fulton works exclusively with black and white photographs, unlike Richard Long who has used colour. Fulton's photographs are connected exclusively with his walks, and he chooses the views he photographs to symbolize the walk. Neither Long nor Fulton is interested in the printing and developing process of the photographs, but only concerned to take the photograph. Fulton will also produce photographs which resemble panoramas, joining separate shots together. By the winter of 1979 Fulton recorded that he had made sixty-four walks in eight years, a handful with friends, most alone.

A significant number of Fulton's photographs share a motif, that of the winding path or road. Typically quite large, his photographs are unusually interesting and beautiful in their own right. The effortful nature of the walks he takes is noted in the title: for *The North Sea* (summer 1977) he undertook a non-stop seventy-mile road walk from the west coast to the east coast of northern England. The sizes of his photographs also vary, and there is no particular format for the number of works taken to symbolize his walks – they may be single images or a sequence. Although he has walked in many places including the Himalayas, Fulton also has an affinity for the ancient walkways of England: the Pilgrims' Way that leads to Canterbury for instance. His work is the walk; the art work remains the exhibited and published photograph, with short, explanatory caption as a text. Words and visual image are equal partners in the final art.

Bernd and Hilla Becher are German artists; Bernd (b. 1931) trained as a painter, his wife Hilla (b. 1936) as a photographer, and they began working together in 1959. Their photographs have been published in periodicals, as books, and exhibited internationally and are exclusively concerned with man-made structures. They began photographing jointly, after Bernd Becher had already given up painting and print-making, feeling photography served his purpose better. The photographs form a documentary archive of certain kinds of building – for example, water-towers, silos, pit-heads (winding-towers), gas-holders, coal-washing plants, silos for coal, cooling-towers. Photographs of the same kind of structure are then grouped together. The Bechers believe that their photographs provide a good deal of information, and they make great efforts to seek out the structures they photograph, having worked widely in America and Europe. Because the interest in form, and formal relationships between strongly marked and delineated shapes, have been such a feature

143

88 Bernd and Hilla Becher
One of *Three Pit-Heads*, 1977

Bernd Becher and his wife, Hilla, collaborated to collect information for his paintings on industrial subjects. They wanted information in 'its simplest form' and turned to photography. Their photographs have now become their art and are of the intricacies of visible industrial structures that are fast fading away, becoming obsolete. Their work is almost invariably exhibited and published in sequential form. The interest

in structure, shape, form and texture, which is integral to modern Abstract Art, allows the Becher's audience to appreciate the subjects of the photographs as anonymous sculpture. A modification of the techniques of investigation apparent in the social and natural sciences – the collecting of data, the publishing of lists – has here been used creatively. For the Bechers present no conclusions or solutions and pose no problems. In a sophisticated version of art for art's sake, these structures – collected as examples of vanishing

species – are appreciated for themselves. Apart from labels indicating what kind of structure is displayed, and its geographical siting, we are given no information about its size, present use, or possible future. But the Bechers alert the spectator to the extraordinary structures in our midst and the impassive, even bland and undramatic, nature of their black and white photography is curiously effective.

of twentieth-century art, and in particular of a good deal of Abstract Art, it is natural that the phrase 'anonymous sculpture' should have been used of the structures the Bechers photographed. The idea of the anonymous sculpture fits very well with another idea of twentieth-century art, that of the found object, the art discovered simply by selection from the real world. This idea has been prevalent since Duchamp designated ordinary manufactured objects as art. Bernd, who first worked as a painter of industrial landscapes, living in an area of Germany that had one of the longest industrial histories in Europe, started both taking photographs and collecting old photographs for his painting. But, especially with the collaboration of his wife, it seemed that photographs answered his purpose better than the subjective involvement in composing imaginatively in more conventional fine art media. The Bechers are interested in documenting the structures that are disappear-

ing, the historical buildings of the Industrial Revolution, those that are clearly separate and functional. Thus they do not choose to photograph entire complexes, industrial estates or factories, textile-mills, and so on. Rather, they concentrate on the individual structure. They have also specifically declined to comment on whether their work is art or not, only saying that the question is not very interesting to them, but that the art audience would be the most open-minded towards their work. A photograph has a sharp overall focus and an attention to detail that the Bechers feel sympathetic to; typically their work is shown in a series of related subjects framed together. The Bechers' work is also expressive of another important idea for twentieth-century art – and design, too: that form follows function. Even so, what is fascinating is the amount of individual variation that is found within the categories of building that they photograph, and the human urge to decorate even the functional. Their art is typical of our times because part of its purpose is revelatory, to 'sensitize' the observer to the ordinary world.

What is notable about the photographs of Richard Long, Hamish Fulton and the Bechers is that the human presence directly expressed is absent: Long and Fulton photograph sculptures and walks, but they themselves do not appear. The Bechers' photographs of industrial sculptures never show a person. Another artist who through the photographic medium documents human activities but rarely shows the human presence is the Californian Ed Ruscha (b. 1937), an exceptionally gifted draftsman, a witty and inventive print-maker, and a painter from time to time. One of his characteristic activities has been the outcome of devoted attention to certain features of Southern California life: for example gasoline stations, parking lots, swimming pools, of which he took photographs which were published as little books. *Various Small Fires* was one title, *Real Estate .Opportunities* another; another publication was *Every Building on the Sunset Strip*, yet another *Some Los Angeles Apartments*, and another *A Few Palm Trees*. Like so many modern artists, Ruscha fits into a variety of categories, and we may be just as interested in his work as a maker of books – book as art work – as his use of photography. His photographs exist only in book form as sequences of photographs on the subject as announced in the title, and are not exhibited separately.

Photography may also document performance which centres on the human presence. The German artist Klaus Rinke (b. 1939) studied mural painting, was a painter of abstract pictures

145

89 Ed Ruscha
Standard Oil Station, 1966
90 Working photograph

This inventive and witty American is a print maker who has used actual organic substances in his prints, giving a new meaning to the idea of drawing from the real for art. He has also used photographic material in different ways. A series of photographs of artifacts, objects, and environments in Southern California – from palm trees to swimming pools, and parking lots to buildings on Hollywood's Sunset Strip – have acted as oblique, imaginative comment-aries on Californian life. Ruscha has an incisive eye for the American image. Thus *Standard Oil Station*, here seen in working photograph and finished print, may be an image that recalls the alienation expressed by the painter and print maker Edward Hopper when he turned to gas stations as subject matter. But here in modernist style, with echoes of the Bauhaus (form following function), the scene is free of people. A simple stylized print allows us, if we wish, to see *Standard Oil Station* as a metaphor for America itself, linked by a vast road system, with gas stations now a folkloric part of American life; and Standard, indeed, is part of the limbo land of Middle America seen as a state of mind rather than a geographic region.

and then became a maker of most remarkable sculptures (using water being pumped as a kind of material, for example). Then, using his own body in action as a demonstrator, recorded it in photographs, films and video. Rinke continues to work in a variety of media, with different methods, making installations which conform to some aspect of the conventional notion of sculpture and also working in new ways. Publications of his work have consisted of substantial series of photographs. A work called *Mutations* (1970), for example, consists of 112 photographs of himself (hands and face) performing in front of the camera; the actual pictures were taken by the photographer Monika Baumgartl, for practical reasons. Photographs may be taken by Rinke, or of Rinke: in each case, however, Rinke forms and directs the action.

Rinke is himself the chief actor, and has described the basic impulse for his work in the problems of his immediate surroundings, a confrontation 'sometimes fear and sometimes joy'. Through photographs he attempts to place himself in time and space: one sequence simply portrays Rinke receding in space,

another series shows him in profile in a piece called *Going Through the Format / Horizontal Plus Vertical Equals Diagonal*, another, oddly parallel to Hilliard's use of the photograph to demonstrate time, is Rinke full face in a sequence of sixteen photographs in which he first appears sharply defined and fades into nothingness, a clock set at just after 1.15 placed above his shoulder, and the whole titled *A Moment (Diminishing) or Disappearing in the Medium*. Many of his photographs document performances: *From the Horizontal to the Vertical* is dead-pan and hilarious, Rinke in the midst of the woods, heaving a thin, slim, tall log from the horizontal to the vertical to join a forest of trees, partly an illusionistic trick. Rinke performs in two ways: both for the camera, and for the public. The camera documents both kinds of performances, those on which he engages alone, and those that have an audience. Whether the photographs are taken by him or by others is not considered important; both he and his collaborators photograph for his work. What is important is that he develops, prints, and exercises choice and editorial control of the photographic images that both represent the work, and even more frequently are the work.

The use of the photograph is an irresistible invitation to art as documentation – and art as autobiography. It is arguable that the dissemination of photography destabilized the art of painting, and the two modern and contemporary manifestations in which a photographic mode is dominant make this clear. Using every resource possible, a significant number of artists who use photographs as the starting point or source for their painting therefore make the subject of the painting the photograph. Thus the photographic, rather than the graphic interpretation which might have been achieved by drawing rather than photographing the observed scene, is dominant.

And how better to record one's life and times, and to use that for art, than through the photograph? The concentration on the self in a new way, the public expression of private emotion, has been a salient feature of the arts in the twentieth century – not just the visual arts, but literature and the performing arts of opera, theatre, and dance. Here too the routes followed have been in their diversity paralleled in several of the arts: on the one hand increasing abstraction (which can be seen as a very subjective act, having so little or deliberately remote connection with the observed world), and, on the other, highly personal representation.

It is rare, though, to discover an artist who is an active photographer whose own art seems so different in idiom and

147

mode from the photographs he has taken. But one such, on the surface at least, is the German Otto Wols (1913-51), whose art, usually on a small scale, is identified with the School of Paris. Wols' painting is melancholy, sad, wondering; Wols' pictures usually have a central configuration, but are paintings very often of mood and emotion rather than representational in intent: they represent a profoundly sad, puzzled and puzzling inner life with images dependent for their compelling nature on an imaginative way with colour, and, as was characteristic of certain French artists of his time, on touch and texture. Wols worked as a photographer before he became a painter; when he came to Paris he was in touch with the Surrealists, and then with the existentialist philosophers. Wols was passionate about drawing, fascinated by the physical actions of hands and fingers necessary to produce drawing, and later by the physical actions required to produce painting, and his drawing and painting – highly personal, often abstract although with figurative associations, often symbolic as titles like *The Blue Magician* might indicate – were a kind of antithesis to the photography on which he had so energetically engaged before. As a photographer he had an eye for the disregarded, for the surprising, for the poignant beauty of the ordinary. He was an acute observer. He was also brilliant at composing. A number of painters have become photographers, fewer perhaps have made the journey the other way, and still fewer have shown such a striking difference, in appearance at least, in their work in varying media. The shared sensibility might be in this: just as Wols so strikingly observed the oddities and simple incongruities of the world around him when he photographed, as he amused himself in assuming various striking facial expressions for self-portrait photographs, so too he listened as it were to the promptings of the inner voice and inner mind. His drawing and painting are like dreams, amorphous forms half glimpsed, and he exploited that Surrealist technique of automatism – allowing the hand to make what marks it would – and other arbitrary techniques common to the intellectual climate of the time.

If Wols' art is a profile of the inner emotions, exhibiting some of the same attention to the subtleties of detail and texture as his earlier work in photography, others have been more blunt about the autobiographical nature of their work.

The Austrian Arnulf Rainer (b. 1929) is a self-taught artist who has had a varied and chequered career, producing prints and paintings before an intense collaboration with the camera based

91 Arnulf Rainer
Lächerlin, 1974

Rainer photographs himself, and others, in contorted positions and making ferocious faces, with a range of exaggerated expressions, and he emphasizes his facial distortions by great scribbles over the surface of the photograph. This raises interesting questions not only about what we may do to ourselves, but how we may appear to ourselves – and others.

in part on his own performances on and to camera: the camera has been his audience. He often has used a mirror – to communicate with himself, he has said. A series of works he did was called *Face-Farces*, described as grimaces, facial forms, over-drawings, painted photographs. Rainer has vividly described the sense of excitement he feels when he is drawing, and in a most unusual way he has combined the sense of excitement, and body movements made while drawing, with the use of photography. He began to perform – make faces – for the camera in one of those automatic-photography booths which are to be found everywhere; later he began to collaborate with a photographer who took the photographs while Rainer performed. Then comes a process of selection from the photographs, and finally the photograph is treated as something which is somewhere between a blank sheet and a drawing, and Rainer energetically draws or paints over the photograph. 'Painting-over' is the process, Rainer has declared, between polarities of destruction and perfection. 'Body-language' was the title of Rainer's exhibition at the Venice Biennale of 1978 and the sub-divisions included 'Self-demonstrations' and 'Self-transformations'. This tortured self-examination has numerous precedents in twentieth-century art, but Rainer's obsessive work with the camera, followed by careful selection from a huge number of prints, followed by the manipulation and treatment of the selected self-images, has formed a huge body of art as a personal body language. He has described how he nerves himself up for these performances, how he has in his art practised 'accentuated self-

149

reproduction, but also symbolic change and self-destruction'. Rainer's use of himself – and other people too upon occasion – and the ritualistic yet spontaneous over-painting on these human images seems an unusually effective echo of the contrasting, even opposing urges to self-destruction, and self-admiration and self-improvement that are part of the prevailing ethos of Western society. And it is the more striking because of our unconscious assumption that the photograph of the person is 'real'. Rainer's fierce art embodies urges to commit sacrilege and worship, simultaneously, in a manner both brutal and elegant. Where Rinke arranges the photographs he makes of himself, and of performances, and of himself in action, sometimes in a limbo-land of a wholly neutral background, sometimes in landscape and city places, Rainer is almost invariably posing and gesturing in a neutral space, and vividly accentuates each pose – graceful, grotesque – by graphically drawing and painting on the photographic image.

Lucas Samaras (b. 1936) is a polymath of an artist, a Greek who went to live in America when he was twelve, and who has described his art as a way of coming to terms with a sense of alienation, and as a form of fantasy. His art is fantastic: he has used all kinds of materials, he has made assemblages, constructions and boxes, he has transformed mundane objects such as chairs into fantastic constructs. Perhaps above all, a theme running through much of the strikingly visual objects and wall-hanging pieces he has made has been an autobiography – a way, as he has put it, of distilling his distance. He is fascinated by the self-portrait, to the extent that he has even used, vividly, X-rays of his own skull. His boxes, mirrored, elaborately decorated and treated, often contain photographs of himself. He started photographing himself in the 1960s, and a very large body of work has grown up with himself as model, although at the same time Samaras has pursued his wildly decorative and flamboyant art in other media, in for instance wall hangings that are an amalgam of tapestries, quilts, samplers and paintings. These sewn fabric paintings are called Reconstructions. For a time, early in his career, Samaras was an adept in that very sixties art of Happenings, events motivated by both visual and theatrical aspirations. Whereas a significant number of the boxes Samaras made incorporated his photographic image, by the late 1960s he had embarked on a sustained attempt to explore himself photographically, with a Polaroid; in 1971 Samaras published a *Samaras Album* which contained 405 photographs he took of himself in different poses, costumes and therefore roles. With

92 Lucas Samaras
Photo-Transformation, 1973

Samaras is a master of the manipulated photograph and his work, highly emotional in content, makes of the photograph something expressionist, violent and distorted. The artist may pose himself, using theatrically exaggerated lighting, or he may actually manipulate the photographic emulsions as the image is emerging. (See also opposite p.112.) These are performances in which violence and activity, indicative of fantasy – dream or nightmare – are frozen, with only the photographic elements linking the whole to reality, guaranteeing a kind of authenticity. This is the artist as he sees himself and as he presents himself, with the inner life outwardly expressed.

the SX-70 process, from the mid-1970s Samaras has taken an unusually expressive range of self-portraits by Polaroid, for here he could interfere and manipulate the process of developing, and he called the series that eventuated from his fascination with the process Phototransformations. The Phototransformations are like dream or nightmare stages of the self: the interference here is different from the use of the self by both Rinke and Rainer. With an artist like Rinke, the camera acts as witness and reporter, and one feels he uses himself only because it is convenient to do so: there is surprisingly little narcissism involved. With Rainer, there is in the photographs, which are often as much defaced as enhanced, a sense of aggression barely

controlled, of attack: this is one of the reasons the results are so disquieting.

With Samaras, the quest for the self through the medium of the photograph is obsessive, even at times absurd, and often theatrical. Theatricality was paradoxically underlined by the tiny, miniature size of the Auto-polaroids. But there is an intensity, an odd and poignant beauty, and a curious and devastating frankness in this search for the self. By presenting himself –especially in the Phototransformations, a curious echo of the half-hidden photographs of himself found in the elaborate boxes he made in the 1960s – as a fragment from the sub-conscious, floating to the surface, and by taking the photograph and manipulating it, Samaras makes of himself something for investigation. Through the medium of the Polaroid, Samaras becomes for himself both subject and object. Rarely can such a public attempt at reconciliation, attempting to examine and perhaps even exorcize the sense of being alien of which he has seemed so conscious, been carried out with such flamboyant grace. His art is often erotic, highly sexually charged, and is also at the same time ironic and distanced. He works as sculptor, painter, draftsman, and uses the idioms of abstraction as well as representation, the latter mostly confined to the photoportraits.

Gilbert and George's art is autobiographical and biographical, simultaneously, as they are themselves an unusual example of artistic partnership. They do their own photographic work, developing, printing, and enlarging. Their art is their life, as expressed in their early designation of themselves as The Living Sculptors. Gilbert (b. 1943, in the Dolomites) and George (b. 1942, in England) met when studying at St Martin's. They have made huge wall drawings, engaged in performances, created multiples, sent sculpture through the post in the form of letters and cards, made video-tapes, published books (rather endearing prose poems), but above all they have made photopieces or photo-works, and recently photograms, which often combine photo-graphs (and photograms) in panel form. The images have moved from straight, at times idealized, autobiography and biography of the outward semblances of their life – dandified, elegant Gilbert and George posed carefully in immaculate rooms, in their house in London's East End (their mailing address is Art for All) – to incorporating more and more of the outside world in their photopieces. Samaras has made of his life – especially through the use of photography – an art, and an art object. In a very different way, Gilbert and George have done something of the same. 'Being living sculptures is our life blood, our destiny,

93 Gilbert and George
Buds and Fruit, 1980

Gilbert and George compose with photographs, arranging a single vastly enlarged image across a grid. The effect of these large pieces is surprisingly emotional – the sense of the fragment-ation of city life, for instance, is powerfully communicated – and the fragments chosen by the artists (rarely is a full tableau recorded, and the back-ground is often undifferentiated) may be interpreted in conjunction with the titles as symbols. Subjects, even trees and plants, are often curiously sinister.

our romance, our disaster, our light and life.' When their dual career as one, or single career as two, began, Gilbert and George performed, often in feats requiring unusual stamina: standing still, for instance, for hours at a time. What remain are the photographic documentaries of the early performance events: from being living sculptors, Gilbert and George carried on sculpting – through the medium of photography. From exhibit-ing naïve and endearing enjoyment, and a mild eccentricity, the photopanels became more strident, more violent, more distres-sed, reflecting perhaps that 'to be with art is all we ask', as the living sculptors put it, was not quite enough. Violence and despair intruded, with photographs being dyed red, and work from the mid-1970s coming under the generic titles of *Bloody Life*, and *Bad Thoughts*. From 1976 images from the real world outside the enclosed world of Gilbert and George's own wanderings began to be incorporated, mediated always through the artists' choice and selection: that is, they themselves no longer appeared in every image. Even so the contents remain autobiographical, and can be read as meditations or feelings about the world: violent, sad, surprising, and tender, and usually expressed in an oblique manner.

Some artists through the medium of photography examine the world, and perhaps one of the most unusual, enterprising and interesting projects has been that of the British artist Stephen Willats (b. 1943). Willats began after an extensive training in art school as a constructor of wall-hanging light works that often involved audience/spectator participation. From these Willats began to investigate society, and trans-formed himself into a social scientist armed with artistic licence. That is, he did not have to investigate, report, choose statistical samples, and so on: he could concentrate on individuals while

borrowing certain techniques from the social sciences, such as the diagram, the questionnaire, and indeed people's willingness to co-operate and be questioned, obviously responding not only to the attention but to some vague notion of research. His intentions were always clear, and he has always had both the co-operation and the collaboration of his subjects. A title for a major exhibition at the Whitechapel was 'Concerning Our Present Way of Living'. Willats publishes his own magazine, *Control*, which contains articles from other artists working in related areas.

Willats takes his own photographs, of his human subjects in their settings, and with their co-operation and collaboration: that is, they often choose the settings together. He explores through questions and conversations what their concerns are; he explores what people feel is done to them, and what they feel they choose to do and be; and he explores states of being. Thus, a recent project in West Berlin explored the notion of *Passivity*, through a photographic essay, with text, caption and recorded conversations, about the feelings, aspirations, questions and hopes of the smart, fashionable young owner of a West Berlin boutique. The idea of passivity referred of course to the fact that she spent most of her waking hours in her shop, looking out of the window, waiting for clients, friends and customers. *Escape* concerned an elderly childless widow whose emotional well-being was centred on her care for her allotment garden. Willats is interested in social networks and relationships, in social roles, in how people feel themselves to be, and how they perceive and are perceived. To this end he accompanies verbal investigation with visual investigations, taking enormous quantities of photographs. He works with people in city apartments, and even with that curious city phenomenon, wasteland, and the life of people and of abandoned objects that wasteland contains,

94 **Stephen Willats**
The Lurky Place, Panels One, Two, Three and Four, August 1978

Willats uses the camera to investigate and to compose. His work is not, however, documentary or illustrative; it stems from observed reality, and from intensive but self-directed investigations to his own brief. In a combination of techniques – interviews, photographs – he constructs immaculately executed large compositions, which use inventive methods of making a whole image of

several photographs connected by words, phrases and lines. In his own use of the diagram form he expresses the connections between external appearances and inner thoughts. In his art Willats makes a world which corresponds to, or has recognizable parallels with, 'reality'. In so doing he constructs chains of images which intensify our apprehension of the invisible life and activities which bind the objects in the external world together into a total environment. Willats' art is based in part on the assumption that the viewer is familiar

with newspapers, television and photography. He is both sympathetic towards people and critical of the man-made environment, and he is absorbed by the relationship of the individual to institutional society, observing communities and individuals. The Lurky Place is a waste land in West London, surrounded by housing estates and industry. The waste land is used by people who live near it for a variety of pursuits, in which people find kinds of privacy and freedom, establishing new connections in an area which is in limbo.

My institutionalised past.

Identify the moments of transition.

My basic unit of accommodation.

Piece together the reasons for leaving.

My role within a planned economy.

Unravel the dreams from reality.

My generation's outlook for the years ahead.

Restructure the framework of priorities.

155

focusing here on a piece of wasteland called *The Lurky Place,* in West London, which has been a project that has continued for several years. *Living with Practical Realities* is the title for another Willats project. The interesting question is why Willats has not simply made books of documentary photographs rather than art works which are shown in a gallery. Willats' magazine is the vehicle of the elaborate theory that lies behind much of the work; the art simplifies dramatically the assumptions and purposes that lie behind. What the visitor sees is an immaculately prepared and printed, very large photographic panel, with several photographs superimposed on a large photograph which serves as mood and scene-setter. The photographs are connected by simplified captions and lines, a visual equivalent for the social and personal network that Willats is exploring in his work. Perhaps some of the importance is that the work is out of context: Willats sees art as a tool for raising social and individual consciousness, and as expressing something he has come to call 'counter-consciousness': perhaps what people really feel in contrast to what they ought to feel, and to the pressures of society. The most immediate way in which Willats has felt he can express this is through the medium of conversation and interview, distilled into captions and occasionally used as sound accompaniment, and in photographs which depended on the subject's co-operation both in helping to devise the composition and in choosing the scenes. However, Willats took the photographs himself, and when choosing them, often again with the co-operation of the subject, uses them uncropped and unretouched. The photographs remain thus unaltered, raw material. The editing process takes place in two ways: through choosing what photographs to use in the finished art piece, and by the placing of photographs for the composition of the final piece, which may incorporate a variety of photographs. Thus Willats' procedure feeds into several twentieth-century ideas and methods in terms of art. He uses what he goes out to find, that is human beings in certain settings, so that the whole of his work is like a series of found objects which he does not seek to alter nor impose upon in terms of his ideas. And he puts these things together in a way that is reminiscent of collage and to a certain extent photomontage, although without altering his material as photomontage is wont to do. The altering comes through juxtaposition and relationship of image to image. And the narrative – word and image – depends too for some of its efficacy on our being accustomed to the notion of photo-journalism.

95 Sol LeWitt
Autobiography, 1979

LeWitt is known for his use of lines, straight and curved, in an art that reflects and refracts the elements of the built environment, and his vast wall drawings embody a basic programming that can give rise to amazing variations in appearance. His photographs often concentrate on elements of that built environment, such as sections of a brick wall. It is a natural extension that LeWitt should photograph the objects among which he lives. As in his most characteristic work the essential paring down to geometric elements reminds us forcibly of the vocabulary from which visual art is built, so these objects remind us of how the emotional richness of a life may be made partly visible through the seemingly casual clutter of the objects with which we surround ourselves.

It may seem a very long way to the art of Sol LeWitt (b. 1928), the American Minimalist or Conceptual draftsman, print-maker and sculptor. LeWitt's art has concentrated on the scaffolding of a visual vocabulary to an unusual degree. He has described his own art as being logical statements which are made using formal elements as the grammar. LeWitt has also written extensively, with a simple use of language to express complicated concepts: an echo with words of his concern to reduce things and appearances to handsome essentials. Minimal Art has been called ABC Art because of its interest in reducing art to an alpha-bet – to line, colour, and form that imitates nothing. Le Witt's opulent austerity expressed itself in three-dimensional and two-dimensional structures, most dependent on line but also frequently exploring colour. LeWitt's wall drawings, which can be sold to and installed in museums and art galleries, typically by other hands, depended on the artist's directions, a programme of lines, a diagram which could be followed by art students in

reproducing the wall drawings. The process became part of the art work. LeWitt himself travelled extensively, making wall drawings in a number of countries. And where he travelled he saw grids, decorative or functional, the markings mostly to be found on the metal circles that act as covers for pipes, and entries to the piping system for gases and liquids, that run in a complex network under city streets. Like the Bechers, whose concern with industrial constructions led them to take photographs of what they found, which was then treated as anonymous sculpture, LeWitt found an art that had been made without art in mind. Curiously, some museums have made the impressions of such normally disregarded city street-furniture the objects of school projects. LeWitt went further, and published his colour photographs of these grids in a book called *Photogrid*. He has used photographs taken by others too to explore the notion of the city as grid: aerial photographs of Florence and of New York for example. He has also photographed the brick wall he looked at frequently in New York, as it formed a view from where he lived; in this wall he found a changing odd beauty which he attempted to express, communicate, or show to others through his photographs.

His art, stripped to essentials, uses visual building blocks, often built up into elaborate, complex patterns. His photographs find, and focus on, such visual elements in the found environment.

Ger Dekkers (b. 1929) and Jan Dibbets (b. 1941) are two Dutch artists who have consistently explored landscape and natural structures through the medium of photography. Dekkers is concerned almost exclusively with the Dutch landscape, a place of course criss-crossed with canals, walls, dykes, paths, trees planted in rows: a kind of natural grid, tended, manipulated by man in collaboration with nature. This too then is anonymous sculpture, and Dekkers does something which much contemporary art does, by its very reduction to essentials: he alerts us to the ordinary, disregarded, and in this case the underlying structure of a highly contrived 'natural' landscape, in land that is amongst the most cultivated and cared for in the world. Dekkers has declared his purpose, or his subject, to be an exploration of the effect of culture and landscape; he is aware of two factors, the documentary and his own personality. He has used the adverb 'emotionally' to describe the choice he makes when deciding what angle to photograph from, what kind of focus and view he wants; further emotion enters in when making choices from the images taken. His photographs, immaculate

and in colour, act in series, unified by a horizon line or a repetitive feature. They are remarkably effective and compelling in persuading us to look with new attentiveness at the real world, and also in themselves, whatever the intentions of the artist, they work as effective striking images, because of the strength of the natural/man-made features of the landscape, exaggerated by the choices in terms of perspectives and views made by the artist. Titles such as *Planned Landscapes 25 Horizons* indicate Dekkers' interests. It is not insignificant that the great Dutch painter Piet Mondrian began as a painter of acutely observed landscape before he forged a new abstract language and idiom which depended on strong horizontals and verticals. Here in quite another way the mathematics and geometry of the highly contrived landscape are expressed, and in Dekkers' sequential photographs the whole is often more than the sum of its parts.

Jan Dibbets is a younger Dutch artist who also, like several others who have turned from the making of three-dimensional and two-dimensional objects to the taking of photographs, studied for a while at St Martin's, London. His work takes the form of sequential photographs, usually in colour. The method is often programmed: thus for *The Shortest Day* (1970) Dibbets photographed light between sunrise and sunset every ten minutes. Unlike Dekkers, who simply shows or upon occasion projects his photographs, Dibbets uses his photographs in a highly formalized way, placing them on walls, using them in installations, and making geometric shapes with the photographs as elements, thus forming larger compositions. Often photographs are combined with drawings, and titles such as *Structure Piece* indicate his interests. There is a dry and splendid wit at work too, as with one of his earliest pieces, called *Dutch Mountain*, in which the 'mountain' was a shape contrived from the arrangement of a series of photographs of the beach and sea. It is not so much the photographs themselves that are altered, as the ways they are used. The photographs for Dibbets are part of a process in which they act like pencil lines, brush strokes, or other elements in picture making. But because they are also photographs of recognizable things, and are often combined with captions (we know these arranged views of beach and sea are Dutch mountains because that is the expressed title of the piece), Dibbets' work acts on the spectator at various levels. The subject is often the way the work was done, the 'how' of the work. His work has been described as occupying an area between 'nature' and 'cool geometry'. Whereas Dekkers is concerned to describe through his photographs as directly as

159

96 Jan Dibbets
Self-portrait as a Photographer, 1980-1

Dibbets' photo-pieces and photo-collages make new constructions, handsome and beguiling diagrams which question ideas about space. He often works with interior and exterior details: details of a room, a church or art gallery, and architectural spaces such as city squares. Here his own figure taking the photographs is part of the finished piece.

Other of Dibbets' photographic works record the artist's minimal interference in existing landscape, a kind of art-gardening; records of such appearances and changes in light are sequentially arranged, as the shadows in his studio, or eighty photographs recording the city light through the shortest day.

From the mid-1970s, Dibbets has made works, whose medium is the beautifully printed colour photograph, which explicitly examine the surfaces of vegetation and water reflections, and these he calls *Structure Studies*.

possible the structural basis of man-manipulated landscape, Dibbets overtly manipulates his imagery as he constructs his pieces which use photographs just as one element, as part of the installation.

We have seen that some artists perform directly for the camera; others use the camera and photographs to seek out structures in the natural or man-made world; still others use photographs as souvenirs, mementoes, stand-ins for the work which in turn become the work. And there are yet others who stage or programme events and tableaux for the photographer.

160

The Dutch artist Ger van Elk (b. 1941) has used photography
in a variety of ways, including the staging of tableaux of an
ambiguous kind, which often refer to the history of art, and
which use photographs in imaginative ways. He has also treated
photographs with gouache and ink, or placed photographs on
canvas. Van Elk has suggested that he uses the photograph to
save time: the photograph is his 'faithful friend', for immedi-
ately with a photograph you receive something resembling reality.
He uses paint – drawing techniques too – to put or to underline
emotion and intention on the photograph. Van Elk was a
painter who studied art history, then turned to the photograph
as a short cut, but one that, just as do the quotations from the art
of the past that he likes to deploy, has a resonance, persuades
the spectator to believe.

Boyd Webb (b. 1947 in New Zealand) is another artist who
stages events for the camera, isolating aspects of modern life. His
tableaux, unlike those of van Elk, are often in simple, neutral
settings, rather like the galleries in which his work is viewed, after a
period of photographing events outdoors; the events or tab-
leaux themselves have a crazy surreal logic, which again we are
persuaded to believe in because of that unconscious assumption
of the authenticity of the photograph. Thus he sets up frozen
moments for the camera; his work too is often sequential,
episodic. Boyd Webb tells stories, plays games.

The American Bruce Nauman (b. 1941) is a sculptor, who also
works by making installations and environments, films and
videotapes. He performs, too, often in a witty, ironic manner,
commemorating the tableaux he makes himself by means of
photographs. Many of his built environments require spectator
participation: we have to walk through the spaces he has made,

especially as he often makes corridors and rooms. The spectators become performers, especially through a clever, judicious use of mirrors, the whole like an unusual refinement on the distortions sometimes encountered on fairgrounds and in fun palaces when spectators enter mirrored installations and experience pleasurable or worrying feelings of displacement and distortion.

Nauman's own performances include for instance *Self-Portrait as a Fountain* in which the artist is calmly and elegantly spitting out a jet of water; or *Feet of Clay*, in which for one moment we think we are looking at a pair of legs ending in skeletal feet, until we realize the feet are encrusted with clay. There are other effective jokers at work with the photograph, including another American, William Wegman (b. 1943), who has an anarchic sense of humour, an ability to turn things gently, sardonically, upside down. Boyd Webb, Bruce Nauman, William Wegman share an ability to jolt our preconceptions, and a mood of serious play: Webb uses others as models, Nauman and Wegman often work with themselves, and a domestic environment, although recently Wegman has turned to more 'straight' photography. Jokes and ironies abound: Wegman often photographed, sequentially, his dog, and the dog's name was Man Ray. A photograph captioned *Untied On Tied Off* showed a pair of feet, one wearing an untied boot, the other with a boot tied round the hairy leg. Narrative sequences, jokes, the artist as performer, all are methods, ways and attitudes implicit in the expanding use of photography by people who are called artists, often by virtue of two characteristics or aspects of their life and work: usually they have been trained at art schools, universities and colleges in the fine arts; they are written about and discussed in art magazines; they are exhibited in art galleries and their work is purchased by art museums. Thus, it is the context that helps provide the definition.

In the past several decades the number of artists using photographs and photography has increased dramatically, and the problem of whether art should be divided by media has been a question not unconnected with the large number of artists using photography. The use of photography in print-making has become a widespread practice, coincident with a revival of the most arduous hand-crafted print-making. This is a neat example of the continuing paradoxes and contradictions in contemporary art: on the one hand, a return to the craft of art, an insistence in an age of mass-production on the worth and value of the hand-done (seen also in a revival of craft); and on the other, an exploitation not only of mass and popular imagery for

the fine arts, but of processes associated with the mass media, such as photography.

A new relationship has been forged among artist, camera and photography. New art attitudes, embodied in the labels of Conceptual Art and Minimal Art, have implied that the art object is less important than the idea it carries. Meanwhile, artists whose art can be labelled Land Art, who use remote places for their work, or whose work is invisible except through some sort of documentation, and visual artists involved in performance works, have also found new ways to use photography. The artists who *take* their own photographs are but a fraction of the scores, the hundreds of artists who in the past twenty years have turned to *using* photographs. The vast projects of the environmental artist Christo are documented by photographs, but Christo believes in using 'professional' photographers. Much of the work in the hands of artists has been concerned with the nature of photography, and through photography interesting questions about society and the nature of reality. Mixed media are now a way of art life.

For example, the exhibition called 'Directions 1981' which is part of a series at the Hirshhorn Museum, Washington, DC, a museum which neither collects photographs as such, nor has a department of photography, but which does have a good deal of photographic material as used by artists, was concerned as its title indicates to emphasize recent ideas in art. The majority of the work was paintings, sculptures, constructions and installations. Yet there was also included the work of a 'straight' photographer, Debora Hunter, that is, an artist whose preferred medium was the photograph, used almost in documentary fashion. She made the following statement: 'I am motivated to make photographs out of a need to understand myself and my world. The process of making art helps provide meaning to my existence and the clarification of my identity.' Thus there is neither divergence nor dichotomy here between the taking of photographs and the making of art. Conrad Atkinson (b. 1940), an outstanding English artist in the same show, uses photographic material extensively to document and describe his fierce and strongly felt social concerns: he is the artist not as social analyst, but as social critic, a kind of updated Heartfield. The concern of art is life, he has said, and to this end he uses whatever material, published, written, documented, that he sees fit, as well as his own photographs and drawings, combined into wall-hanging pieces exhibited in galleries and museums. In the same exhibition, Jeff Wall is an artist who has also studied art history

163

98, 99 Conrad Atkinson
Northern Ireland 1968 – May Day 1975

Atkinson is interested in raising questions and problems that are usually political in nature. Rather than writing and publishing his views in newspapers or books he prefers to criticize endemic, even insoluble, situations or crises by presenting visual essays in museums or galleries. As these often contain quantities of material, both visual and verbal, they can be difficult to assimilate in a conventional way, but Atkinson persists in using that context. One of his most effective pieces is a collection of Northern Ireland graffiti, exhortations, slogans and posters. Here the bulk of the material worked well to indicate the pervasive nature of slogans and phrases, often contradictory, on the city environment.

intensively: his method is to set up elaborate tableaux which are processed photographically, the results existing as gigantic Cibachrome transparencies, exhibited in gallery spaces. Photographic techniques can be manipulated at will, borrowing from advertising and mass-media conventions, and from the conventions of the fine arts, and even from the social sciences (the photograph used as an investigatory tool), as well as being turned in on itself to investigate the nature of photography. 'Photography as Art, Art as Photography' has been the theme of various publications and exhibitions in recent years; photography as a method for artistic experiment has been vigorously explored, and in the process the working definitions for whatever it is that constitutes art are being subtly and irrevocably altered.

EPILOGUE

The photograph is everywhere. Even television conveys a good deal of its information with the still image. We all take photographs. Who is not familiar with the over-eager tourist anxious to find the best views for his camera, not himself? Even as we look, we cannot help framing what we see: what a good shot that would make, we think to ourselves. Or we may half unconsciously regret the transient effect, the sense of place and atmosphere, smells and sounds, that we cannot capture in the photograph. We may use photography to record art that is hardly visible to the naked eye: with luck and a telephoto lens we can see, for instance, details of the Sistine Chapel that have not been seen since Michelangelo descended from his scaffold. We are provided with a new reality, or an analogue for observed reality. As art – something made – marched alongside the real world, so now do photographs, augmented by television. Indeed, this process has arrived at a point where reality begins to approach fiction: victims of violence, for instance, have felt that what was happening was like a television play, or a newspaper photograph.

Artists, whatever their special interests, are hardly immune from the impact of the general visual culture. Although a small group has used film and video in recent years, this manifestation has not become widespread for reasons that in some respects parallel the use of photography in its earliest years: cumbersome equipment, and incompatibilities between various systems. Another reason has to do with the use of time in films and video, which makes them more akin to the performance arts, rather than paintings and sculptures, where spectators choose their own viewing time, as they do with still photographs. Thus film and video are in a category of their own between the visual arts and the performing arts, while photography remains allied with the visual arts (much to the chagrin of many photographers, but that is another story).

It is arguable that the existence of photography has increased the rigour of selection made by the artist. He may use the camera, but he will be surprised at the detail the photograph will give him, often the excess of it, which he must select and edit. The indiscriminate recording of detail possible for photography allowed painting to develop along other lines, to show imaginatively that which cannot be seen except with the mind's eye. Not for nothing did Kasimir Malevich use the phrase 'the non-objective world' for 'abstract' art, that is, paintings and sculptures which derived their form from mental acrobatics rather than from what could be found in nature, the observed world. Thus forms hitherto unperceived, unrepresented, or not regarded as intrinsically interesting in themselves, rather than as handy devices for background decorative effects, took the centre of the stage; colour too was liberated from its descriptive nature.

Curiously, though, it has been persuasively argued that artists used certain of the visual conventions of photography – for instance, cropping, the informality of the snapshot, the stolen moment, the unguarded second – before photography itself existed. Further, it has been suggested that the basic practical requirements for photography, long known as separate constituent elements, were brought together from the 1820s on because of new moments of vision in the fine arts. Certainly painting explored both the instant, frozen moments, and high definition reality, before photography was technically capable of either. A significant number of artists contributed to the early technical advances of photography, often in the process becoming for posterity associated with the techniques of photography rather than painting. And it must be more than coincidence that the nineteenth century saw the apogee of the idea of Realism – in literature and words, as well as in visual images and paint. The idea of the current, the observable, the documentary and the reportable marched hand in hand with industrialization, with the advance of the mechanical age, and the camera. It was after all the beginning of the age of the newspaper reporter, and indeed, at times, it was the reporter who reported facts in order to reform.

The desire to illustrate modern life was so dominant that ordinary life began to be ruthlessly examined at just the time that photography was invented, developed and expanded. Thus, paradoxically, photography was part of the complex cultural movements labelled Realism, and at the same time accelerated in catalystic fashion the development of the visual arts in certain directions away from Realism. Realism itself remained contro-

versial, shocking and scandalous, as did the art movements that came about in antithesis to Realism.

During the closing decades of the nineteenth century major artists created, painstakingly, the ardent informality of the family snapshot before such snapshots were publicly current, for no professional photographer would have agreed to show in public images of such apparently casual ease. Snapshots were for the amateur, after all. Nor, of course, could they have worked with colour in the way that the painters did.

While we may suggest that artists preceded and anticipated the expansion of the visual vocabulary that photographers have so ruthlessly disseminated – pre-echoed it, as it were – the relationship has been a reciprocal one. The expansion of art history continues to show how omnivorously and with what gusto artists seized on public sources of photography, while not always admitting it. Yet the history of art from its own beginnings, and art itself, have always been conscious of sources and precedents. Quotations from other artists are perhaps the greatest single resource of individual artists. 'Art into art' describes the phenomenon; copying is itself a well-known training device. Acknowledgement of sources from the past has been an honourable course for artists, which has even lent validity, the authenticity of reinterpreted tradition, to images. Naturally artists' catholic appetite has embraced photography.

We have examined the ways in which artists have used their own photography as source material, as a kind of drawing, as recording or documentary, and parallel to their other work, as a medium in its own right. In our concluding chapter, on the recent art of the 1960s and the 1970s, we observed how the photograph has become for many artists the primary medium, often recording other activity planned and undertaken by the artist. Throughout, we have only been able to take a sampling of artists. The number of distinguished, intriguing, innovative artists who have been directly involved with photography could easily have been trebled, but we would have been faced with a listing of hundreds, an art-and-photography shopping list through the past 150 years. The few have stood for the many.

But we may also note a continuing phenomenon in the way we look at art. In the past, many lost works of art have been known through the medium of print. Marcantonio Raimondi's engraving, executed about 1515, after a now lost drawing by Raphael, *The Judgement of Paris*, is a famous case in point. Poses from this print have been used in works as various as Rubens' *The Judgement of Paris,* about 1600, and Edouard Manet's *The Picnic* (*Le*

Déjeuner sur l'Herbe) of 1862-3 – a painting that caused outrage at the time – and it should be remembered that Raphael himself drew upon a variety of sources.

In present-day circumstances, many lost works are known only through photographs. Art itself is studied through photographs. Major art-history institutions have huge collections of photographs and slides; and the enormous growth of museums, of special exhibitions, and of art history as an academic discipline, have led to huge publishing programmes, dependent on photographic reproduction. We study art and appreciate art through photography, buying slides, photographs, postcards and books. The illustrations in this book, whether of paintings, sculptures or photographs, are themselves photographs.

In a very real sense, André Malraux' famous idea of the 'Museum without Walls' has come to mean photographs. Certain contemporary artists who are not themselves photographers have in frequent instances preserved their works through the media of films and photography.

One of the most interesting of recent developments in the history of art is the idea of the reconstruction. This has been particularly important for our understanding of innovatory Russian art in the first three decades of this century, when political and social difficulties, as well as the often deliberately informal nature of the art itself, led to widespread loss and destruction. Thus, a British sculptor, Martyn Chalke, has reconstructed sculptural constructions by the legendary Russian artist Vladimir Tatlin, from photographs. In 1974, four sculptures – the *Spatial Apparatus*, 1919 – by the brothers Georgii and Vladimir Stenberg were reconstructed in a collaboration between an art historian and a gifted technician. The reconstructions were based on documentary evidence which included plans by Vladimir Stenberg, and Stenberg's own photographs of the works taken during the Constructivist exhibition in Moscow in January 1921. These samplings, for a number of significant artists, are manifestations of the entire Russian Revolutionary period in art – a period which has recently gained significant recognition as perhaps the most advanced and extreme in twentieth-century art.

In the past two decades, many works of art have become deliberately ephemeral or physically remote from cultural centres. One example is the work of the Bulgarian-American artist Christo, whose major projects are usually ephemeral, and sometimes remote. In 1976, Christo designed and had built a vast work called *Running Fence*, which was just that: a fence made

of shimmering white fabric, eighteen feet high and over twenty-four miles long, running through Sonoma and Marin Counties, north of San Francisco, California. Several years of planning and seeking of permissions were undertaken before the *Running Fence* was built. These preparations were part of the art work, as were the immense collaborative efforts necessary for the actual construction. A condition was ephemerality: this was no permanent fence but a two-week realization of it. To help finance the project, the cost of which ran into several million dollars, Christo, as is customary for all his projects, made many collages and drawings of plans and the proposed appearance of the environmental work, which were sold. These often incorporate photographs, for which Christo makes a point of using professionals. He is the artist and instigator; the draftsmanship is his, but the photographs of proposals, and of the work, are taken by professionals. *Running Fence* now exists in the memories of those who saw it and took part in the project; in the films of it that were made; and in thousands of photographs, some of which are part of publications created during and after the event.

Works of art are known to the vast majority of their audience through the camera. Not only do we study the art of the past through the photograph, but contemporary art is disseminated through publications that rely on photography, and may now exist for most spectators *only* through photography.

The museum is the camera, the camera is the museum, the art is the photograph and the photograph is the art. And the phenomenon of the artist as photographer is just one special aspect of a blood relationship between art and photography now so intimate that the bonds are indissoluble.

CHRONOLOGY

	HISTORICAL	ART	PHOTOGRAPHY
1816			Joseph Nicéphore Niepce begins experiments with photography (continues through 1820s). Generally accepted to be first person to expose a light-sensitive material in a camera (1822) – heliography (France).
1821	Michael Faraday invents electric motor and generator (Britain).		
1824		Richard Parkes Bonington and John Constable exhibit at 'English Salon' in Paris.	
1825	First passenger steam railway, Stockton to Darlington (Britain).		
1829			Niepce signs agreement to collaborate with Louis Jacques Mandé Daguerre to perfect heliography.
1830	Louis Philippe of France (until 1848).		
1832	Republican uprising in Paris.		
1835			William Henry Fox Talbot begins work on first two-stage photographic process (Britain). Images called 'Talbot-types' or 'calotypes' and process patented in 1841.

1836		Sir John Herschel (Britain) invents word 'photography' (from Greek 'photos', light and 'graphein', to draw). First uses words 'negative' and 'positive' for two-stage process. Discovers that sodium thiosulphate, commonly called hypo, is more effective fixer than sodium chloride (common sale) that Talbot used.	
1837	Queen Victoria of England (until 1901).	Daguerre also finds way of fixing photographic process with salt – daguerreotype (France).	
1838	First electric telegraph (Britain).		
1839		Hippolyte Bayard stages first photography exhibition, showing another process for fixing 'light drawings' (France).	
1842		Herschel invents blueprint process.	
1843		David Octavius Hill collaborates with chemist and calotypist Robert Adamson and partnership produces thousands of calotypes.	
1844	J.M.W. Turner's painting *Rain, Steam and Speed* is astonishingly modern study and acknowledges enormous technical advances made during Industrial Revolution.		
1848	Year of Revolution. *Communist Manifesto* by Karl Marx and Friedrich Engels. Second Republic proclaimed in France – Louis Napoleon President by December.	Pre-Raphaelite Brotherhood founded in England.	
1849	John Ruskin, most influential British critic of nineteenth century, published *Seven Lamps of Architecture*.	Gustave Courbet, pioneer of radical Realism, paints *The Stonebreakers*.	
1850	Charles Dickens: *David Copperfield*.	J.F. Millet's *The Sower* dignified rural labour when industry was expanding in cities and had symbolic and religious overtones.	Louis Désiré Blanquart-Evrard invents new sensitive paper – albumen paper – for making photographic prints (France).

1850			Gustave Le Gray uses waxed paper negative, which improves on calotype because it sharpens detail (France). Following researches by Sir David Brewster and Jules Duboscq, stereoscopic camera comes into common usage.
1851	The Great Exhibition, Crystal Palace, London.		Influence of Great Exhibition extensive because photography categorized as scientific medium and photographers brought together. Frederick Scott Archer demonstrates collodion, or wet-plate, process as early as 1848 but not published until now. The Société Héliographique is formed in Paris. Julia Margaret Cameron begins substantial body of work.
1852	Victoria and Albert Museum opened in London. Napoleon III, The Second Empire (France) until 1870.		
1853			Félix Tournachon Nadar opens photographic studio in Paris with brother Adrian. Photographic Society of London founded, and first president is Sir Charles Eastlake.
1854	Crimean War (until 1856).		André Disderi patents 'carte-de-visite' photograph in which multiple poses can be taken on same negative (France).
1855	Paris World Exposition.	Courbet works on *The Painter's Studio* and holds one-man show 'Le Réalisme'.	First effective dry-plate process is published by Dr Taupenot.
1856	Bessemer process permits mass production of steel (Britain).		
1857	Indian Mutiny.		Swedish photographer Oscar Gustave Rejlander, working in Britain, used combination printing –combining several negatives to make one picture.
1859	Charles Darwin: *On the Origin of Species by Means of Natural Selection*.		

1860	George Eliot: *The Mill on the Floss*. Abraham Lincoln elected President of USA.		
1861	American Civil War (until 1865); slavery abolished in USA. Women first given vote (in Australia).		James Clerk-Maxwell demonstrates to London's Royal Institution first colour photographic process based on trichromatic theory, known as 'additive' system.
1862	Victor Hugo: *Les Misérables*.		
1863	First underground railway in London.	Edouard Manet's *Déjeuner sur l'Herbe* causes national scandal when exhibited at Salon des Refusés.	
1864			Carbon process is introduced by Joseph Wilson Swan. With fine tonal ranges it enables high quality mass production for first time (Britain).
1865	Leo Tolstoy: *War and Peace*. Lincoln assassinated.		
1867	Marx: *Das Kapital*, Part I.		
1869			Eadward Muybridge develops first practicable camera shutters which diminish time needed for exposure. Explores recording of motion, capturing single phases of animal and human locomotion. Louis Ducos du Hauron invents different method of colour reproduction known as 'subtractive' system –basis of colour film today (France).
1870	Franco-Prussian War and Siege of Paris.		Richard Leach Maddox substitutes gelatin for collodion as medium for photographic emulsions and, within a decade, method almost completely replaces collodion wet-plates for making negatives.
1871	Fall of Paris and suppression of the Commune.		
1872		Claude Monet paints small oil sketch, *Sunrise*, which inspires term 'Impressionism' when exhibited at first Impressionist Show (1874).	

1873			William Willis patents platinum prints.
1874	Thomas Hardy: *Far from the Madding Crowd*.		
1876	Alexander Bell takes out patent on telephone (USA). Mark Twain: *Adventures of Tom Sawyer*.	*L'Absinthe* by Edgar Degas is considered shocking view of modern life.	
1877		Auguste Rodin's *Age of Bronze* – his first major work – criticized for its realism.	Muybridge photographs movements of galloping horse in systematic series of instant exposures. Continues to experiment (USA).
1879	Thomas Edison's electric light (USA). Henrik Ibsen: *A Doll's House*.	Society of American Artists founded.	
1880	Formation of the Socialist Workers in France.	Rodin's *Gates of Hell*. Fifth Impressionist Exhibition.	George Eastman registers first USA patent, based on drawing for dry-plate coating apparatus.
1881	Henry James: *Portrait of a Lady*.	*Fourteen-Year-Old Dancer* by Degas. Sixth Impressionist Exhibition. Manet's *Bar at the Folies-Bergères* begun (completed 1882).	Eastman forms Eastman Dry Plate Company, New York.
1882		Seventh Impressionist Exhibition.	Etienne Jules Marey completes construction of 'chronograph', camera with moveable slit disc over fixed photographic plate, vastly increasing possible number of exposures per second (France).
1885	Gottlieb Daimler and Karl Friedrich Benz pioneer automobile (Germany).		
1886		Eighth and last Impressionist Exhibition.	
1887			Marey adds moveable plate to 'chronograph', also produces roll-film camera. Is one of pioneers of cinematography.
1888	John B. Dunlop invents pneumatic tyre (Ireland).		Kodak No 1 introduced: small box-type camera taking circular pictures 2½ inches in diameter.
1889	Eiffel Tower built in Paris.		Edison shows first motion pictures.

1891	Oscar Wilde: *The Picture of Dorian Gray*.	Eastman Company opens factory in Harrow (England) to make paper and film.	
1892	First exhibition of the Nabis (Hebrew word for Prophet) in Paris includes Pierre Bonnard and Edouard Vuillard.	Frederick Eugene Ives, Philadelphia, devises portable apparatus –Kromskop – to view three stereoscopic transparencies together in register, filtering thrice through primary colours.	
1893	World's Fair, Chicago.	*The Cry* by Edvard Munch is shocking searing portrayal of human anguish and heralds new personal individual concerns in visual imagery.	Edison turns hand to Kinetoscope: first commercial instrument to show naturally moving pictures. Displayed at World's Fair, Chicago. Known as peep-hole machine. John Joly (Dublin) invents method of making colour photograph not having to be viewed through apparatus.
1894			Lumière brothers, Auguste and Louis, invent cinematograph (France).
1895	Guglielmo Marconi invents wireless telegraph (Italy) Wilhelm Roentgen discovered X-rays (Germany).		
1896			Robert Paul, London scientific instrument maker, demonstrates at London's Royal Institution machine for projecting films to large audiences.
1897	Count Ferdinand von Zeppelin makes first airship (Germany).		
1898		The Ten America Painters, an American Impressionist group, formed.	
1899	Boer War begins.		
1900	British Labour Party founded. Boxer Rebellion (China). Sigmund Freud: *The Interpretation of Dreams*.	Sensational Rodin Exhibition, includes photographs of his work. Establishes his world-wide reputation.	
1901	First wireless message sent across Atlantic. First powered aircraft flown by Wright Brothers.		

1902			Exhibition of American Pictorial Photography at National Arts Club, New York; beginning of Photo-Secession movement. Alfred Stieglitz starts *Camera Work*.
1903	George Bernard Shaw: *Man and Superman*. First Ford motor car factories (USA).	*The Old Guitarist* by Pablo Picasso.	*Daily Mirror* founded this year is first daily newspaper to be illustrated solely with photographs, heralding profession of photo-journalism (Britain).
1904	Anton Chekhov: *The Cherry Orchard*.		Lumière announces the development of Lumière Autochrome plates, first popular colour process.
1905	Albert Einstein's *Special Theory of Relativity* published in Germany.	The Fauves exhibit at Salon D'Automne in Paris. Expressionism is new 'ism' applied to groups of artists in France and Germany.	Little Galleries of Photo-Secession open in New York.
1907		*Les Demoiselles d'Avignon* by Picasso anticipates many modern art movements, beginning with Cubism.	Lumière Autochrome plates are marketed commercially for first time.
1909		Marinetti's first Futurist Manifesto.	
1910	Development of first plastics.	*Manifesto of Futurist Painting*. Manet and Post-Impressionists hold major exhibition in London (partly organized by Roger Fry) and cause sensation.	
1911		Cubists – Braque, Picasso, and others – show for first time as a group. First 'Blaue Reiter' ('Blue Rider') held in Munich (includes Kandinsky). Camden Town Group, led by Walter Sickert, founded in London.	Anton Giulio Bragaglia begins experimenting (until 1916) to find way of making dynamics of movement visible by moving camera while taking pictures. Founds Photodynamism (Italy) American painter and photographer Alvin Langdon Coburn frees photography from dependence on 'reality' by developing three-way mirror system, and searching for abstract imagery to parallel abstract movements in painting and sculpture. Ezra Pound calls these geometrical photographic compositions 'vortographs'.

1912	First Balkan War.	Marcel Duchamp paints *Nude Descending a Staircase* which becomes major image for modern movement. Cubists use collage which eventually becomes medium in its own right. Futurists exhibit for first time in Paris.	
1913	Second Balkan War.	'Armory Show', first major international showing of controversial modern art held in America. The Vorticists formed; led by Wyndham Lewis. Russian painter Vassili Kandinsky develops abstract painting; publishes *On the Spiritual in Art*.	Dr Oskar Barnack produces Leica, first modern small-format camera, simple to use.
1914	First World War (until 1918).	Kandinsky moves towards total abstraction, as does Piet Mondrian.	
1915	Italy enters First World War. First use of poison gas.		
1916		Monet works on great series of *Waterlilies*. Dada begins.	David L.W. Griffith: *Birth of a Nation*, forerunner of modern film productions (USA).
1917	Russian Revolution, Bolsheviks take control. USA enters First World War.	Revue Dada appears and Galerie Dada opens in Zurich. De Stijl ('The Style') begins in Holland, movement of geometric abstraction.	
1918	Armistice. Women over thirty given vote in Britain. German Revolution. Great 'flu epidemic all over Europe.	Russian art movements advance, and Kasimir Malevich paints *Suprematist Compositions*, ultimate abstractions of geometric shapes.	Raoul Hausmann makes first photomontages (Austria). Christian Schad invents 'schadographs', predecessors of photogram.
1919	Treaty of Versailles. Founding of Communist International. First crossing of Atlantic by air (Alcock and Brown).	Vladimir Tatlin designs *Monument to the Third International*. Kurt Schwitters begins *Merz* collages. Constantin Brancusi creates *Bird in Space*. The Bauhaus founded by Walter Gropius at Weimar; publishes *Bauhaus Manifesto*. First exhibition of Group of Seven (Canadian landscape painters).	

1920	American women receive vote. First general radio broadcasts (Britain and USA). Prohibition in USA.	Fernand Léger's *The Mechanic*, an optimistic affirmation of some aspects of modern world.	
1922	BBC begins regular broadcasts. T.S. Eliot: *The Wasteland.* James Joyce: *Ulysses.* Civil War in Ireland. Fascists come to power in Italy.		Man Ray produces first Rayograms in Paris. László Moholy-Nagy experiments with photograms and photoplastics.
1923	Union of Soviet Socialist Republics established.		Eastman Kodak announce black and white 16mm film and 16mm Kodak Motion Picture Camera and Kodascope Projector – thus home movie making possible. (By 1933 there is standard 8mm equipment.)
1924		First *Surrealist Manifesto*; the movement exploits accidents of chance and imagery of dreams.	First Leicas leave Leitz factory in Germany. Ernemann from Dresden produces Ermanox camera with fastest ever lens, allowing indoor photography. Leicas and Ermanox enable beginning of modern photo-journalism.
1925		International Exhibition of Decorative Arts in Paris gives rise to term 'Art Deco'. First Surrealist Exhibition. Bauhaus moves to Dessau.	
1926	General Strike in Britain. Television invented by John Logie Baird (Britain).	Henry Moore works on *Draped Reclining Figure.*	
1927	First solo flight over Atlantic (Charles Lindbergh).	Piet Mondrian's geometric *Composition in Red, Yellow and Blue.* Max Ernst produces Surrealist works.	Emergence of motion pictures.
1928	D.H. Lawrence: *Lady Chatterley's Lover*. Women over twenty-one given vote in Britain.		
1929	New York stock market collapses; world-wide recession and Great Depression begins.		'Film und Foto' exhibition held in Stuttgart: most extensive and influential international panorama held to date. *Foto-Auge* ('Photo Eye'): volume of pictures published in

1929			Stuttgart, presenting concentrated account of important twentieth-century achievements. Franke and Heidecke put Rollieflex on market. Reportage photographs published in *Illustrated London News*.
1931		Salvador Dali's *Persistence of Memory*. Formation of Abstractin-Creation group in Paris.	First photo-electric meter for photographers, followed by Weston Exposure Meter (1932) which needed no battery.
1932	Aldous Huxley: *Brave New World*.	Alberto Giacometti's sculpture *Woman with her Throat Cut*.	
1933	Nazi party comes to power in Germany.	Bauhaus closed in Germany.	
1934	Hitler becomes leader of Nazi party.		
1935	Mass purges begin in Russia.		Kodachrome film invented by Leopold Mannes and Leopold Godowsky, working with staff from Research Laboratories of Kodak. 'Subtractive' colour film eliminates need to make more than one exposure and can be used in any camera.
1936	Spanish Civil War begins (until 1939).	International Surrealist Exhibition in London.	First issue of *Life* magazine appears in New York.
1937	Jet engine first tested.	Picasso's *Guernica*. New Bauhaus founded in Chicago by László Moholy-Nagy.	First issue of *Look* published.
1938			*Picture Post* published in London. Kodak Super Six-20 camera.
1939	Second World War begins. John Steinbeck: *The Grapes of Wrath*. Ernest Hemingway: *For Whom the Bell Tolls*.		
1940	Fall of France and Battle of Britain.	Max Ernst paints *Europe After the Rain*.	

1940	Neville Chamberlain resigns and Winston Churchill forms a coalition government (Britain).	Henry Moore begins *Shelter Drawings*. American Abstract Expressionism begins.	
1941	America enters war.		Negative-positive principle introduced in Kodacolor Film (similar to previous film except that image not reversed to positive).
1942	T.S. Eliot completes the *Four Quartets*. Jean Anouilh: *Antigone*.		
1944		Francis Bacon's *Three Studies for a Crucifixion*.	
1945	Atomic bomb dropped on Hiroshima. Unconditional surrender of Germany. George Orwell: *Animal Farm*. President Roosevelt dies (USA), succeeded by Harry Truman.		
1946	UNESCO established. First electronic computer built.		
1947	First supersonic flight.		Ektacolor film produced by Eastman Kodak (photographer can now process own colour negatives). Polaroid Land process invented by Edison H. Land, enabling photographer to process high quality picture inside camera immediately (USA).
1948	Harry Truman elected President in his own right. State of Israel proclaimed. Norman Mailer: *The Naked and the Dead*.	Jackson Pollock's *Composition No 1*.	
1951	First nuclear power stations, Britain and USA.	'Abstract Painting and Sculpture in America', big exhibition at Museum of Modern Art, New York.	
1952	Dwight Eisenhower elected President of USA. Contraceptive pill developed.		
1953	Josef Stalin dies. Dylan Thomas: *Under Milk Wood*. Queen Elizabeth II crowned.		

1954		Mark Rothko's *Deep Red on Maroon*. Jasper John's *Flag*.
1955		Robert Rauschenberg's *Bed*, mixed-media construction, and *Monogram* (1955-9).
1956	Suez crisis; Suez Canal closed.	British artist Richard Hamilton's collage, *Just what is it that Makes Today's Homes so Different, so Appealing*, is intellectual precursor of Pop Art.
1957	First earth satellites in orbit. Treaty of Rome.	
1961	First man in space (Yuri Gagarin, USSR)	
1962		Andy Warhol bases images on photographs of Marilyn Monroe.
1963	President Kennedy assassinated (USA).	Polaroid Automatic 100 Land camera.
1964	Vietnam War begins. Publication of *Thoughts of Chairman Mao*.	British artist Bridget Riley paints *Crest* and Pop Art begins.
1966		'Primary Structures' exhibition at Jewish Museum, New York, launches Minimal Art, or ABC Art.
1967	Six-Day War between Israel and Arab nations. First heart transplant.	
1968	World-wide student protests.	
1969	Two USA astronauts are first men to land on moon.	
1970		Joseph Beuys of West Germany becomes influential figure. Robert Smithson's *Spiral Jetty of Rock and Earth* made in Utah's Great Salt Lake.
1974	President Nixon resigns following Watergate scandal.	
1976		Christo's *Running Fence*, over twenty-four miles long, in California.

BIBLIOGRAPHY

No one can write on the subject of photographs and photography, photography and art, without acknowledging an incalculable debt to the work of Helmut and Alison Gernsheim, Beaumont and Nancy Newhall and John Szarkowski.

The two pioneering foundation studies of the relationship between art and photography are by Aaron Scharf and Van Deren Coke.

The major collection of images relating to painting and photography may be found in Erika Billeter's substantial exhibition catalogue.

GENERAL READING

Beaton, Cecil, and Buckland, Gail, *The Magic Image: The Genius of Photography from 1839 to the Present Day*, Weidenfeld and Nicolson, 1975, and Little Brown & Co., Boston/Toronto, 1975

Bernard, Bruce, *The Sunday Times Book of Photodiscovery: A Century of Extraordinary Images, 1840-1940*, Thames and Hudson, 1980

Billeter, Erika, *Malerei und Photographie im Dialog,* Kunsthaus Zürich und Benteli Verlag Bern, 1979

Gernsheim, Helmut and Alison, *A Concise History of Photography*, Thames and Hudson, 1971

Hamilton, George Heard, *Painting and Sculpture in Europe 1880-1940*, Penguin Books, 1967

Newhall, Beaumont, *The History of Photography from 1839 to the Present Day*, Secker and Warburg, 1964

Rotzler, W., *Photography as Artistic Experiment: From Fox Talbot to Moholy-Nagy*, Amphoto, 1976

Scharf, Aaron, *Art and Photography*, second revised edition, Pelican Books, 1974

Van Deren Coke, *The Painter and the Photograph: From Delacroix to Warhol*, Albuquerque/ University of New Mexico Press, 1972

CHAPTER I

After Daguerre: Masterworks of French Photography (1848-1900) from the Bibliothèque Nationale, Metropolitan Museum of Art, New York in association with Berger-Levrault, Paris, 1981

Baron, Wendy, *Sickert*, Phaidon Press, 1973

Bellony-Rewald, Alice, *The Lost World of the Impressionists,* Weidenfeld and Nicolson, 1976

Boyle, Richard J., *American Impressionism*, New York Graphic Society, Boston, 1974

Comini, Alessandra, *Egon Schiele*, Thames and Hudson, 1976
Egon Schiele's Portraits, University of California Press, 1974

Corn, Wanda M., *The Colour of Mood, American Tonalism 1880-1910*, M. H. De Young Memorial Museum and the California Palace of the Legion of Honor, San Francisco, 1972

David Octavius Hill 1802-1870. Robert Adamson 1821-1848, Scottish Arts Council, 1970

Degas Letters, edited by Marcel Guérin, translated by Marguerite Kay, Bruno Cassirer, 1947

Eadweard Muybridge: The Stanford Years, 1872-82, Department of Art, Stanford University, 1972

Edvard Munch, Arbeiterbilder: 1910-1930, Der Verein, Hamburg, 1978

Edvard Munch: Symbols and Images, National Gallery of Art, Washington, 1978

Eugène Delacroix: Selected Letters, 1813-1863, selected and translated by Jean Stewart, Eyre and Spottiswoode, 1971

Fotografia Polska, International Center of Photography, New York, 1979

'From Today Painting is Dead': The Beginnings of Photography, Arts Council of Great Britain, 1972

Galassi, Peter, *Before Photography: Painting and the Invention of Photography*, Museum of Modern Art, New York, 1981

Gustave Courbet 1819-1877, text by Hélène Toussaint, Arts Council of Great Britain, 1978

Hendriks, Gordon, *The Photographs of Thomas Eakins*, Grossman, New York, 1972

Isaacson, Joel, *Claude Monet*, Phaidon Press, 1980

Journal of Eugène Delacroix, The, translated by Lucy Norton, edited with an introduction by Hubert Wellington, Phaidon Press, 1980

Joyes, Claire, *Monet at Giverny*, commentary on paintings by Andrew Forge, Mathews Miller Dunbar, 1975

Maas, Jeremy, *Victorian Painters*, Barrie and Rockliff, The Cresset Press, 1969

Mathews, Oliver, *Early Photographs and Early Photographers: A Survey in Dictionary Form*, Reedminster Publications, 1973

Monet's Years at Giverny: Beyond Impressionism, Metropolitan Museum of Art, New York, 1978

Novak, Barbara, *American Painting of the Nineteenth Century*, Pall Mall Press, 1969
Nature and Culture: American Landscape and Painting 1825-1875, Thames and Hudson, 1980 and New York: Oxford University Press, 1980

Ovenden, Graham, *Alphonse Mucha Photographs*, Academy Editions, 1974

Photographer Thomas Eakins, essay by Dr Ellwood C. Parry III, catalogue notes by Dr Robert Stubbs, Olympia Galleries, Philadelphia; ACA Galleries, New York, 1980

Pickvance, Ronald, *Degas 1879*, National Gallery of Scotland, 1979

Reade, Brian, *Art Nouveau and Alphonse Mucha*, London, 1967

Reff, T., *The Notebooks of Edgar Degas*, 2 vols., Oxford: Clarendon Press, 1976

Rewald, John, *The History of Impressionism*, fourth revised edition, Secker and Warburg, 1973

Salomon, Jacques, *Vuillard et son Kodak*, Le Fevre Gallery, London, 1964

Scharf, Aaron, *Mucha*, Academy Editions, 1974

Stevenson, Sara, *David Octavius Hill and Robert Adamson*, National Galleries of Scotland, Edinburgh, 1981

Thomas, D.B., *The First Negatives*, third impression, H.M.S.O., 1976

Thomas Eakins Collection of the Hirshhorn Museum and Sculpture Garden, The, Hirshhorn/Smithsonian Press, 1977

Varnedoe, Kirk, 'The Artifice of Candor: Impressionism and Photography Reconsidered', *Art in America*, vol. 68, no. 1, January 1980, pp.66-78
'The Ideology of Time: Degas and Photography', *Art in America*, vol. 68, no. 6, Summer 1980, pp. 96-110

Whitford, Frank, *Egon Schiele*, Thames and Hudson, 1981

CHAPTER 2

Ades, Dawn, *Dada and Surrealism Reviewed*, Arts Council of Great Britain, 1978
Experimental Photography, Arts Council of Great Britain, 1980
Photomontage, Thames and Hudson, London, 1976

Alexander Rodchenko, edited by David Elliot, Museum of Modern Art, Oxford, 1979

Art of the Twenties, edited by William S. Lieberman, Museum of Modern Art, New York, 1979

Avant Garde in Russia, New Perspectives 1910-1930, The, Los Angeles County Museum of Art, 1980

Avant Garde Photography in Germany 1919-1939, San Francisco Museum of Modern Art, 1980

Bauhaus 1919-1928, edited by Herbert Bayer, Walter Gropius, and Ise Gropius, Secker and Warburg, 1975

Causey, Andrew, *Paul Nash*, Clarendon Press, 1980

Paul Nash's Photographs – Document and Image, Tate Gallery, 1973

Christian Schad, Staatliche Kunsthalle, Berlin, 1980

Cityscape 1910-39, Arts Council of Great Britain, 1977

Dada Photo Montagen, Kestner Gesellschaft Hannover, 1979

El Lissitzky, Galerie Gmurzynska, Cologne, 1976

La Fidélité des Images: René Magritte, Le Cinématographe et la Photographie, Editions Lebeer-Hossman, Brussels, 1978

Freeman, Richard B., *Ralston Crawford*, University of Alabama Press, 1953

From Shore to Shining Shore: Photographs of the United States 1935-43, from the Farm Security Administration Archives, Impressions Gallery of Photography, 1978

Germany, The New Photography 1927-33, documents and essays selected and edited by David Mellor, Arts Council of Great Britain, 1978

Gray, Camilla, *The Russian Experiment in Art 1863-1922*, Thames and Hudson, 1962

Haus, Andreas, *Moholy-Nagy: Photographs and Photograms*, Thames and Hudson, 1980

Hill, P., and Cooper, Thomas, *Dialogue with Photography*, Thames and Hudson, 1979, and Farrar, Straus and Giroux, New York, 1979

Jaffee McCabe, Cynthia, *The Golden Door, Artist-Immigrants of America, 1876-1976*, Smithsonian Institution Press, Washington, 1976

John Heartfield 1891-1968: Photomontages, Arts Council of Great Britain, 1969

Kahmen, Volker, *Photography as Art*, translated by Brian Tubb, Studio Vista, 1974

Karginov, German, *Rodchenko*, translated by Elisabeth Hoch, Thames and Hudson, 1979

Lines of Power, Hirschl and Adler Galleries, New York, 1977

Lissitzky, Lazar Markovich (El Lissitzky), *Russia: An Architecture for World Revolution*, translated by Erich Dluhosch, Lund Humphries, 1970

Lissitzky-Küppers, Sophie, *El Lissitzky: Life, Letters, Texts*, Thames and Hudson, 1980

Man Ray: The Photographic Image, edited by Janus, Gordon Fraser, 1980

Marcel Duchamp, edited by Anne D'Harnoncourt and Kynaston McShine, Thames and Hudson, 1974

Moholy, Lucia, *Marginalien zu Moholy-Nagy. Moholy-Nagy, Marginal Notes*, Scherpe Verlag, Krefeld, 1972

L. Moholy-Nagy, essay by Kinsztina Passuth, Arts Council of Great Britain, 1980

Morse, John D., *Ben Shahn*, Secker and Warburg, 1972

Naef, Weston J., *The Collection of Alfred Stieglitz: Fifty Pioneers of Modern Photography*, Metropolitan Museum of Art, 1978

Photographs by Man Ray: 105 Works, 1920-1934, Dover Publications, New York, 1979

Precisionist View in Ameerican Art, The, Walker Art Centre, Minneapolis, 1960

Raoul Hausmann: Photographies 1927-1957, edited by Roger Vulliez, Editions Créatis, Paris, 1979

Rotzler, W., *Photography as Artistic Experiment: From Fox Talbot to Moholy-Nagy*, Amphoto, 1976

The Rouge: The Image of Industry in the Art of Charles Sheeler and Diego Rivera, Detroit Institute of Arts, 1978

Rubin, William S., *Dada, Surrealism and Their Heritage*, Museum of Modern Art, New York, 1968

Schmalenback, Werner, *Kurt Schwitters*, Thames Hudson, 1970, and Harry N. Abrams, New York, 1967

Schwarz, Arturo, *Man Ray: The Rigour of Imagination*, Thames and Hudson, 1977

Siepmann, Eckhard, *Montage: John Heartfield*, Elefanten Press Galerie, West Berlin, 1977

Soby, James Thrall, *Ben Shahn*, Penguin Books, 1947

Stanislaw Ignacy Witkiewicz 1885-1939, Richard Demarco Gallery, Edinburgh, 1979

Stott, W., *Documentary Expression and Thirties America*, New York: Oxford University Press, 1973

CHAPTER 3

Bogart, Michele, 'Photosculpture', *Art History*,
vol.4, no.1, March 1981, p.54
Brancusi: The Sculptor as Photographer, essay by
Hilton Kramer, David Grob Editions and
Gallaway Editions, 1979
Elsen, Albert E., *In Rodin's Studio: A Photographic
Record of Sculpture in the Making*, Phaidon Press,
1980 (in association with the Musée Rodin)
Rodin Rediscovered, National Gallery of Art,
Washington, 1981
Geist, Sidney, *Constantin Brancusi 1867-1957: A
Retrospective Exhibition*, Solomon R.
Guggenheim Foundation, New York, 1969
Kenneth Snelson, essay by Howard N. Fox,
Albright-Knox Art Gallery, Buffalo, 1981
Panoramic Image, The, John Hansard Gallery,
Southampton University, 1981
Scolari Barr, Margaret, *Medardo Rosso*, Museum of
Modern Art, New York, 1963
Tabart, Marielle, and Monod-Fontaine, Isabelle,
Brancusi Photographer, Agrinde Publications,
New York, 1979

CHAPTER 4

American Prints 1913-1963, Arts Council of Great
Britain, 1975
Arte Inglese Oggi (1960-76), British Council and
Comune di Milano, Electa, Milan, 1976
Arthur, John, *Realist Drawings and Watercolours*,
New York Graphic Society, Boston, 1981
Carey, Frances and Griffiths, Anthony, *American
Prints, 1879-1979*, British Museum
Publications, 1980
Chase, Linda, and McBurnett, Ted, 'The
Photorealists: Chuck Close, Robert
Cottingham and Richard Estes', *Art in America*,
vol.60, no.6, November-December 1972
*David Hockney. Paintings, Prints and Drawings
1960-70*, The Whitechapel Art Gallery,
London, 1970
David Hockney. Travels with Pen, Pencil and Ink,
Petersburg Press, 1978
Field, Richard S., *The Prints of Richard Hamilton*,
Davison Art Center, Connecticut, 1973

Francis Bacon, introduction by John Rothenstein,
Tate Gallery, 1962
Hockney, David, *David Hockney*, Thames and
Hudson, 1980 (reprinted edition)
Paper Pools, Thames and Hudson, 1980
Kultermann, Udo, *New Realism*, Mathews Miller
Dunbar, 1972
Livingstone, Marco, *David Hockney*, Thames and
Hudson, 1981
Lucas Samaras: Photo-Transformations, California
State University, Long Beach and E.P. Dutton,
New York, 1975
Lyons, Lisa, and Friedman, Martin, *Close Portraits*,
Walker Art Centre, Minneapolis, 1980
Newton, Charles, *Photography in Printmaking*,
Victoria and Albert Museum, 1979
*Photographer as Printmaker: 140 Years of Photographic
Printmaking*, Arts Council of Great Britain, 1981
Photo-Realism: Paintings, Sculpture and Prints from
*Photo-Realism: Paintings, Sculpture and Prints
from the Ludwig Collection and Others*, Arts Council
of Great Britain, Serpentine Gallery, 1973
*Pop Art in England: Beginnings of a New Figuration
1947-63*, essay by Frank Whitford, Arts Council
of Great Britain, 1976
Rauschenberg Photographe, Centre Georges
Pompidou, Musée National d'Art Moderne,
Editions Herscher, Paris, 1981
Rauschenberg: Werke 1950-80, third edition, Tate
Gallery and Kunsthalle Berlin, 1981
Richard Hamilton, introduction and commentary
by Richard Morphet, Tate Gallery, 1970
Robert Rauschenberg, National Collection of Fine
Arts, Smithsonian Institution, 1976
Sylvester, David, *Interviews with Frances Bacon,
1962-79*, new and enlarged edition, Thames and
Hudson, 1980
Tomkins, Calvin, *Off the Wall: Robert Rauschenberg
and the Art World of our Time*, Doubleday & Co,
New York, 1980
Usherwood, Nicholas, *The Brotherhood of Ruralists*,
Lund Humphries in association with the
London Borough of Camden, 1981

Alley, Ronald, *Catalogue of the Tate Gallery's Collection of Modern Art other than Works by British Artists*, Tate Gallery in collaboration with Sotheby Parke Bernet, 1981

Ammann, Jean-Christophe, *Europe in the Seventies: Aspects of Recent Art*, Art Institute of Chicago, 1977

Arnulf Rainer, Whitechapel Art Gallery, Spring 1980

Arnulf Rainer: Body Language, Venice Biennale, 1978

Artist and Camera, Arts Council of Great Britain, 1980

Bernd and Hilla Becher, Arts Council of Great Britain, 1975

Beyond Painting and Sculpture: Works Bought for the Arts Council by Richard Cork, Arts Council of Great Britain, 1973

Contemporary Artists, edited by Colin Naylor and Genesis P-Orridge, St James Press, London, 1977

Edward Ruscha: Prints and Publications 1962-74, Arts Council of Great Britain, 1975

11 Los Angeles Artists, Arts Council of Great Britain, 1971

European Dialogue, Biennale of Sydney, 1979

Fulton, Hamish, *Skyline Ridge*, P.M.J. Self, 1975

Ger van Elk, Venice Biennale, 1980

Gilbert and George, 1968-80, Municipal Van Abbe Museum, Eindhoven, 1980

Jan Dibbets, Scottish Arts Council and Welsh Arts Council, 1976

Jan Dibbets, Stedelijk Museum, Amsterdam, catalogue no.534, 1972

John Hilliard, Elemental Conditioning, Museum of Modern Art, Oxford, 1974

Kahmen, Volker, *Photography as Art*, translated by Brian Tubb, Studio Vista, 1974

Live in Your Head: When Attitudes Become Form 1969/70, Kunsthalle Bern, Switzerland, 1969

Modern Portraits: The Self and Others, Wildenstein, 1976

Neusüss, Floris M., *Fotografie als Kunst: Kunst als Fotografie*, DuMont Buchverlag, Cologne, 1979

New Art, The, Hayward Gallery catalogue, Arts Council of Great Britain, 1972

Richard Long, Municipal Van Abbe Museum, Eindhoven, 1979

Richard Long: Twelve Works 1979-81, Coracle Press for Anthony d'Offay, London, 1981

Rose, Bernice, *Drawing Now*, Museum of Modern Art, New York, 1976

Russell, John, and Gablik, Suzi, *Pop Art Redefined*, Thames and Hudson, 1969

Sol LeWitt, edited and introduced by Alicia Legg, essays by Lucy R. Lippard, Bernice Rose, Robert Rosenblum, Museum of Modern Art, New York, 1978

Stephen Willats: Concerning our Present Way of Living, Whitechapel Art Gallery, 1979

Szarkowski, John, *Mirrors and Windows: American Photography Since 1960*, Museum of Modern Art, New York, 1978

Time Words and the Camera: Photoworks by British Artists, edited by Jasia Reichardt, Graz, 1976

LIST OF ILLUSTRATIONS

187

32 *A child of the Terrasse family*, *c*. 1899
photograph
courtesy of Antoine Terrasse. © SPADEM

33 *Robert and Charles Terrasse*, *c*. 1899
photograph
courtesy of Antoine Terrasse. © SPADEM

34 *Marthe*, *c*. 1900
photograph
courtesy of Antoine Terrasse. © SPADEM

35 *The Servant of Abraham*, 1929
oil on canvas, 24 x 20 in (61.0 x 50.8 cm)
The Tate Gallery, London

36 *Photomontages* for Mayakovsky's
poem, *About This*, *c*. 1923
British Library

37 *Entrance to the Soviet Pavilion*, 1940
photomontage
VEB Verlag der Kunst, Dresden

38 *The Constructor*, 1924
photomontage
VEB Verlag der Kunst, Dresden

39 *Around the Table*, 1917
photograph
Collection Musée National d'Art Moderne,
Paris. Courtesy Madame Marcel Duchamp.
© ADAGP

40 *Photogram*, *c*. 1925
3¾ x 2¾ in (9.70 x 6.80 cm)
Sotheby's, Belgravia

41 *Schadograph*, 1938
Collection, The Museum of Modern Art,
New York. Courtesy of Christian Schad

42 *Kiki with African Mask*, *c*. 1925
photograph
Sotheby's, Belgravia. © ADAGP

43 *Surrealist Object*, *c*. 1933
photograph
Sotheby's, Belgravia. © ADAGP

44 *The Park Wall*
photograph
The Tate Gallery, London. Copyright
the Paul Nash Trust

45 *Totes Meer*, 1940-1
oil on canvas, 40 x 60 in (101.6 x 152.4 cm)
The Tate Gallery, London. Copyright
the Paul Nash Trust

46 *Wrecked Aircraft*
photograph
The Tate Gallery, London. Copyright
the Paul Nash Trust

47 *Untitled, New York City*, *c*. 1934
photograph
Fogg Art Museum. Gift Mrs Bernada
B. Shahn. © Estate of Ben Shahn

48 *Vacant Lot*, 1939
tempera, 19 x 23 in (48.3 x 58.4 cm)
Wadsworth Atheneum, Hartford

49 *Sacco and Vanzetti*, 1931-2
tempera on paper over composition board,
10½ x 14½ in (26.7 x 36.8 cm)
Collection, The Museum of Modern Art,
New York. Gift of Abby Aldrich
Rockefeller

50 Photograph of Sacco and Vanzetti
United Press International Photo

51 *Untitled* from the *Ford Plant* series, 1927
gelatin silver print, 7½ x 5¾ in
(19 x 14.9 cm)
Collection of the Art Museum of the
University of New Mexico, Albuquerque

52 *Rolling Power*, 1939
oil on canvas, 15 x 30 in (38.1 x 76.2 cm)
Smith College Museum of Art,
Northampton, Mass. Purchased 1940

53 *Loplop introduces members of the
Surrealist Group*, 1931
cut-and-pasted photograph, pencil, and
pencil frottage, 19¾ x 13¼ in
(50.1 x 33.6 cm)
Collection, The Museum of Modern Art,
New York. Purchase. © SPADEM

54 *Monument to Balzac*, 1897
gelatin silver print, 9⅛ x 10¼ in
(23.1 x 18.0 cm)
Phaidon Press. Courtesy of Musée Rodin,
Paris

55 *Young Girl Kissed by a Phantom*, 1880s?
salt print with ink notations, 7⅞ x 10¼ in
(20.0 x 26.0 cm)
Phaidon Press. Courtesy of Musée
Rodin, Paris

56 *Seated Ugolino*, 1877
albumen print with ink notations,
6¾ x 5⅛ in (17.0 x 12.9 cm)
Phaidon Press. Courtesy of Musée
Rodin, Paris

57 *The Kiss*, 1898
gelatin silver print, 15½ x 11⅞ in
(39.3 x 30.0 m)
Phaidon Press. Courtesy of Musée
Rodin, Paris

58 *View of the Studio*, 1925
photograph
courtesy of David Grob. © ADAGP

59 *Mlle Pogany II*, 1920-1
photograph
courtesy of David Grob. © ADAGP

60 *Leda*, *c*. 1925
photograph
courtesy of David Grob. © ADAGP

61 Working on *An Endless Column*,
c. 1924
photograph
Arts Council photograph. © ADAGP

62 *Reclining Figure*, 1933
photograph
Henry Moore Foundation

63 *Corner of Studio*, *c*. 1936
photograph
Henry Moore Foundation

64 *Figure*, 1933-4
photograph
Henry Moore Foundation

65 *Mother and Child*, 1931
photograph
Henry Moore Foundation

66 *Brooklyn Bridge*, 1980
silver print, 15½ x 91¼ in
(39.4 x 231.8 cm)
Zabriskie Gallery

67 *Lao*, 1978
oil on canvas, 32 x 32 in (81.3 x 81.3 cm)
courtesy of Robert Cottingham

68 Working photograph for *Lao*
courtesy of Robert Cottingham

69 *Woolworth's*
oil on canvas, 40 x 56 in
(101.6 x 142.2 cm)
Collection of Doris and Charles Saatchi

70 *Linda Pastel*, 1977
pastel on paper, 29¾ x 22⅛ in
(75.6 x 56.2 cm)
photograph courtesy The Pace Gallery,
New York

71 *Chuck Close in his Studio*, 1976
photograph
Heidi Faith Katz. Photograph courtesy
The Pace Gallery, New York

72 *Portrait of Ethel Scull*, 1963
silkscreen enamel on canvas, 35 panels
each 20 x 16 in (50.8 x 40.6 cm) Leo
Castelli. Mr and Mrs Robert C. Scull

73 *Bianca Jagger*
photograph
Galerie Bischofberger

74 *Mr and Mrs Clark and Percy*, 1970-1
acrylic on canvas, 84 x 120 in
(214.0 x 305.0 cm)
© David Hockney 1970-1. Courtesy
Petersburg Press. The Tate Gallery,
London

75 Working photograph for
Mr and Mrs Clark and Percy
© David Hockney 1970-1. Courtesy
Tate Gallery Archives (Accession no.
7221)

76 *Visual Autobiography*, 1968
photomontages
Museo Civico di Torino. © SPADEM

77 *Cosmetic Series*, 1969
collage, pastel, acrylic and cosmetics on
lithographed paper
Richard Hamilton courtesy Waddington
Galleries Ltd

78 *60 Chevies*, 1971
oil on canvas, 45 x 63 in
(114.3 x 160.0 cm)
courtesy O.K. Harris Works of Art

79 *One Eleven Diner*, 1977
oil on canvas, 38 x 52 in (96.5 x 132.1 cm)
courtesy O.K. Harris Works of Art

80 *Glassware I*, 1978
acrylic on canvas, 52¼ x 40 in
(132.7 x 101.6 cm)
Nancy Hoffman Gallery

81 *Skylight*, 1981
screenprint, edition 125, image size
30 x 20 in (76.2 x 30.8 cm)
Anderson O'Day. Courtesy of Brendan
Neiland

82 Working photograph for *Skylight*
courtesy of Brendan Neiland

83 *Monticello*, 1978
photograph
courtesy Angela Flowers Gallery

84 *Crumpled Car*, 1978
photograph
courtesy Angela Flowers Gallery

85 *Camera Recording its own Condition*
photographs, 84 x 72 in
(213.3 x 182.9 cm)
The Tate Gallery, London. Photograph
courtesy John Hilliard

86 *Circle in Africa*, 1978
photograph
Anthony d'Offay Gallery. Courtesy of
Richard Long

87 *No Horizons*, 1976
framed photograph with text,
19¾ x 35¼ in (50.2 x 89.5 cm)
Waddington Galleries Ltd

88 *Three Pit-Heads*, 1977
photographs
Leeds City Art Gallery

89 *Standard Oil Station*, 1966
screenprint, 25¾ x 40 in
(65.4 x 101.6 cm)
courtesy of Ed Ruscha

90 Working photograph for
Standard Oil Station
courtesy of Ed Ruscha

91 *Lächerlin*, 1974
photograph
Atelier A. Rainer

92 *Photo-Transformation*, 1973
SX-70 Polaroid, 3 x 3 in (7.6 x 7.6 cm)
photograph courtesy The Pace Gallery,
New York

93 *Buds and Fruit*, 1980
photo-piece (12 panels), 71 x 78½ in
(180.0 x 200.0 cm)
Anthony d'Offay Gallery

94 *The Lurky Place*, 1978
photographs
Lisson Gallery. Courtesy of Stephen
Willats

95 *Autobiography*, 1979
black and white photographs mounted
on board. 62 sheets, 12 x 24 in
(30.5 x 61.0 cm)
courtesy of John Weber Gallery

96 *Self-portrait*, 1980-1
photograph, pencil and paper mounted
on plasticized board, 72¾ x 72¾ in
(185.0 x 185.0 cm)
Anthony d'Offay Gallery

97 *Sportive Sculpture with Star*, 1981
acrylic paint on colour photograph on
canvas, 90 x 90 (290.0 x 290.0 cm)
Serpentine Gallery, London

98 *Northern Ireland 1968 - May Day 1975*
75 colour photographs 5 x 7 in
(12.7 x 17.8 cm) and 64 typed sheets
8¼ x 5¾ in (21.0 x 14.6 cm)
photograph courtesy of Conrad Atkinson

99 *Northern Ireland*
as above
photograph courtesy of Conrad Atkinson

COLOUR ILLUSTRATIONS

A *Reclining Woman with Green Stockings*,
1917
tempera and black chalk on paper.
Signed and dated. 11 x 17¾ in
(28.0 x 45.0 cm)
Private Collection. Photograph courtesy
Galerie St Etienne, New York

B *Siesta - The Artist's Studio*, 1908-10
oil on canvas, 39½ x 51¼ in
(100.3 x130.1 cm)
Felton Bequest 1949, National Gallery
of Victoria, Melbourne. © SPADEM

C *Pillar and Moon*, c. 1938-40
oil on canvas, 20 x 30 in (50.8 x 76.2 cm)
The Tate Gallery, London. Copyright the
Paul Nash Trust

D *Danseuse*, 1880s
charcoal and pastel sketch
courtesy Christie's, London/Bridgeman
Art Library

E *Marilyn*, 1977
oil and acrylic on canvas, 96 x 96 in
(243.8 x 243.8 cm)
courtesy Louis K. Meisel

F *Photo-Transformation*, 1974
SX-70 Polaroid, 3 x 3 in (7.6 x 7.6 cm)
photograph courtesy The Pace Gallery,
New York

G *512*, 1970
oil on canvas, 78 x 78 in
(198.1 x 198.1 cm)
courtesy of Robert Cottingham

H Working photograph for *512*
courtesy of Robert Cottingham

I *Early Morning, St Maxime*, 1968-9
acrylic on canvas, 48 x 60 in
(122.0 x 153.0 cm)
© David Hockney. Courtesy Petersburg
Press

J *Panorama Dutch Mountain*, 1971
photographs and drawing on board,
19½ x 39⅜ in (49.5 x 100.3 cm)
The Tate Gallery, London. Courtesy of
Jan Dibbets

INDEX

191